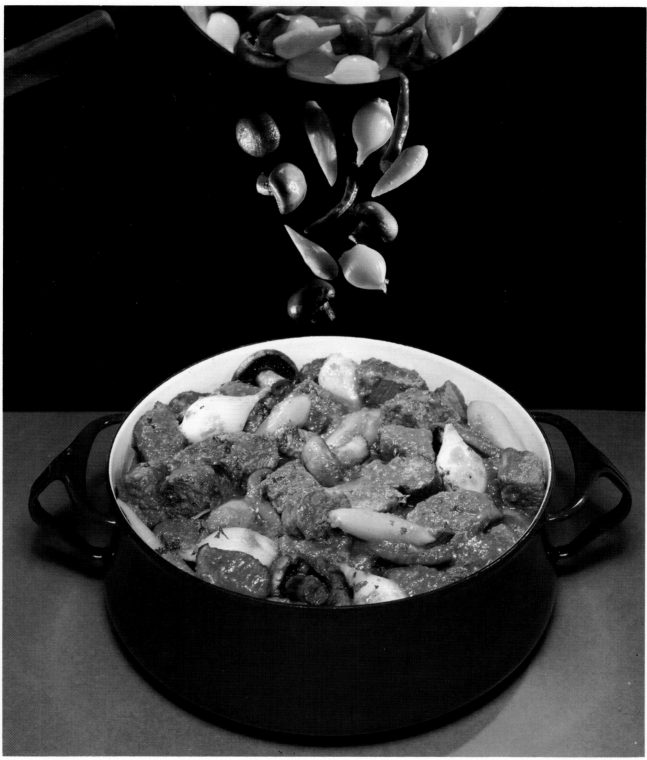

William Pell shot this beef stew in eight different sections to produce this one sharp image. It's not so much a multiple exposure as a jigsaw exposure. It's an 8×10 film print shot at f/32 with a one-second exposure.

Photography by William Pell

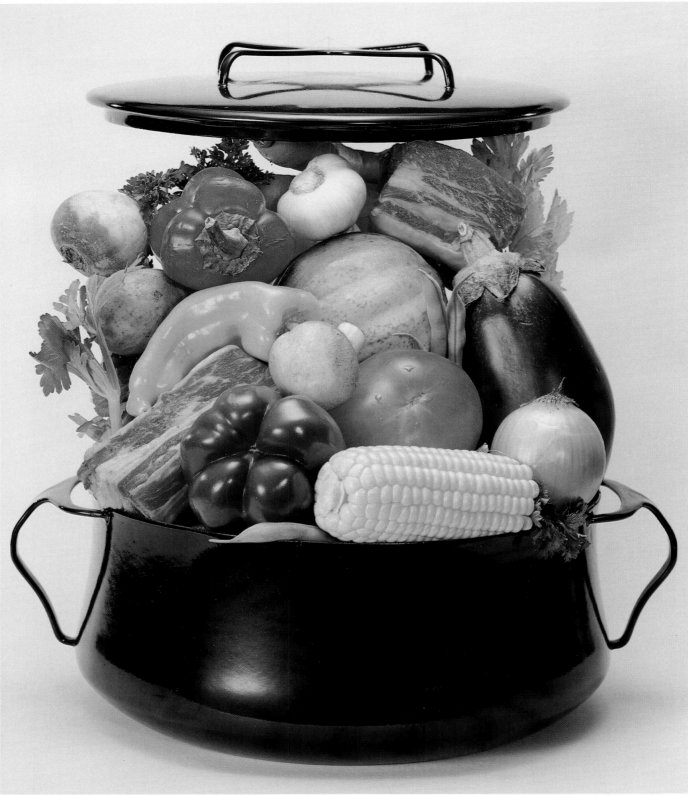

Photography by William Pell

The kudos for the cover of All in One Pot *(Ace Books) belong chiefly to food stylist Betty Pell, who defied gravity with a masterful network of invisible skewers and wires that held all of the comestibles in place and left everything looking extremely palatable.*

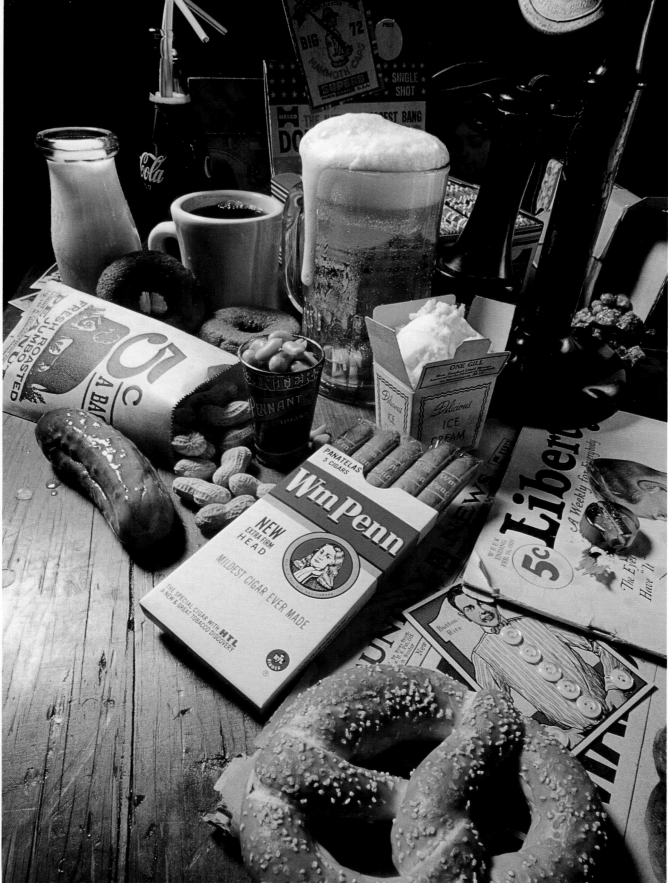

Donato Leo used a 20mm lens and shot at f/22 to get the desired depth of field for this advertisement for William Penn cigars.

Donato Leo

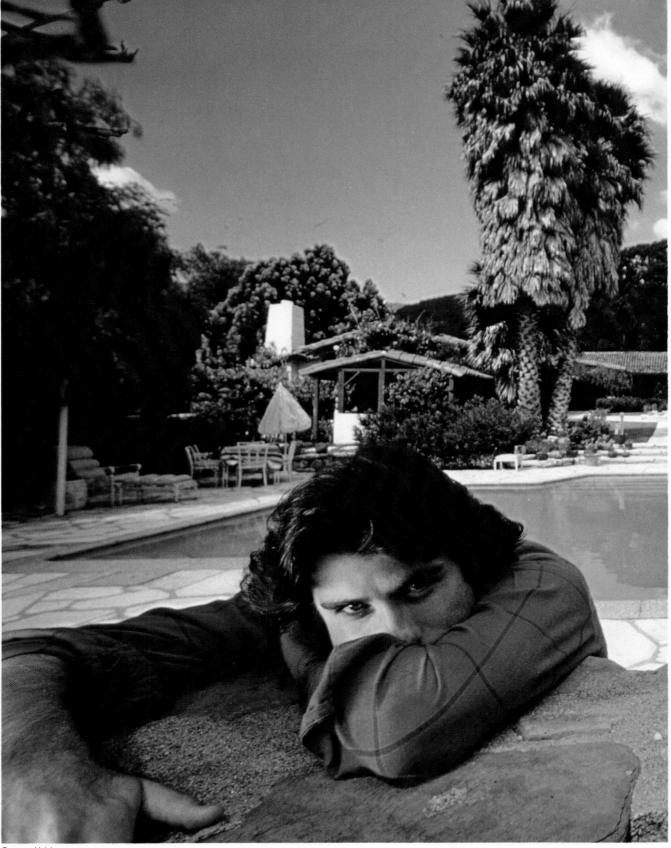

Gregory Heisler

Surely thousands of shutterbugs have photographed John Travolta, seen here at his California home. But how many, before Gregory Heisler, had portrayed the actor as a kind of emerging creature from the black lagoon?

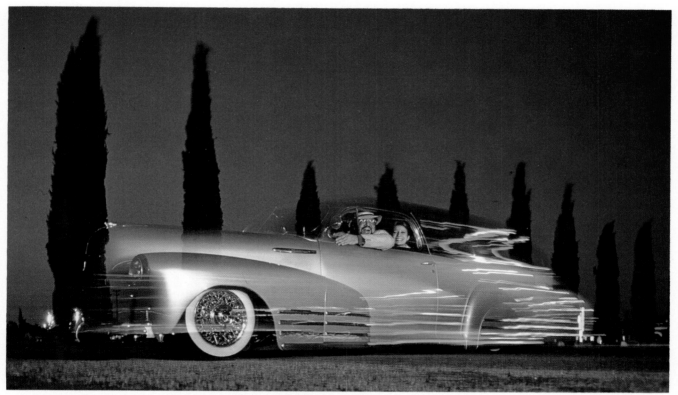

Gregory Heisler

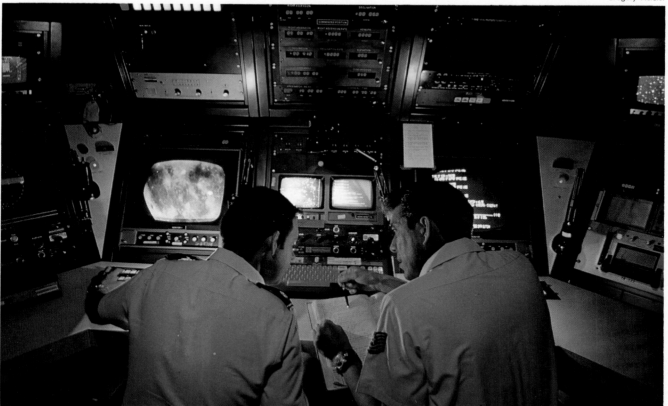

Gregory Heisler

Good acting and a knowledge of a few photographic tricks (the streaks were created by having the car go backward, not forward) went into the dazzling image, top, by Gregory Heisler. Heisler often goes to extraordinary measures to capture what the human eye actually sees. Inside this cockpit he set up strobes in front of the pilots and used a very long exposure to capture the TV pictures.

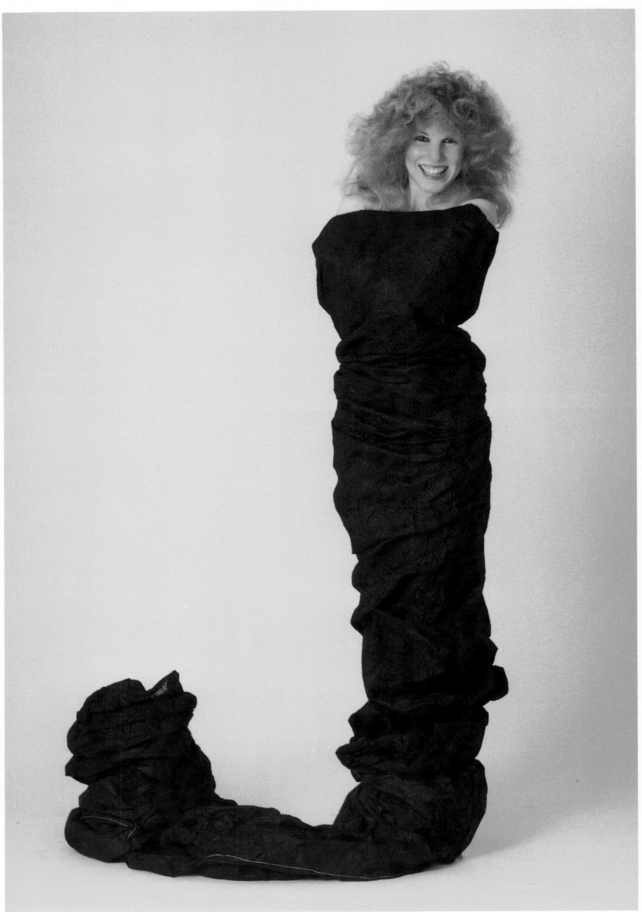

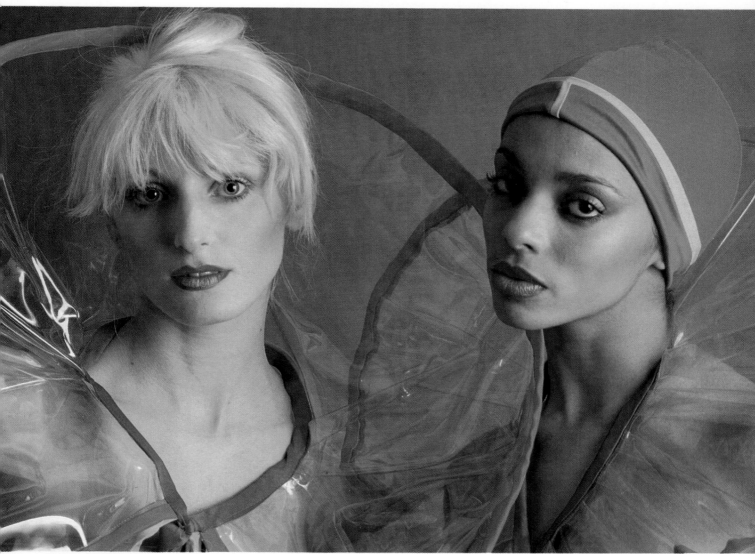

*Timothy Greenfield-Sanders origi-
nally took the picture on the facing
page for the now defunct* Soho
Weekly News *to make an anti-
punk statement. The photo was
shot with a 105mm lens on a
Nikon F8. At the height of the
New Wave movement, Greenfield-
Sanders photographed the vividly
colorful punk fashions, above, also
for* Soho Weekly News.

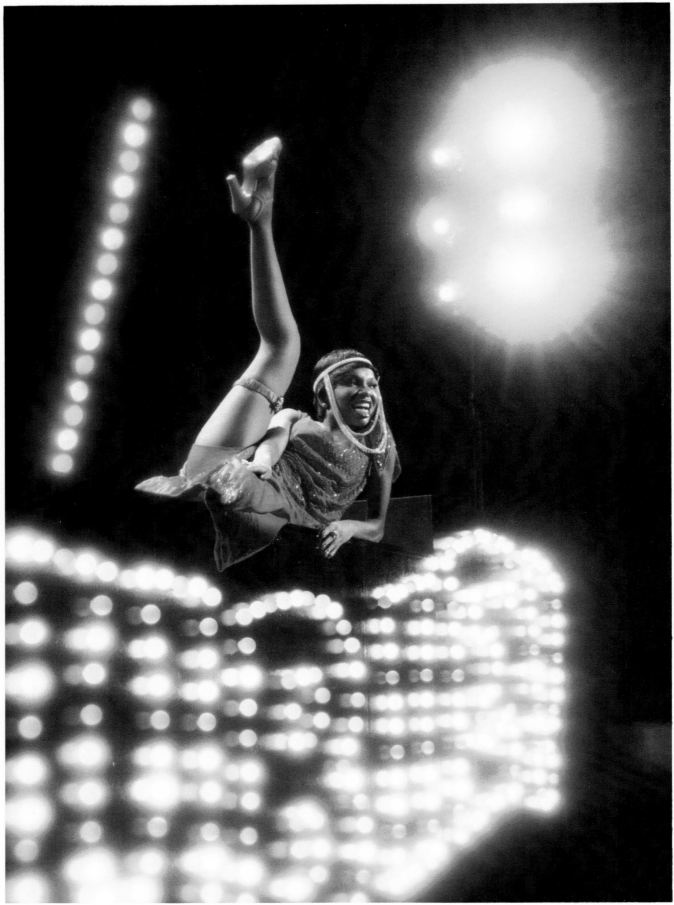

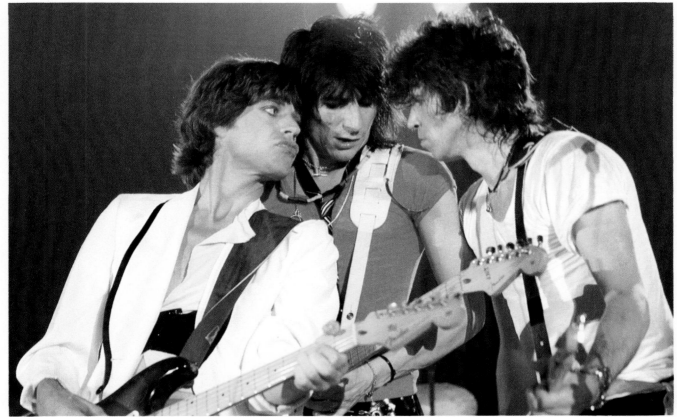

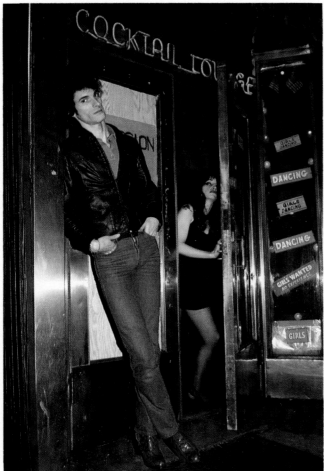

Peter Cunningham is now a frequent fixture at theater dress rehearsals where publicity shots like this one (facing page) for the musical Eubie *are taken. Every concert photographer has his favorite Rolling Stones shot, and here is Richard Aaron's, featuring the mincing frontline triumvirate of Mick Jagger, Ron Wood, and Keith Richards. Mink DeVille, left, is a New Waver-cum-romantic crooner, with the aura of a leatherclad Parisian street singer. His posture and attitude are here captured by Ebet Roberts.*

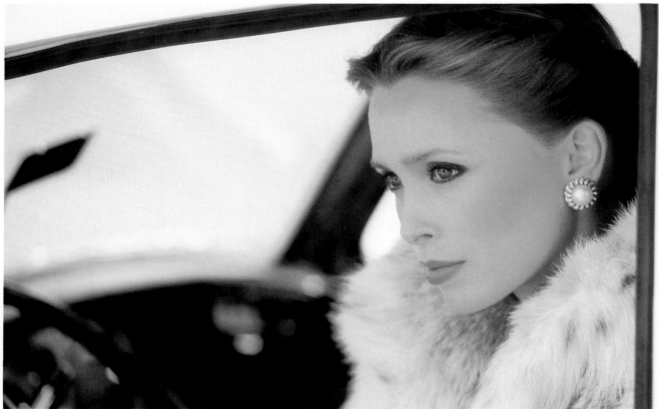

Klaus Lucka, Photographer

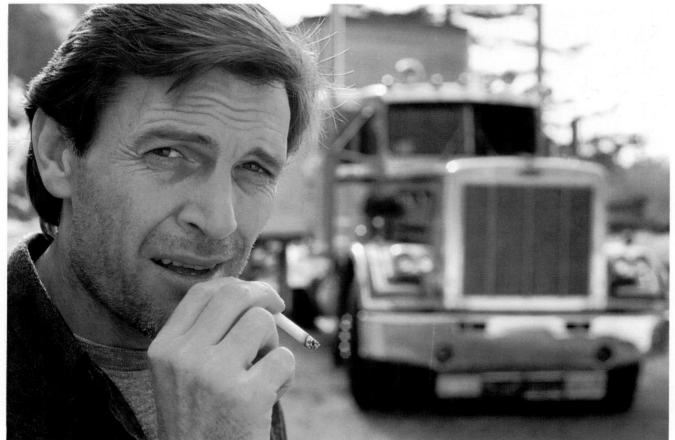

Klaus Lucka, Photographer

Klaus Lucka captures the essence of ruggedly handsome men and elegant women, as these two test shots indicate.

*The bright, contrasting colors and perfect
symmetry attracted Steve Krongrad who made
the colors even deeper during duplication.*

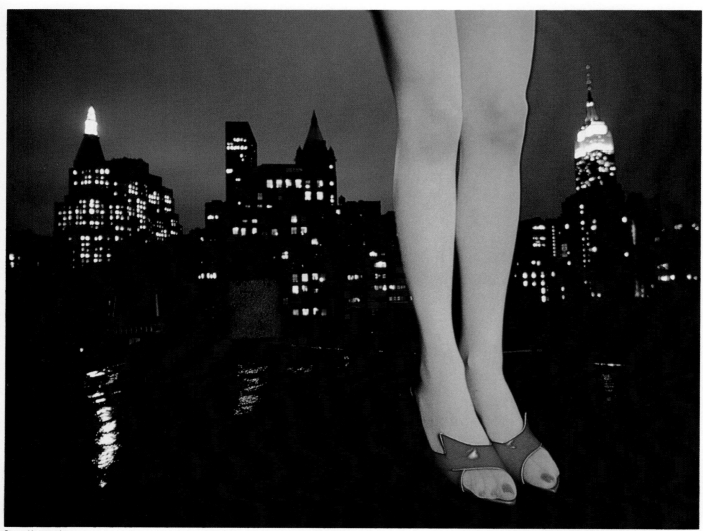

Steve Krongard

The proprieter of these lovely legs was positioned on a rooftop about twenty city blocks in front of the night skyline. She cooperated with photographer Steve Krongard as he experimented with this mingling of two kinds of architecture; reportedly, she was very cold. Even the best photographers experiment playfully in their spare moments.

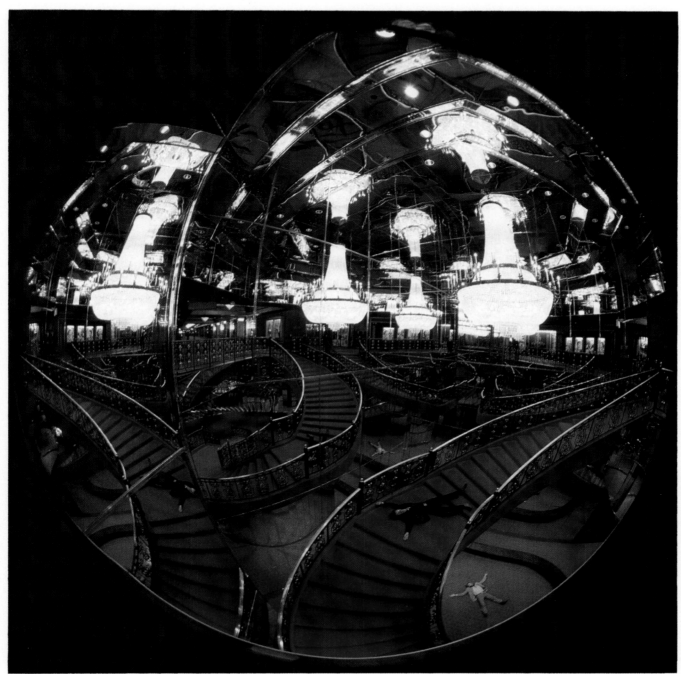

With time to kill while staying at the MGM Grand in Reno, Al Satterwhite equipped his camera with an 8mm fisheye and a ten-second self-timer to capture an even more bizarre view of an almost surreally garish hotel lobby. The prostrate bodies on the stairway belong to Satterwhite and an assistant.

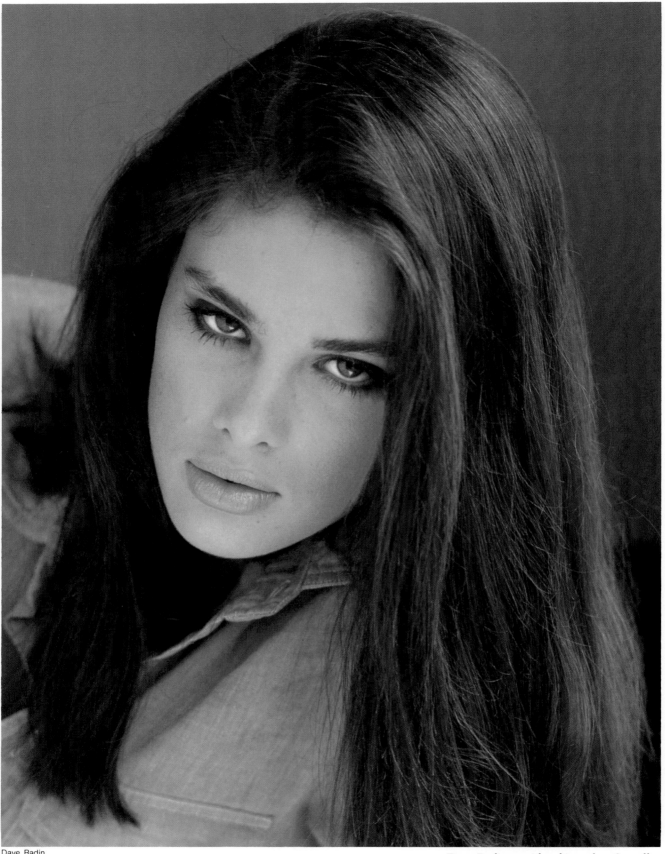

Dave Radin

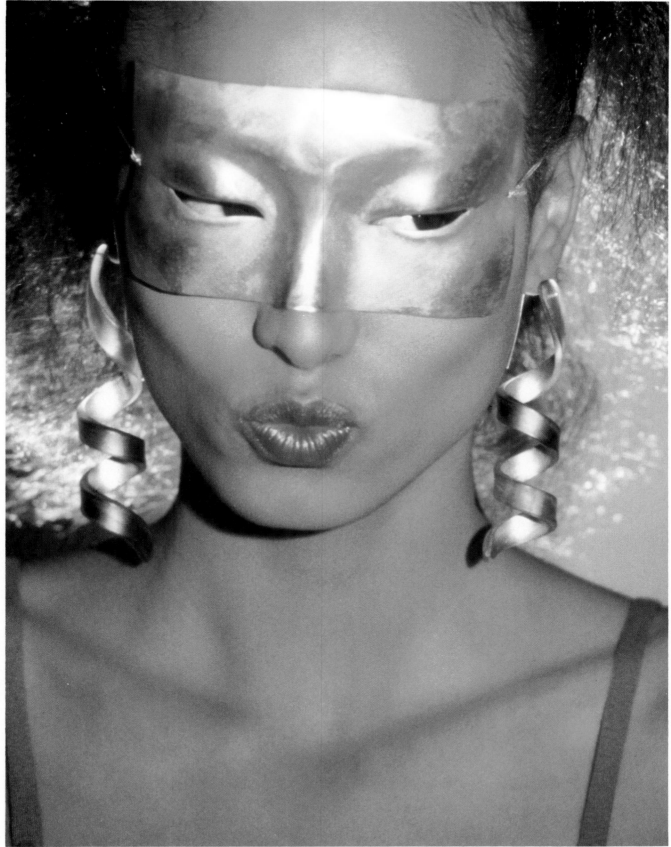

Jacek Kropinski

Kropinski, after a long New York assistantship with Michael Reinhardt, has elected to try his hand as a fashion photographer in Europe, with results like the picture above.

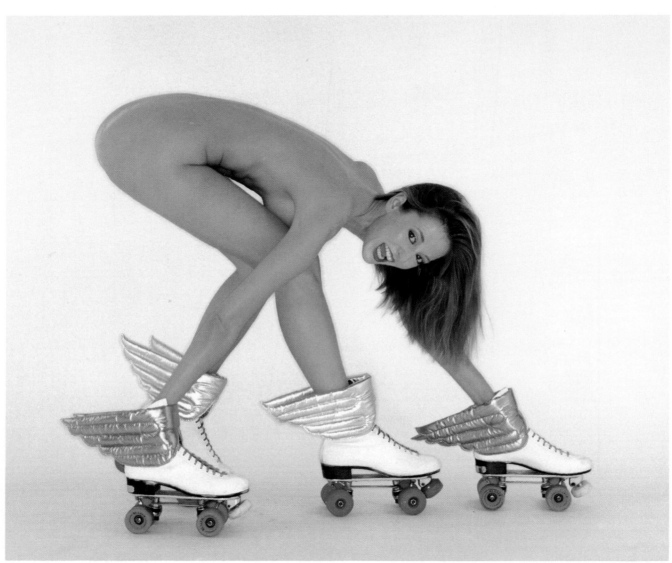

As a model turned photographer,
Ariel Skelley combined her skills to
illustrate the fact that she could
travel quickly to any assignment. . . .

Ariel Skelley

GETTING TO THE TOP IN PHOTOGRAPHY

BY PETER GAMBACCINI

AMPHOTO
American Photographic Book Publishing
An Imprint of Watson-Guptill Publications
New York, New York 10036

To Sean Callahan

Copyright © 1984 by Amphoto

First published 1984 in New York by American Photographic Book Publishing:
an imprint of Watson-Guptill Publications, a division of Billboard Publications, Inc.,
1515 Broadway, New York, N.Y. 10036

Library of Congress Cataloging in Publication Data
Gambaccini, Peter, 1950–
 Getting to the top in photography.
 Includes index.
1. Photography, Commercial—Vocational guidance.
I. Title.
TR154.G36 1984 770'.23'2 84-379
ISBN 0-8174-3906-4

ISBN 0-8174-3905-6 (pbk.)

Manufactured in U.S.A.

First Printing, 1984
1 2 3 4 5 6 7 8 9/88 87 86 85 84

CONTENTS

INTRODUCTION 5

THREE GENERATIONS: A PHOTOGRAPHIC CHAIN 6
STEVE KRONGARD 8
ERIC MEOLA 12
GREGORY HEISLER 15

ASSISTING: FOUR OVERVIEWS 22
GIDEON LEWIN 24
CHAD WECKLER 28
PEGGYANN GRAINGER 33
PAUL CORLETTE 37

FOOD AND STILL LIFE 40
LYNN ST. JOHN 42
CHARLES GOLD 45
DONATO LEO 50
WILLIAM PELL 52
MICHAEL O'NEILL 55

PHOTO ILLUSTRATORS 58
KLAUS LUCKA 60
JIM SALZANO 64
AL SATTERWHITE 68
JOY AUBREY 74

JOURNALISTS 76
WALTER IOOSS 78
HARRY BENSON 82

PORTRAITURE 84
TIMOTHY GREENFIELD-SANDERS 86
ARNOLD NEWMAN 89
FREDERIC OHRINGER 93

**FASHION AND BEAUTY
AND THE HIGH LIFE** 96
DARLEEN RUBIN 98
ARIEL SKELLEY 103
JACEK KROPINSKI 105
DAVID RADIN 109

MUSIC AND THEATER 114
RICHARD E. AARON 116
PETER CUNNINGHAM 119
WARING ABBOTT 121
EBET ROBERTS 124

INDEX 128

Special thanks to
Ilene Wagner
Jim Charlton
Herb Weiss
Susan Flato
Jeanette Mall
Barbara Lieberman
Tim Metevier
Darleen Rubin

Introduction

They can transform ordinary food into a feast so succulent that the most well-stuffed among us go scurrying to the nearest restaurant. They make each article of apparel so enticing and comfortable that we simply must have it, even if we are several sizes too large to wear it without appearing ridiculous.

They see a new side of the famous people we thought we knew so well, and they preserve that aspect eternally for all of us to share. And they capture the most fleeting moments for permanent record—the instants that may be exciting or agonizing but which are all unchoreographed and unrepeatable. Those images would be destined to vanish forever if not for these most watchful eyes.

They are photographers; their presence is more apparent and their function more important with the passing of each day. Their profession holds the promise of artistry, creativity, glamour, and fortune, and the number of people eager to join the photographic fraternity increases daily.

Photography is not *easy.* The pictures that stun us on the pages of a magazine didn't come to pass merely because a man or woman pointed a camera at something.

There's much more to it than that. Good photography is the result of skills mastered and instincts sharpened. The best men and women behind the camera are the best because they've taken the time to learn—somewhere.

Which brings us to the subject of this book. How does one embark on "Getting to the Top in Photography"? What are the best ways of launching a successful career with a camera? There are a number of routes one can take to reach the pinnacle of the photography world, and the people profiled in this book started and persevered in a wide variety of ways. One of the tried and tested and reliable methods for getting to the top in photography, however, is by being a photographer's assistant.

The assistant occupies a rather extraordinary niche. There are very few other positions from which a person can witness the entire process of creation, from conception to execution. An assistant is there at the master's side, taking it all in, waiting for the day when he or she will be in business as a photographer and can put to practice what has been seen and absorbed.

Nearly every successful commercial photographer uses an assistant, and assisting takes a lot of the mystery out of the enigmatic realm of photography. It's essential, no matter what field you're trying to enter, to get your foot in the door, and in no case is this more true than with photography. Getting to the top in photography requires getting *inside*, even if it be at the low end of the pecking order. On the outside, you can only guess as to how the profession works; as an assistant, you'll see it first-hand and up close. In the best of cases, an assistantship means practical on-the-job training, an education in business, and a valuable set of connections.

The value of assistants is undeniable; some photographers would collapse rather than function without them. The value of *being* an assistant is also undeniable. If you're absolutely certain about what your photograhic goals are, an assistantship with the right mentor may be the best way to achieve them. And if you're not so sure, assisting a qualified boss in two or three different fields may help you make up your mind.

There are as many approaches and specialties in photography as there are photographers. Everyone's experience, either as boss or assistant, is different. Investigating the situation at a studio where you feel you'd want to work is obviously advisable.

In preparing this book, we interviewed many photographers and assistants, each with his or her own saga to tell. You would do well to weigh all of these stories and figure out what an assistantship might mean in your endeavor to get to the top. In the context of this volume, you may hear several people making essentially the same statement; at other times, two persons may supply rather contradictory testimony. Conditions vary from studio to studio. People agree and disagree. Life's like that.

One thing that should emerge from reading this modified oral history is an appreciation of the fact that in many cases an assistantship is nearly mandatory and in even more cases it is advisable. Where big money is concerned, clients do not tend to throw it at untested photographers. However, if you've proven yourself by the side of a reputable artist, it can make an enormous difference—in your marketability *and* ability.

Getting to the top in photography requires preparation. The people interviewed here, all at various stages in their careers, were prepared or were still preparing themselves for the creative and commercial success they all covet. We believe this book can be part of that preparation. We think it is the most thorough glimpse yet published of how one can progress from "square one" to the loftiest pinnacles of the photographic profession. We hope that it will help you define your photographic goals and give insight as to how those aims can be pursued and achieved.

PETER GAMBACCINI

THREE GENERATIONS: A PHOTOGRAPHIC CHAIN

THE POPULARITY of <u>Roots</u> a few years ago sent everyone to find the various "roots" and branches of their own family trees. If they knew where they came from, people believed, they could understand who they were now and how they got that way.

In this sense, photography is no different from the rest of life. Our understanding of a master photographer's work is enhanced if we know whom that photographer learned his trade from — and our knowledge becomes even more acute if the student-teacher connections can be traced back beyond one generation.

Steve Krongard, Eric Meola, and Gregory Heisler, three important photographers we interviewed, are also former photographer's assistants. Moreover, their lives are intriguingly intertwined. Krongard is a recent assistant to the venerated Pete Turner and has ventured forth on a photo career of his own. Meola, several years before, was also an assistant to Turner. And Heisler was an assistant to several photographers, one of whom was Meola.

There are common elements in all three men: they have been exposed to and assimilated some of the same information about their business. They have also gone separate ways, developed their own styles and areas of expertise, <u>and</u> they have formulated their own opinions about photography and the way to prepare for a life in this field. Their observations are grouped together in "Three Generations: A Photographic Chain" because their comments offer a more meaningful picture if they are taken together — as branches of the same tree, if you will.

STEVE KRONGARD

"PETE TURNER U." is how Steve Krongard refers to the place where, as studio manager for about two years, his livelihood was earned and his continuing education unfolded. "It feels like the most exclusive graduate school," suggests Krongard. "Graduates of Pete Turner U. have a sense of how to market themselves. You meet people here who will be of great help to you afterward."

Pete Turner U. is in fact Turner's spacious multi-purpose studio above the Carnegie Recital Hall in Manhattan, and the "curriculum" is professional photography at its very finest. The "graduates" are former studio managers or assistants of Turner, and the list is every bit as impressive as Krongard indicates. The eminent photographers who honed their trade under Turner's tutelage include Eric Meola, Anthony Edgeworth, Michel Tcherevkoff, and Ted Kaufman. The latest graduate is Krongard, who is now taking his own assignments.

In the months since leaving Turner U., Krongard has photographed editorial spreads for *Fortune, Omni, Science Digest, Money,* and *Penthouse,* and his commercial clients have included Atari, Coleco, and IBM. He was one of the photographers selected for the ambitious book, *A Day in the Life of Australia,* and will be one of thirty-five photographers from seventeen countries contributing to the forthcoming tome, *Salute to Singapore.*

Turner is among the most visionary, pioneering, and versatile picturetakers on the planet. His repertoire includes fine art, beauty, still life, special effects, travel, auto, and industrial photography. As Krongard puts it, the attitude here is that "Pete is the best in the world at what he does," and what he needs in terms of staff is "people who can act independently at his level of standards."

That is why a studio manager like Krongard, who was still working for Turner at the time of our interview, is so vital. While titles and duties vary from one business to the next, frequently a studio manager is essentially at the top of the assistants' totem pole. With Turner's approach, says Krongard, the staff, which includes a secretary-bookkeeper and one or two additional assistants, is the studio manager's staff. There is a fairly "strict pecking order. I work closely with Pete, work out what has to be done, and help conceptualize things." Another assistant "opens up the studio, runs errands, and gets lunch. When it comes to the shoot, we share."

Turner's staff is fairly small, considering the range and complexity of assignments he handles. But it is a staff designed for what has to be done *in the studio.*

When he goes out on location, which he may do as much as half of the time, he and his studio manager hire whatever additional people will be needed.

Krongard has found that freelance assistants are "all over the place," and generally possess "more experience, a better sense of themselves, and are more professional" than many of the people who come to seek full-time spots. "There's a good solid corps of freelancers. They're cold, unemotional, and they get the job done."

Supplementing the regular staff for location shoots was largely Krongard's responsibility. For a series of somewhat surreal ads promoting magnificently colorful sinks, bathtubs, whirlpools, and even a combination sun lamp-steam bath-fan-shower-stereo system for the Kohler Company of Wisconsin, a decision was made to photograph in a desert area of southeastern California. In preparation, Krongard went out to Los Angeles in advance of Turner, checked into a hotel, and began the process of hiring assistants, location scouts, stylists, and models. Douglas Kirkland, an esteemed photographer and a chum of Turner, had recommended some Los Angeles-based assistants. One full-timer would be coming out in a few days with Turner from New York. Krongard recalls, "I figured out what I needed and hired one extra guy. I wanted to be covered. The job had a big enough budget." One reason for the extra personnel may have been the enormous amount of equipment involved. An extra hotel room was booked just to house the twenty-five to thirty cases, and assistants took turns on a twenty-four-hour guard.

Steve Krongard had a design and architecture background and only a limited knowledge of photography when he met John Van Schalkwyk, a Boston cameraman with "a beautiful sense of light, a brilliant guy with a great business sense." Van Schalkwyk became Krongard's teacher and benefactor. After Steve decided he wanted to make his move to New York, Van Schalkwyk actually bought him about $200 worth of Cibachrome equipment and printing paper. Krongard spent six months putting together a list of contacts and a portfolio; between his professional and personal obligations, he estimates he was in the Boston studio and darkroom an average of twenty hours a day during his last three months there.

Krongard emphasizes that he was putting together "a portfolio aimed at getting assistant's work." It did not include the work he might personally have preferred — landscapes, for example — but stressed work done in the studio and "an understanding of the tools." His goal was "a meticulous portfolio about which no one could have any technical criticism." There were no dust

spots on the prints, which was a way of letting photographers know "I wasn't going to screw up their film." Krongard sought to achieve, and looks for in others, "ten to thirty pieces with a sense of balance and design and neatness. I would never hire a slob here."

Turner was the first person Krongard saw upon coming to New York. He sat in on sixty interviews during the search for his own replacement in Boston, so he was fairly familiar with the process. And he knew what to look for now when he interviewed for Turner — an assistant who was "smart and eager." An assistant "who wants it badly, really badly." It helps, Krongard believes, to "be a chameleon in a way, to quickly assess personalities and adapt to them."

There are important distinctions an assistant will discover if he earns a position on the Turner payroll. Assistants are not expected to act like mere hired hands. "He doesn't want full-time assistants, he wants photographers," explains Krongard. "He demands a lot from people here, and he insists on giving a lot." It is a small team, but there is "so much that has to be done" that Krongard might pay a freelancer $100 for a day to scout out a location within Manhattan rather than forfeit an assistant's presence in the studio.

"Pete gives the staff a lot of responsibility. There's a lot of dealing with the clients, and a lot of important decision-making," observes Krongard. That approach is distinctly different from the photographer who prefers that the assistant have nothing at all to say to outsiders who enter the studio. What the assistant earns from being so deeply in the thick of things, says Krongard, is "a kind of street smartness and business acumen that you can't get right out of school."

TURNER ALSO DIFFERS from many commercial photographers in that he works almost exclusively with 35mm cameras. It is, according to Krongard, a flexible system. "It gives you a lot of mobility, and it's the only format you can use Kodachrome with." He adds, "35mm chromes can be tack sharp. Kodachrome is a virtually grainless film. In terms of sharpness, there's really no need for larger formats."

A more important reason for Turner's preference for the 35mm may be that the special techniques he's developed are especially suited to that kind of camera. He has made advances with contrast enhancement and intensified color saturation, and he has mastered a method of combining five images on a duplicating machine which he "pretty much built," according to Krongard. Turner has also modified his own Nikons and has a remote-control device which makes aperture adjustments of a quarter or a third of a stop.

"People who leave here are stronger in all areas, not just technical ones," Krongard believes. There is always a logical, step-by-step progression at work in tackling a task, and "people who leave here are more prepared to solve difficult problems because of this approach."

An agile mind is an essential tool for work at the Turner digs. An assistant must have "a sense of how things go together. You have to be able to figure things out," says the studio manager. "My carpentry isn't great, but when I build something it doesn't fall down. It's not my natural inclination, but if I have to wire something, it gets wired. If I need square edges, they get squared."

Turner does not walk around with "I'm the boss" written all over his persona, points out Krongard. "He gets pissed off if you say you work *for* him. He wants you to think of this as a team effort. He doesn't hesitate to ask an assistant a question in front of a client. He'll change something if a lowly assistant has a better opinion. He treats them with a lot of respect in public and backs them up."

WORKING FOR TURNER means plenty of travel. It may be somewhat glamorous, but it is not a vacation. "When you go on location, you have to be prepared to work twenty-four hours," observes Krongard. "If you have to be holding a fill card all day in 100-degree sun, you have to be prepared for that. You may be building a set for sixteen hours and be burnt or bit while the photographer and the art director are drinking margaritas in a thatched hut. In Africa, an assistant is the person who has to remember to bring snake repellent."

Krongard understands the hesitance of some seasoned assistants to venture out on their own. The reasons, he says, can include "fright, lack of knowledge, and the absence of a portfolio. It's hard to build a good portfolio while you're working with someone else. For some people, it's too easy to just keep on answering those phones."

However, Krongard doesn't believe the problem of accumulating capital with which to start a business is an insurmountable problem. "There are ways you can start a business without putting out a whole lot of money," he contends.

AT THE TIME he was interviewed for this book, Krongard had staked out a comfortable middle ground by striking a deal with Turner. He could get

his own clients and commence his own photography while still working for Turner. When scheduling permitted, he could use Turner's studio or go on location with his own clients.

"I'd much rather get started from within a studio," Krongard said. "I have all the equipment. I have a great address. And I have Pete's support." It sounded like a perfect setup — the security of a regular job while working to get one's own photographic feet on the ground. However, an assistant shouldn't go looking for a job expecting something like this to automatically occur. The Turner-Krongard arrangement is far from common.

Krongard happened upon these storage tanks near Reno just after they had been repainted a dazzling white. The spectacular brightness appealed to the Manufacturers Hanover Leasing Corporation; they purchased the shot for one of their ads.

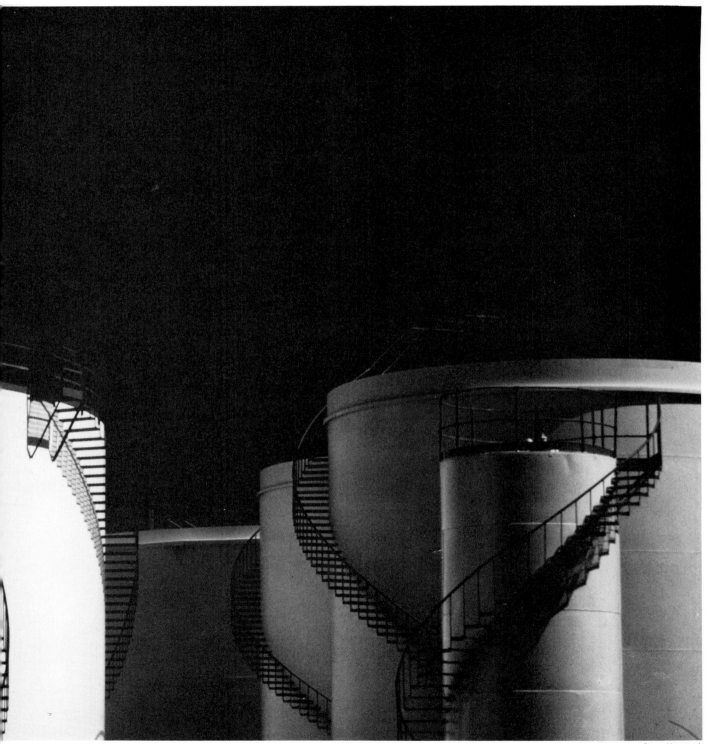

Steve Krongard

11

ERIC MEOLA

TODAY, ERIC MEOLA is among a handful of still-life photographers who are truly the apple of an art director's eye. He is also an accomplished travel photographer and has an impressive oeuvre of album cover work, including the famed shots of Bruce Springsteen and saxophonist Clarence Clemons on "Born To Run." In his days at Syracuse University, however, Meola was an English major who took a few photography courses at the Newhouse School of Journalism, "mainly technical stuff in color printing." He was doing some color work of his own, and determined before he got his B.A. that photography was his career choice — and that assisting an established and respected photographer would be the smartest first step he could make. So, before going out on his own, Meola served as Pete Turner's assistant for eighteen months.

MEOLA HAD SEEN Turner's pictures in *Holiday, Esquire,* and *Look* and knew "he was the guy I wanted to work for." He first visited Turner a year before his graduation, and Turner told him to come back in one more year. "He liked my color. He thought I 'showed promise,'" remembers Meola. "But he was fairly open about my not having a strong technical background." The time was 1967, in the midst of an era of phenomenally successful photographers with immense studios and technically oriented assistants.

Meola did go back, and was put off again for another couple of months. But he kept with it, and Turner finally took him on. Turner had been doing mostly editorial travel spreads and was in the process of greatly expanding his studio space and going after more commercial assignments. With so many other new expenses to worry about, Turner was logically aware of overhead, and Meola notes "he knew he could get me cheap." And Turner would be learning a lot himself in the coming months. "He didn't want someone who knew so much more than he did that he'd feel lost," explains Meola.

A great deal of Meola's labor in his first six months with Turner was "menial" and included "chopping through walls" to get the studio into the desired form. But in the process, he says, "Pete and I were learning how to light and use strobes together."

The stint with Turner was a crucial one for Meola. "I'd come to New York and shown my portfolio and had run up against a brick wall," he comments. "At that time, art directors had basically conservative clients and looked on a lot of young photographers who came by as freaks and hippies." Moreover, he acknowledges, "I came out of college with a sophomoric portfolio."

His apprenticeship with Turner taught him a lot. "People would come to Pete for his own thing. He'd always cover what *they* wanted. But he had an open mind and could see clear to what *he* got out of it." Turner had the unique capacity to please the client while concurrently satisfying his own creative inclinations.

There is a pitfall to being exposed to this procedure, Meola warns. "People coming out of Pete's studio have a hard time realizing that 50 to 80 percent of commercial photography isn't like that. It's 'this is it, this is what we want, and we know you can do it.' He was able to go beyond that and extract something for himself." Assistants with aspirations of being autonomous photographers must understand that in many cases they will be expected to meet exact specifications of an art director or account executive. The reverse of that, of course, is that an executive may have a less than complete picture of just what he is looking for, and he will hire a particular photographer because he trusts his ability to fill in the spaces in that vision.

As Turner's employee, Meola's opportunities to shoot were "very rare," but that was hardly to be considered unusual. "There's always that menial thing that's part of the photographer's life that the assistant gets caught up in," Meola notes. "There's bookkeeping, or making sure he keeps a lunch appointment. There's that *and* the photographer's photography, which of course comes first. As for one's own creative inclinations, he learned "there's very little time for that, or energy."

Nevertheless, Meola had the opportunity of being part of a business that was really getting on its independent feet and would become a hallmark of the industry. "What I was getting out of it was practical, first-hand knowledge about dealing with art directors and seeing the neuroses and last minute deadlines. And I was becoming more mature. I learned to think ahead; Pete was very good about telling us to always anticipate.

"Working for Pete may have been like serving in the Army," Meola says with wistful fondness. The job is "rigid and disciplined. You might leave there hating the guy or nearly cracking up. But most people look back and say 'Hey, the guy taught me something.'" One of the major lessons was "how to look at things obliquely, not just straightforwardly."

One of the most important matters in an assistant's life is knowing when to leave and move on. "You reach a point where you know you're not going to learn much more, or things are getting repetitious," Meola remembers. "It's time for you to add your own dimension to it. You get tired, too, of hearing the same voice saying 'Get me a cup of coffee.' You want to be your own boss.

"A lot of people might leave earlier," he believes, "but you worry 'Am I going to fall flat on my face?'"

And even when the break comes and you're out on your own, you're not a full-fledged "adult" in photographic terms, he adds. "There's still a three- to four-year process of further maturing and beating your head against the wall." As distressing as the frustrations and anxieties of one's formative professional days are, they are thoroughly to be expected.

ERIC MEOLA SUGGESTS that in an ideal world, a photographer would function happily without an assistant. "Ideally, we'd all like to work out of a shoulder bag." An assistant is just "more overhead, one more person to cater to."

It may happen when one huge and complicated job comes his way, or it may be that the sheer volume of work becomes too much for one person to handle all alone. Whatever the case, it's a good bet that the newly independent photographer will discover there are situations where he must have an assistant. "We start out using freelancers," notes Meola, "and you ease into it. Suddenly you need him once a week, then every couple of days." Pretty soon, he's on the payroll.

Now, as an established star in the photographic firmament, Meola customarily gets five to ten phone calls a day and a couple of letters in the mail from people wanting to be his assistant. Many of them "are looking at the *Blowup* aspects," he observes, referring to the popular movie in the sixties, and seeking a rather unrealistic notion of incessant glamour and excitement.

One Meola assistant with a decided difference was Gregory Heisler. Meola and Heisler met in 1975 through a mutual friend, magazine editor Sean Callahan. Heisler had been working with famed portraitist Arnold Newman and was looking for another assistantship.

"I had a gut reaction that Greg was very interested in photography and not just one aspect of it," recalls Meola. "Greg was intensely interested in quality, in things looking right.

"You can have a sixth sense about it, saying the chances of this guy working out are good," Meola continues. "A lot of guys just want to be assistants. Greg wanted to be a photographer." Today, Greg Heisler is one of the foremost examples of an attentive assistantship and personal diligence paying off.

As in any endeavor where an alliance of two must inevitably dissolve into a pair of separate undertakings, much speculation is made about distribution of business after an assistant leaves his boss to set up his own studio. Is it to be expected that a newly established photographer will try to spirit clients away from his old employer?

"That's something that you can't worry about," Meola calmly states. "Photographers are among the most neurotic people around. The competition is increasing all the time. Maybe each year the amount of photography to be done goes up a bit, but not as much as the amount of photographers there are to shoot it." The spiriting away of clients is "only a natural thing," he believes.

What does perplex him is the wholesale borrowing of intricate and very personal techniques. "That *does* bother me. Sometimes I literally wake up with an idea, and suddenly it starts showing up in an assistant's work elsewhere." He's not so distraught if it happens with a long trusted crony who's now running his own show; what bugs him is to see his influence in the product of a competitor who now employs an assistant he may have used on a freelance or short-term basis.

MEOLA SPEAKS OPENLY in favor of an "ongoing relationship" between photographers, their former assistants, former mentors, and other members of the photographic community. "We're all in this together," he surmises. "There shouldn't be antagonisms or jealousies." If the circumstances allow it, he has even lent another photographer a strobe, a Hasselblad, or even his studio for a day. And when he took a protracted vacation and photo odyssey to Morocco a while ago, he directed that any assignments coming in to his studio be turned over to Heisler, whose technical virtuosity he could wholeheartedly recommend.

When picking an assistant nowadays, Meola is interested in seeing examples of the person's work, and has found in many cases that "if you were to ask them to see their portfolio, they'd have nothing new." He would want someone "who doesn't mind long hours and who possibly isn't married, because their life will tend not to be 9 to 5." And although Meola says the assistant must be someone "who doesn't expect a lot of bucks," the wage scale he mentions is more than livable. "The guy's got to respect you and know you're not taking advantage of him," he adds.

Meola prefers an assistant with "some technical knowledge, but I'm more interested in a guy having the will and desire to take good pictures and not just see this as a three-month stint." Meola uses Nikons, Polaroids, Hasselblads, and view cameras and would favor a person familiar with those devices, plus knowledge of the benefits of tungsten vs. strobe and of how films react to different conditions. But he stresses, "I've got to have a gut reaction about someone's personality"; a good assistant must be personable and able to interact with other human beings.

"Every single day you're dealing with a different situation," says Meola, who elects not to be pegged into one photographic hole. "Someone will call me about a certain job and I'll have to turn around 180 degrees from what I was thinking and adjust to that set of problems. An assistant has to do that also."

He is looking for "someone who's thinking ahead of me, who's anticipating the problems, and who's always thinking it can be better. All of these things come back to the one essential ingredient, which is quality. You'll get guys who see something wrong and say 'That's okay, they'll retouch it.' Maybe they can retouch a job, but they'll never retouch your chrome."

Meola asserts "I tend to be strict with an assistant the first few months," but he doesn't want them to be overly timid. "I want them to look at the shot, see how they'd conceive it, and give me ideas. You can become intent on one aspect of it. You're only human, you're not God. Assistants should feel they are your equals, your peers." There are, however, limits to an assistant's initiative. Meola warns, "At the same time I don't want him jumping up in front of an art director and me and saying, 'You're both wrong.'"

He also suggests that if an assistant does make an error, obfuscation is not the correct response; he wants to know what happened. "If they open up a camera and expose the film before rewinding, I want to know it right then and there, not the next morning when I open up my light box."

Meola is properly meticulous. His is a well-organized operation, and he makes a comprehensive list of everything he and his backups will need for a particular shooting, especially if it's at an outside location. The list is constantly being revised.

Nothing is so obvious that it shouldn't get special attention, he explains. There is a story, he says, that Gregory Heisler likes to tell about his days with Meola. An early morning departure for a Long Island location was scheduled, and Heisler was scurrying around loading up the car with the various and sundry equipment the session would require. There was heavy lifting, and there were details to remember, but finally everything was straightened away. Heisler and Meola piled into the car headed for Long Island.

Heisler turned on the ignition, and the car radio began to play. The voice was that of Paul Simon, singing his latest hit — "Kodachrome." The assistant turned to his boss. "His face was white," Meola laughs. "Our eyes met. We had forgotten to take any film. And we were going somewhere that was at least thirty minutes in any direction from where we could get any,

and who knows what kind we'd find anyway." God bless that radio programmer who dug Paul Simon, and pay heed to Eric Meola, who says, "On every single shooting I've done, I've always had film left over." And with the elaborate checklists Meola now prepares for each assignment, such a snafu is unlikely to recur.

Some assignments don't exactly demand skilled labor, merely *lots* of labor. Back in the final days of the original *Life*, Meola was tabbed to shoot a spread on pocket calculators, a fairly new development at that time. He and his friend, a *Life* staffer, mulled it over and decided that the calculators should be photographed in a field of what they were replacing — pencils. *Thousands* of pencils. The next day, Meola was on the phone ordering more than 5,000 pencils, and he acquired a piece of black foam with holes in it where the pencils could be fitted. For ten hours each day for a week, Meola and *three* assistants put the long thin objects in the small round holes, making sure that the pencils in the foreground were lower than the ones further back so the proper perspective would be maintained. It was painstaking, monotonous labor, but the result was a strikingly vivid illustration of the concept Meola had in mind.

John Stuart was somewhat taken aback by what confronted him in his first week as Eric Meola's latest assistant. "We had one of the toughest jobs we've ever had when I first got here," he remembers. "We were at it until about 2 a.m. every morning. I asked myself, 'God, is it always going to be this hard?'" Well, perhaps not quite *quite* so arduous, but Stuart never expected that an assistantship would be like one of those cushy desk jobs. "When you're looking for an assistant," he says, "ask for a little bit of genius and tons of craziness."

In college, Stuart had majored in veterinary medicine and treated photography merely as a hobby. But cameras eventually replaced cats as his main vocation, and he first tried his hand at journalism. Alas, he found it upsetting. "You had no control over the shot. Getting there is half the story." He signed on to help someone who was doing "catalog stuff" but concluded "God, this is really boring." Today he says, "I realized there were a few people doing artistic work. I'd sent out 200 resumes but had really narrowed it down to about four photographers I wanted to work for." One was Meola, and Stuart persisted until he happened to be around and available when the photographer needed a new assistant. Stuart agrees that when it comes to getting the assistantship you covet, "a lot of it really does get down to being in the right place at the right time."

GREGORY HEISLER

MORE SO THAN anyone else encountered in the preparation of this book, Gregory Heisler is a model of how one can take the assistant's route to the top of the photo world, and how to pick and choose your assistantships to get precisely the skills, contacts, and whatever else you need to get a healthy start as a photographer.

Heisler was also the most difficult to pin down for an interview. Still in his mid-twenties, he has a good solid core of a half-dozen or so clients who keep him hopping from one airport to the next. Although he says he had only really been shooting on his own for eighteen months when he finally sat down to be interviewed, he was already doing covers and other major assignments for *Life*, was frequently shooting the lead story for the *New York Times Magazine*, and had a number of record album covers to his credit. His work has since appeared in *Geo* and *Connoisseur*.

WHAT EMERGED from the time spent with Heisler was an almost textbook success story of a young man who knew, at every step along the way, what would be best for him to do next and who apparently refused to allow anything, even the most blanket form of discouragement, to prevent him from making the career move he thought best at the time.

As he grew up in Skokie, Illinois, photography was a mere hobby for Heisler, who wanted to be an astronomer. He entered the University of Wisconsin, and when the grandeur and excitement of astronomy gave way to a less exhilarating day-to-day scientific routine, he turned more and more to photography. He spent what would have been his junior year of college working for a publisher of yearbooks in Chicago. "I shot 60,000 high school seniors in one year," he recalls. "It did a lot to bring me out personally, doing people."

From there he went to the Rochester Institute of Technology. He now says, "I didn't like it at all. What they were teaching was years out of date. Their idea of New York photographers and what they do is way off base." Teachers were actually kicking him out of the studio for staying there too long, and telling him he was spending too much time in the darkroom.

Returning to Chicago, he intended to become a photographer's assistant and perceived three possible paths to take. There are "lots of food and catalog people in Chicago," he explains, but that's not what he wanted. There is Victor Skzrebinski, the renowned portrait artist who is "a god in Chicago." And there is *Playboy*, the most important national publication originating in the Windy City and one which obviously offered extensive photographic opportunities.

THAT HEISLER was a quick study was verified at the outset of his assisting career. He spent one day working for a food photographer in Chicago, and at day's end he received the man's permission to try some of his own 8 × 10 shots.

The next day a frequent visitor to the studio was rifling through the results of the previous day's takes. Coming upon a couple of 8 × 10s he particularly liked, he told the photographer, "Congratulations, this is the best work you've done in a long time." The pictures he was talking about were Greg's. Heisler was not asked to come back.

When he tried to offer his assisting services to *Playboy Magazine*, he got the same sort of treatment almost anyone contacting a big company out of the cold is accustomed to receiving. The personnel department told him there were no openings for assistants and that the magazine had a waiting list a mile long anyway.

Heisler, however, *wanted* to work for the magazine and he wasn't going to be put off. He got on the phone again and managed to speak directly to Bill Arsenault, one of the leading *Playboy* photographers, who was happy to hear from Greg. "We never talk to *anyone*," he told him. A short time afterward, an assistant came down with an illness, and Heisler got the call to come in and work.

"At *Playboy*," says Heisler, "my biggest kick was meeting Pompeo Posar," who shoots many of the magazine's centerfolds. "He's shaped more young men's minds than Dr. Spock." Heisler quickly discovered that when the photo sessions began, "there was no screwing around. Everybody's trying to make it comfortable and relaxed. If anything, they (the photographers) are so relaxed that the girls become aggressive."

Assistant Heisler's tasks were "mostly setting up before and taking down afterward. You're working when you're there. There's no ogling; you're busy." Still, it's hardly routine stuff. On his first job at *Playboy*, Heisler had to haul up, by ropes, two girls who were going to be doing various stunts on gym rings. When the photography was completed, he lowered them down. "All of a sudden there were these two panting girls on a mattress," he remembers. "They were the two most beautiful girls I'd ever seen."

Work perhaps, but great fun, too. It all lasted exactly three weeks. "It was working out fine," stresses Heisler, but he had been pursuing another possibility before starting at *Playboy*. He'd written to Arnold Newman, the portraitist "who was my absolute idol," and finally he got a letter back. The letter was in fact discouraging, informing Heisler that there was no available assistantship, but Heisler didn't take it that way.

He was gratified to have heard from Newman at all, and to have a piece of paper with his signature on it. Later, he called Newman in New York and was again told that no job existed, but now Heisler was encouraged that he had actually *talked* to the famed photographer.

Heisler's reaction was to instantly get on a plane to New York; his *Playboy* cronies "were all excited, they were rooting for me." He called Newman from LaGuardia Airport. "I thought I made myself clear," the photographer told him, but after a little behind-the-scenes chatter with his wife Gus, and a sudden realization that this unstoppable young man was actually in the city, Newman told Heisler to come in and see him.

AS IT TURNED OUT, Newman had begun interviewing for an assistant and had placed a blind ad in the *New York Times*. When Heisler showed up in his studio, Newman's first test was an ironic one; he gave him a Skzrebinski print to spot. Skzreb, as was mentioned, was Heisler's home-town hero and "at RIT, spotting was my forte." He did just fine. Newman said "Try another day," then extended the trial to a week, and finally took him on as his assistant.

Heisler, who did a great deal of printing for Newman, learned that "as great and as famous as he is, his thing is a mom-and-pop shop." He adds, "When I was working for him (1975-76), he never used strobe once. He used hot lights."

Newman would tell Heisler, "You must learn to anticipate my needs" — something Heisler didn't always find easy to do. "I didn't like assisting as a thing to do," observes Heisler, who obviously understood that it was nevertheless an essential experience. "I don't have a real good head for details, and I had a lot of responsibilities without the fun thing — creating the picture."

During photo sessions, Heisler would hand Newman 4 × 5 film holders or rolls of 35mm film, depending on what format was being used. But as an assistant, he observes, "what you learn isn't f-stops and shutter speeds." It is rather the chance to "see how a guy who's really good works, how he solves problems doing the kind of stuff you want to do."

Working with Arnold Newman was Heisler's ticket to new realms of experience, and also an extensive introduction to New York, the country's most important center of photography. "I saw all angles of the city; in the first two weeks we shot the chairman at Mobil and an artist in SoHo."

From an artistic point of view, one of the major points Heisler took away from his time with Arnold Newman was an appreciation of the wide angle (also called short focal) lens and its possibilities in portraiture. Newman could use it with "no distortions — everything square, unless he wants something else. He shot Gerald Ford for *Esquire* with a 24mm lens. Everything looked normal. He (Newman) keeps parallels parallel, verticals vertical, and the subject in the center with the face not distorted."

In time, Heisler decided he needed to find out about fashion photography from the inside, and he went to assist one of the leading names in the business. His boss was "very open, and very quick." He used motorized Nikons and his forte was "all movement — very active pictures with running, jumping, screaming. And very clean, mostly against white backgrounds."

This particular photographer, observes Heisler, "was into delegating. He couldn't load his Nikons. He couldn't load *or* unload." The man used two cameras equipped with "the same lens, same everything. He could hand crank Hasselblads faster than motorized ones moves. He used two identical cameras, so he wouldn't miss a beat." In fact, his camera moved so quickly that a drunk watching him on an outdoor assignment asked, "Are you making a movie?"

On the set, Heisler discovered, his boss preferred an ambiance that was rather the antithesis of what one sometimes associates with fashion photographers. "There was never any music in the studio, and he never talked to the models. I was shocked," Heisler says.

Somehow, communication between photographer and model must have been established, because the desired results were invariably achieved. Heisler theorizes, "He must have whispered to them before the shoot 'if you don't run around like your life depended on it, you'll never work in this business again.'" There were other ways of getting models to produce the expressions and reactions the photographer was looking for. He would have an assistant lurking out of sight of the model; he would, at the appropriate moment, "goose" her, or pour water down her dress. No actress could duplicate the kind of astonishment these antics produced.

This was also a highly efficient operation, where precise records were kept and "everything was labelled nineteen times. You could really see how a tightly run ship operates," says Heisler. "It looked like a hospital, with white formica everything. You could eat off the floor." The studio operated "like clockwork"; there was a staff of five, and "everybody was there for a specific purpose."

Heisler gave his notice after two weeks. "I felt I'd seen the range of the way things were shot there," he explains. Moreover, "It didn't whet my appetite for fashion at all." The people he had met through Arnold Newman were more interesting, and the work had "more content" in Heisler's estimation.

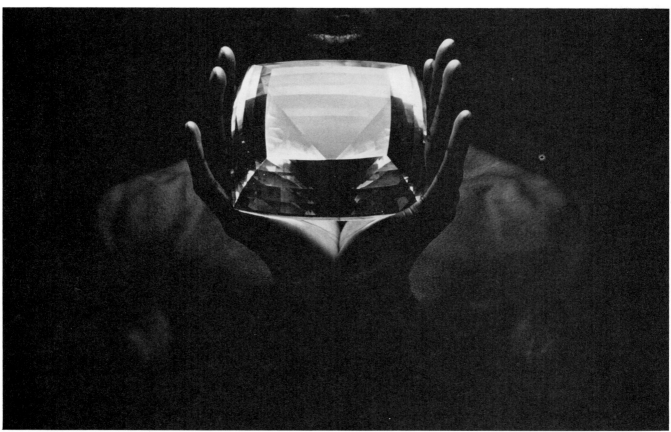

Gregory Heisler

A record ten-pound topaz may be the height of exoticism, and the picture here conveys that flavor. Actually, Heisler shot it with a single source of light in a storage room with a shirtless janitor cradling the gem. "I feel really adaptable," is Heisler's understatement.

GREGORY HEISLER

FTER THIS BRIEF stint, Heisler went to Pete Turner's studio looking for work but ended up joining Eric Meola. Meola's pictures were "sympathetic to Turner's, who was oviously an influence." In fact, Turner had been Meola's boss. For his part, Heisler considered Meola to be "more versatile."

Heisler became the first full-time assistant Meola hired. As Heisler recalls, Meola was doing "as well as you could be doing at twenty-nine." The new boss was also "a real nice guy" and provided the most cooperative photographer-assistant relationship Heisler had yet experienced. "They were definitely his pictures," Heisler says, "but there was a lot of give and take, a lot of 'what do you think?'"

At this point as an assistant, Heisler believes he was "photographically very conscious of what was happening in the picture, but I wasn't super quick or good with details." And he delights in telling the same Paul Simon and "Kodachrome" story Meola had related. Still, Heisler was conscientious and valuable. For example, he notes, "I would save shootings by noticing color shifts that would affect the film."

Meola has a reputation as a very technically oriented photographer, but Heisler found that his essential edge over other lensmen was "more in what he thinks. He's using the same stuff as other people; he's not inventing new light sources." Heisler says, however, that Meola is extremely knowledgeable about the newest equipment, and "plays with his stuff like a kid with a new toy."

When asked what he learned from Meola from a technical point of view, Heisler quickly points to the use of neutral density filters. Such filters can help conquer some very sticky lighting problems by enabling a photographer to alter and balance the brightness of various elements within a single picture. On an automobile ad, for example, the neutral density filter might help Meola bring down the brightness of the sky and bring up the cars situated in the foreground.

The neutral density filter proved to be a lifesaver when Heisler had to photograph a news broadcast in progress in a Baltimore television studio. He had to get the whole studio within the range of his lens. The set, including the on-the-air personalities, was in the middle of the picture. The TV cameraman was actually closest to Heisler, the ceiling featured grids of bright lights, and the floor was covered with a tangle of cables. "If you aimed (lit) for the center, the top would go black and the bottom would go out," Heisler explains. And if, for example, he focused on the grid of studio lights, he would get an overexposed shot that was almost totally white. All of these possible problems were conquered by placing a neutral density filter over

the brightest parts of what was visible in the lens, and Heisler brought everything back into perspective.

"It's pretty much a myth to think you can put together a portfolio while you're assisting," contends Heisler. "You're up to your eyeballs in it; you're absolutely drained." Still, Eric Meola proved to be understanding about Greg Heisler's aspirations and helped further them. He let Heisler use his studio and helped him secure his first photographic assignment in New York. It was a shot of jazz violinist Noel Pointer for *Oui*. Taken in Meola's studio, the picture was eventually used for an album cover. Meola was not hesitant about referring Heisler to people who could use his abilities, and Heisler's entry into *Life* was partly due to word passed from Meola's rep to the magazine's assistant picture editor.

S REWARDING as his time spent with Meola was, Heisler moved on after four months. The reasons were partly financial, but Heisler had also "made a conscious decision to work with different guys." His chagrin is evident as he cites the tendency of some assistants to identify *too* closely with a particular photographer. "They may say, 'We shot such-and-such famous person,' when it was in fact only the photographer who did so." It is common to hear that kind of use of "we" and it is often harmless, but Heisler has known assistants who seem to be thinking they are synonymous with the photographer. They think they are taking the picture. Perhaps they should be, but they aren't, Heisler stresses, and they shouldn't lose sight of that fact.

As an assistant, Heisler always made sure to "keep my eyes open, get ideas, and store everything up. When it came time for me to shoot, I was really ready." But as he progressed as an assistant, his moves were always based on his own estimation of what he thought he needed to find out about next. He tried to hook up with photographers who were *la creme* in an area in which *he* hoped one day to be *la creme*. One remaining field he hadn't explored too deeply was the specialty of John Olson, who is "very big on annual report and corporate work" and was in the process of opening a huge studio that would accommodate big production shooting.

Olson had been one of seven annual report photographers Heisler had queried about assistantships. Heisler got the job for a rather sad reason. Olson's assistant, who was just one day out of photo school, fell down an elevator shaft and broke his collarbone on his first assignment. As a result, observes Heisler, Olson "needed someone right away." Heisler was actually a freelancer for Olson, but the work was steady through

18

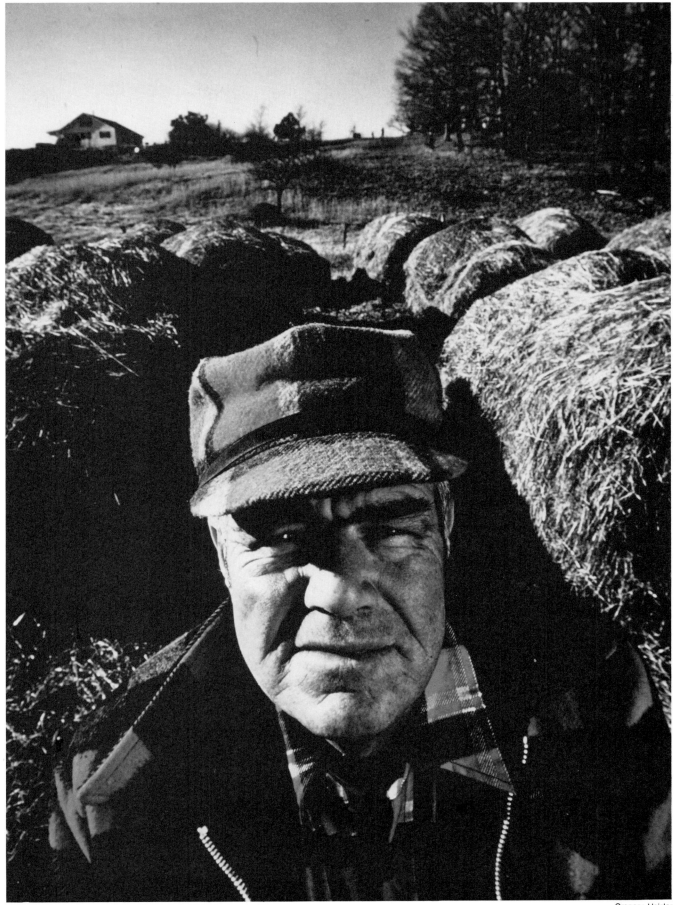

Gregory Heisler

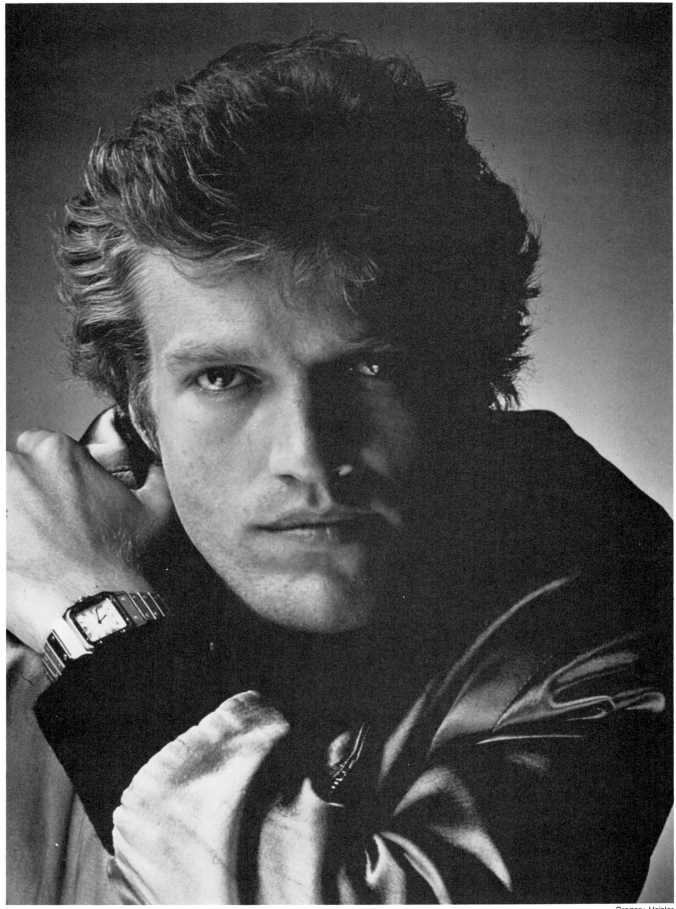

Gregory Heisler

the annual report season, which is "August to February, and heaviest from October to January."

When he was getting ready to take on his own assignments, Greg Heisler was advised by a friend to go and see *Life* picture editor John Loengard. Loengard is a kind of doyen to young photojournalists, and Heisler was not so much looking for work as for tips on how his career should be launched and take shape. As Heisler remembers it, Loengard told him, "You should shoot what you can't *help* but shoot. It'll be your best work. It'll come from the right place. As you look back on it, you'll discover that you have a style."

HEISLER TODAY has style *and* versatility. Mention his name to anyone who knows him and they'll tell you what a terrific personality he has and what a joy he is to work with. It's no surprise that his rapport with live human subjects yields exciting results, but he does just fine with things that neither breathe nor move. His very first assignment for *Life*, for example, was a shot of a Connecticut parking lot. He has also given them a cover picture of Three Mile Island and a "still lifey" image of a ten-pound topaz.

When he was getting his own photography career into high gear, Heisler made every move count. "I didn't blanket New York with promotional things or resumes. Rather than show my work to a million people," he explains, "I will lean to one guy who calls up twice saying 'I really like your work.'"

Now, says Heisler, "I shoot for about six people. They keep coming back. It's a relationship." Part of the reason for such continuity, he says, is that "I'm really enthusiastic about the stuff I shoot. I would have more

fun doing that on Sunday than anything else. The fact that someone's going to fly me somewhere to meet someone I've always *wanted* to meet is better than Sunday brunch in SoHo."

His decision not to spread himself thin, but to establish solid and trusting relationships with a few chosen employers, is paying off handsomely, Heisler feels. At *Life*, for example, "They say 'We like your eyes, plug your eyes into this.'" And a magazine journalist shouldn't panic when, by Heisler's estimate, half the assignments don't work out as planned. Even many of the top photographers, he says, are not flexible or spontaneous enough to work around a snag in the arrangements.

"I'm open and fresh and ready to work with what's there, to make the best of what's there," Heisler emphasizes. "I don't say, 'It's not my kind of picture.'" A client of his may be surprised, but pleasantly so. "They may expect a sunny day picture," he observes, "and I'll give them a nice cloudy day picture." Heisler's reputation for delivering an outstanding image come hell or high water even led one editor sending him out on a story to state, "We might not have an idea for a picture, but we know you'll give it to us."

At the time this book was being prepared, Gregory Heisler may have been the most peripatetic editorial photographer in the country. Does he owe his success to his assisting experiences, and is assisting the route an aspiring photographer definitely must take? "I would not at all say that," he stresses, indicating that another young *Life* photographer had arrived at his current pinnacle by the newspaper route — first the local weekly, then the big city daily. Nevertheless, Heisler believes assisting "is a real super fast-track way to learn what you want to learn. You're slowed only by the limits you put on yourself."

When it came time to make a studio photograph of dancer Peter Martins, Heisler remembered how the light fell on the miner and duplicated it here. It helps to have a "photographic memory," he quips.

ASSISTING: FOUR OVERVIEWS

ONE OF THE main arguments in this book is that an assistantship with one or more successful photographers may be the most advisable way for a fledgling photographer to prepare for his or her own career. The four overviews in this section come from people who obviously were strong believers in the importance of assisting; they've all had extensive experience as assistants and/or studio managers.

Gideon Lewin, now a well-known photographer specializing in fashion, was affiliated with the legendary Richard Avedon as an assistant and studio manager for fifteen years. Chad Weckler, the son of a famed photographer, is one of the most skilled and knowledgeable assistants in the New York area and has been active in programs designed to improve the quality of assistants and the quality of an assistant's life. Peggyann Grainger is primarily a freelance assistant and has special insights into what it's like to be a woman in a job more often occupied by men. And Paul Corlette tells about life as a studio manager for Hiro, one of America's most respected photographers.

More than any other portion of the book, this section should help you decide if an assistantship should be a stop on the road you'll travel to the top ranks of commercial photography. These four overviews give a comprehensive picture of what life as an assistant in a commercial photo studio can be like for you.

GIDEON LEWIN

GIDEON LEWIN'S illustrious photographic career began at the Art Center College of Design in Los Angeles, where he earned a B.A. in photography after majoring in advertising. It was a "very extensive school"; he rates it as "the best in the country", and he, an Israeli, was its first photography scholarship student. As part of his scholarship program, he took care of the school's color lab, and it was here that he began to master the color processing techniques that would make him a uniquely valuable member of a photographic team.

While in school he worked at all formats up to 4 × 5; "I couldn't afford an 8 × 10," he recalls. The school's curriculum was an attempt to simulate real life as closely as possible. There were genuine deadlines and experimental assignments for large companies. Photographers also worked with advertising students who would be future art directors to devise ad campaigns that might in fact be used. "There's one factor missing in the reality of the school," observes Lewin. "Your life and rent don't depend on it. It's a grade at the end, not your livelihood. And you don't have the overhead to worry about."

As a student, Lewin held several jobs to supplement his income. He did all the printing and setups for a Los Angeles photographer, and it was there that he learned the 8 × 10 camera format. At another job in a camera store, he would enlarge the negatives his celebrity clients took with a Minox ("one of the first miniature spy cameras") into 20 × 24 prints.

One holdover from his school days is Lewin's Minolta 2¼. He bought it almost twenty years ago for $60, and it remains one of his favorite cameras. "It's light. I'm so used to it." he states. It is a twin lens reflex camera with "incredibly sharp lenses, and the color resolution is beautiful." Sometimes the most modern, most expensive apparatus is not essential.

WHEN LEWIN DECIDED to come to New York to work as an assistant, he scheduled three job interviews. One was with the city's most famous photographer, Richard Avedon, who hired him on the spot. "A lot of it had to do with timing," Lewin remembers. "There happened to be an opening and I was just the kind of guy he was looking for. He knew about the Art Center School and the good technical background it gave, he liked my work, and he liked me as a person."

It was 1964, and Avedon and his associate, Hiro, had two studios under the same roof. They shared darkrooms and color processing facilities. Each photographer had his own secretary, and Hiro also had his own assistant. The man Lewin was directly answerable to was Earl Steinbecker, the studio manager and first assistant for Avedon.

Avedon's studio was "really set up differently than most," stresses Lewin. There existed a comfortable, family-style atmosphere. No one was meant to be odd-man-out, and Lewin gladly discovered that "an assistant is really involved in everything there."

He did, however, have one "strange" experience shortly after he began work at the studio. Avedon was away, and so was Hiro, and the color processing assistant was supposed to show Lewin around. But when he inquired where things were in the studio, Lewin was told by the ill-tempered color man that he'd have to find them himself.

The problem was merely the color man's distasteful personality and his desire to make Lewin feel ill at ease. No one else was so anxious to show him he was the lowest man on the totem pole, but by contrast this surly fellow showed him how essential it is for the members of a studio team to work comfortably for a common goal. "We had a family, where everybody depends on each other very closely," Lewin explains. "In a big name studio like that, nothing can ever go wrong. That's a tremendous burden. When you make a mistake, you really tremble." In fact, Lewin can't remember ever causing an irreversible disaster, such as exposing film to light or having it slip from a reel during developing, or having a light fail on the set without his awareness. "I've had cameras fail on the set, but I'd realize it. We're all human and can make mistakes, and machines are not foolproof."

When Lewin began with Avedon, the photographer was shooting the principal editorial spreads for *Harper's Bazaar.* Lewin was making $70 a week with no overtime, and the workday could begin at 8:30 a.m. and end at 2 a.m. "You were on the job twenty-four hours a day. I never planned an evening of theater or opera. I wouldn't know until 5 p.m. if I would be on time that night. Your life is not your own."

Within a year, he became Avedon's studio manager, a position he would hold for fifteen years. He didn't expect such a long association at the outset. As far as taking the managerial spot was concerned, he explains, "I didn't want to. I was on a trainee visa that had six months left. I didn't want to take that responsibility for a short time. But Avedon convinced me it would be a wonderful experience, and it was."

"The one very exciting moment" of those early years with Avedon, he remembers, was his first trip to Paris for the major showing of the new fashion design collections. "In those days we went over for two or three weeks," he recalls. "The clothes were shown in the day and were only available to be photographed at night." It was incredibly concentrated, speedy work. Printing of the day's shooting had to be done immediately,

Stephen A. Sylvester

Avedon made his choices for publication as soon as the prints were ready to be seen, and magazine staffers did the layouts right there in Paris. "The pages were put on a plane every two days," notes Lewin. "When we got back to the States, the magazine was all printed."

AS STUDIO MANAGER for such a long period, Lewin did the bulk of the hiring for Avedon. "I never wanted a big team, because I found it was more efficient to work with a small team," he reveals. "And you can't have one bad person in the studio, whether it be technically bad or personality-wise. It all has to click."

He also learned to hire the right people. His first team of assistants was composed of three Europeans he'd met while working on the Paris collections.

"The first one was a disaster," he laughs. "He didn't do any work. He was a nice guy, but he liked to talk. He would sit around and philosophize, and nothing would get done.

"The second one didn't know anything technically. He said he knew everything, but he didn't know anything, and he was lazy.

"The third one was a hard worker and generally efficient, but he couldn't print at all, and I couldn't teach him. He stayed a couple of years. The others I got rid of as fast as I could. After that, I was lucky." Lewin's agreements with assistants were verbal, but

he expected people to stay for two years. That was one reason why he took on so many foreigners; their visas were usually for two years, so they had to stay. Having people from different countries made the studio more interesting culturally, Lewin found. Furthermore, it was his experience that American assistants would accumulate all the information they wanted and move on in search of great amounts of money. Europeans, on the other hand, "still have a guild system. You get formal training in professions. There is a tradition. Trainees there start at age fourteen in studios running errands and stay for years."

Yet he declares, "My best assistants were Japanese. They have the same tradition for the training period, and they are somehow indoctrinated to work very hard. They take responsibilities and commitments very seriously. They're quick and they're fast learners."

Lewin remembers one Japanese assistant who took on the task of making contact sheets of twenty-five years of Avedon's work for editing a future show at the Metropolitan Museum of Art and a fashion book. "He had the radio going upstairs; that is how he learned English," recalls Lewin. "Everyday we asked him what he wanted for lunch. He would say 'hamburger.' One day he came down screaming, and I knew he couldn't make contacts anymore."

Along with the hiring and "the firing, unfortunately," Lewin handled all Avedon's lighting, was "mentally clicking the camera with him," and, with his Art Center School expertise at hand, even did the solarization work on his boss's famous Beatles posters. "The first three years I was a nervous wreck," he confesses. "There was so much going on; I was the nerve center and I radiated out to the other people. Communication was through osmosis. The less I had to say, the better."

Avedon *was* involved with his staff. When Lewin recommended someone, Avedon "would also talk and get the feel of the person. Most of the time we were in agreement." The photographer was "very approachable," but it was usually Lewin to whom he would come to and say "this is what I want done." Notes Lewin, "There has to be one person responsible at the end to make sure everything is done properly. Mr. Avedon had to be free to be creative, come up with the concepts, and deal with clients. Reading the meter on the set was not his department. It didn't matter as long as the light was right," and that was Lewin's responsibility.

In spite of his many duties as Avedon's top assistant, Lewin was beginning his own photographic career. He did so with his employer's complete blessings; Avedon understood Lewin had a living to make. Lewin began by shooting little still-life items for the "Shopping Bazaar" section in *Harper's Bazaar* at night in his living room. Later he worked on the Saks Fifth Avenue ac-

count, handling all their magazine ads, which he serviced at night.

There were changes taking place at Avedon's as well. Avedon switched his alliance to *Vogue.* He and Hiro parted ways out of necessity when the building housing their work spaces was to come down. Lewin found a new studio space for Avedon and was in charge of its construction. "I happen to be very handy. I'm a pretty good carpenter," he states, "and I can fix anything. Also, coming from a small country, I'm adaptable to many situations."

"I always try to find a solution to a problem; I never say it can't be done. I can open up a mechanism, look at it, and see if something is out of whack. I can design and build my own sets if I have the time. Although no photographer or assistant is required to be a jack-of-all-trades, it has its benefits. When building a whole new studio, you can establish certain standards for quality if you know something about putting it together."

WHEN INTERVIEWING assistants for Avedon, and looking for his own people since setting up his own studio in January 1980, Lewin is very straightforward and will see almost anyone. "This job takes somebody who is totally giving. That's really a clue — totally giving," he reiterates. "I didn't hire people because they came to us knowing they would get a lot out of the job. You don't approach it with the possibility of gaining something for yourself." That something — education, insight, and skill — is going to come in the course of things anyway, he notes. But the proper approach includes a realization that "you have to dedicate yourself to the job. I always say you are married to the job. Forget about social life. If you want to be a good commercial photographer, you have to be a good assistant," he believes. "You have to put all your energies into the job in the same way you would do it for yourself."

Lewin does believe photography school is important for an assistant. "The more knowledge you have, the more flexible you can be," he suggests. But he adds, "It's vital not to have the knowledge restrict you. I break rules. I adapt all the information I have to the particular job. It's not a question of rules; it's a question of results."

There are, as Lewin states, some particular pieces of information a capable assistant should have at his or her command. The list includes a knowledge of strobes, the loading and functioning of the boss's cameras, and black and white film processing. In a large studio where you are not going to be the first assistant, you can pick up the rest of the necessary know-how while on staff,

suggests Lewin. In fact, he argues that an abundance of expertise can work against an assistant. "You can't be as good as the photographer, because you won't get the job," he affirms. "You would seem to be in competition."

When Lewin looks at an assistant's portfolio, his primary interest is personality. "The pictures will tell me about a person — whether he's neat and technically proficient in the darkroom. I don't judge the pictures themselves. I want to see where the person is at. If I feel the portfolio is much too good, I may tell the person to open his or her own studio."

One additional item an assistant must understand is that every photographer has his own unique methods, Lewin observes. He noted that most of Avedon's fashion pictures were taken with an 8 × 10, and he agrees "the larger the negative, the higher the quality." But Lewin often prefers a 2¼. "It gives more flexibility, you can move around. Some people are intimidated by a large camera." On the other end of the scale, he notes "I don't like shooting 35mm unless the job calls of it" — unless, perhaps, a client specifically wants slides or the shot demands a special lens more adaptable to a 35mm camera. During a typical fashion session, Lewin may use "three cameras that are interchangeable, perhaps three 2¼s."

An assistantship is not a lucrative form of employment, Lewin acknowledges. "The compensation is not really in terms of money. It's the experience. It doesn't matter what the job pays. I would always do my best." Indeed, he firmly believes that the attitude an assistant displays as a cog in the wheel is a strong indication of how he'll behave when he *is* the big wheel. "A job never goes out of a studio being 'good enough.' It has to be perfect. If you have that attitude, that is how you are going to develop quality — and that is how you will run your own business in the future."

"Work habits are very important," continues Lewin. "If a guy is sloppy in the darkroom, you know he is not going to get the quality you are looking for." The assistant's additional chores can include "anything from cleaning floors to painting sets, looking for locations, answering phones, driving, being able to pack the equipment properly. Maybe cooking — being able to prepare lunch. We usually have about twelve people in here for lunch."

Lewin's own tenure as studio manager and assistant to Avedon was extraordinarily lengthy. Today he says, "Although we got along well, I realized the time would come for me to go. The amount of work I could do creatively there [with Avedon's own clients] was limited. I was always under his wing." And Lewin emphasizes what is perhaps most key to a photographer-assistant relationship: "Avedon was always first. I never put him second at any point."

As far as having the necessary expertise to venture out on his own was concerned, Lewin believes "I was ready the second year of my assistantship. With me it was not just the fact that I was learning. Avedon's studio was the most exciting one can imagine, with many projects going on at the same time — exhibitions, books, and new ideas. It was a wonderful challenge one could not find elsewhere." Lewin had his growing list of clients and photographic responsibilities in any case, and he did not want to be unwisely hasty. "I do not take risks," he states. "I plan everything very carefully."

TODAY, GIDEON Lewin is strongly established as a photographer in his own right, with a client list including Revlon, Bill Blass, Lord & Taylor, J.C. Penney, Saks-Jandel, Avis, *Vogue, Bride's,* and the Israeli Government Tourist Board. He is most noted for his fashion work but he likes a diversification of photographic assignments, including beautiful portraiture.

Variety has, in fact, been a strong suit of Lewin's work, and might be an enticement to an eager assistant. The variety extends to the people he works with. He hires makeup artists and clothing stylists from the outside, rather than keep them on staff. "You want to work with different people to have different points of view," he explains. "You don't want to have just one look."

The pace in a place like Gideon Lewin's studio can be swift, and an assistant must "make sure the studio runs smoothly, that the work goes out on time. That means the same day or the next morning. No job should linger here."

An important fact for assistants to realize, says Lewin, is that "the majority of the time is not spent on photography. That is perhaps 20 percent of it. The rest of the time is planning, maintenance, printing, and planning the next shot. We could be in makeup for three hours and have half an hour to shoot. The amount of the time we shoot is very short. That's the grand finale." Fashion photography, he concludes, is "not all glamour."

With all the uncertainty, the pressures in photography are tremendous, especially in the fashion area. There are short deadlines and unexpected situations. Lewin's summary warning to an assistant is that he or she have the ability to roll with the punches.

It also would not hurt to acquire the kind of lengthy technical preparedness Lewin has accumulated. "I am so tuned in I know when something goes wrong," says a man whose instincts have been sharpened through experience. "One wrong click of the shutter of a strobe, and I hear it."

CHAD WECKLER

CHAD WECKLER grew up watching his father, Chuck, perform as a leading industrial photographer in Burbank, California, and later on as one of the top advertising photographers in the San Francisco Bay area. Son and father are now based in New York City.

As a boy, Chad Weckler was a frequent model in his father's pictures. The elder Weckler kept his studio, darkroom, and office at home, and he'd sometimes ask his son to come in, sit down, and learn a little about what was going on. Chuck Weckler was doing tabletop and location shootings, and quite a number of album cover sessions, so there was plenty for attentive eyes and ears to learn. But in that everyday environment, "there was no glamour involved" for the young Weckler. "As far as I was concerned, my dad was a plumber."

Chad Weckler had demonstrated absolutely no interest in pursuing the same career as his father until Chuck thrust upon him a brochure from the Brooks Institute in Santa Barbara. What intrigued Chad Weckler was the film (motion picture) program. After the first year, however, he headed into photography because "it was cheaper."

THE EDUCATION at Brooks was very basic, very technical, and could be extremely demanding, notes Weckler, who recalls that almost 80 percent of his class was on academic probation in their first year. The available majors were "portrait," "industrial-scientific," "color," "advertising," and "film," but Weckler was able to combine minors in all of them except color into a "commercial" major.

Brooks, he says now, is "a small-town college for small-town people. People come to it from all over the world." In his opinion they were more technically adept than they were creative. "It's said that Brooks students make good assistants and not good photographers," Weckler reflects, noting that they mostly seemed to suffer from a common inability to see the forest for the trees. "A lot of students don't study the competition," he states. "I'd say to another student, 'Come on, let's go to the ASMP (American Society of Magazine Photographers) meeting in Los Angeles. Reid Miles or Annie Leibowitz is speaking.' They'd say, 'No, I have to spot this picture for class.' "

Weckler came out of Brooks knowing "I really wanted to be the best in my field (still photography) and I knew I had to come to New York for that." He joined the jobless, but hopeful, hordes flocking to Manhattan. "New York was the other side of the world," was how he felt at the time. He was in contact with a friend who had already found a job as an assistant, and he waited for his buddy to meet him at the East Side Airlines Terminal.

Here Weckler learned one of his first lessons; assistants often work later than they expect to. A forelorn Weckler waited at the terminal for at least six hours. "I was sitting on my whole life — suitcase, portfolio," he remembers. Finally he hooked up with another friend, an assistant to Michael O'Neill, who gave him a place to crash for a couple of weeks.

Weckler had arrived equipped with a list of "lots of names of people I wanted to work for," and with a three-page resume mentioning "everything from baby-sitting to photography school, and with my picture on it." He'd already sent out about thirty copies, and when he'd call studios, "They'd say, 'Oh yeah, we got it.' I think they were laughing. They were probably saying 'Let's see what this one looks like.' "

IT WAS 1976, and one still-life photographer offered Weckler $120 per week to assist him. Instead, he took a job with George Nakano, a former Young & Rubicam art director who now had his own agency, a film production outfit, and a commercial photography business. To assist Nakano with the latter enterprise, Weckler was offered $50 a week. Totaling up his rent and other expenses, he calculated that he'd just make it.

This was precisely the opportunity Chad was looking for. "I did everything from cleaning the toilet to making out bills for the jobs, and I did all the darkroom work," he recalls. But he considered himself blessed. "I was spoiled. To be the *only* assistant, and not have to go through that second- and third-assistant rigamarole." At the end of his thirteen or fourteen months with Nakano, Weckler was pulling down $100 a week. He had "learned how to be conscientious, to have respect for people and respect for the studio." He had also made a decision to become a freelance.

Weckler's freelance career was brief, albeit spectacularly successful. The Monday after he left Nakano's staff, he was hired by his old boss for a one-day assignment. Maureen Lambray, who had met him at an ASMP meeting six months earlier, picked him to assist on Tuesday and Wednesday. On Thursday, fashion photographer Michael Reinhardt was in need of an extra hand. On that same day, Reinhardt offered Weckler a full-time position at $150 per week. That was a bonanza for Weckler who, to make life as a photographer's assistant economically feasible, had taken to unplugging all his electrical appliances before leaving his house, and walked everywhere instead of paying for mass transit.

Yet life wasn't quite as Spartan as those facts might suggest, Weckler points out. When Nakano's work load was particularly heavy, Weckler might receive

bonuses doubling his regular wage, and he could usually count on Nakano for at least one Chinese meal each week. He never regretted going with Nakano. "I looked at the work and I looked at the man and decided 'I'm going to learn more here for $50. This is where I'm going to get a good foundation.' George is an excellent teacher."

Nakano worked in 35mm, 4 × 5, 2¼, and 8 × 10 formats; Weckler was only truly familiar with the first two when he arrived.

There were other things to be learned as well. "You find yourself in virgin ground when you come out of school. You *thought* you were prepared." One of the first and most vital lessons is about the importance of time. "On your own in a darkroom, let's say, you may spend ten prints to make one good one." On the job, that kind of ratio will likely cause a photographer to ask you to close the door from the outside.

W ECKLER'S SECOND BOSS, Reinhardt, was an extremely busy fellow. There might be five different jobs to work on in a week, and there was a great deal of travel in the winter. The situation was such, Weckler recalls, that "we kept 1,000 rolls of Kodachrome available. My responsibilities had increased tenfold."

Reinhardt also gave bonuses. "When he's been getting paid well, why not pass it along to an assistant?" was the prevailing attitude. There were other perks as well; Reinhardt would even pass along old cameras, or rolls of old film he was getting rid of. In a busy studio, notes Weckler, film is purchased in large quantities partly because Kodak makes a different emulsion every two weeks. A photographer would not go to a job using film from two different emulsions; five or six leftover rolls might be better used by an experimenting assistant.

Still-life photographers whose principal camera is, let's say, a Hasselblad or a 4 × 5, will often double up by shooting with a 35mm as well — it's the surest way to avoid disaster if something goes wrong with one batch of film.

This kind of backup system is not always possible in fashion sessions, which are fast and furious by comparison. Weckler learned from Reinhardt how to compensate for the loss of one form of security. Reinhardt would have a receptacle for film to his left and another to his right. As he used up a roll he would alternate, putting the first to his left, the second to his right, the third to his left, and so on. He would try and make sure to shoot at least two rolls of each outfit worn by a model, thereby assuring that the rolls would be in separate batches.

It doesn't happen often, but a professional photographer can't afford even one catastrophe. Labs have been known to ruin an entire run of film being processed. Reinhardt, therefore, would send his two loads of film through two different runs. Even if one load were a victim of that infrequent laboratory disaster, he'd be in the clear.

From working with Reinhardt, Weckler found that a fashion photographer "has to have an idea about men and women (like his models) as people." It's no surprise to him that many top fashion photogs are European — "They have a better feeling about people." Reinhardt himself lived in Europe for fifteen to twenty years and speaks fluent French and German.

"There are different reasons for having an assistant," says Weckler, who has worked for about thirty different photographers since leaving his full-time stint with Reinhardt. An assistant "can be anything from a slave to really being the photographer. I'll have jobs where I do everything except click the camera. [For other photographers,] some assistants will be technical advisers; some photographers just haven't got the knowledge of strobes." He is respectful of their art, however. "I don't think a photographer should have to go to school. A photographer just has to be a *good photographer*. That's something else."

W ECKLER HAS BEEN a freelancer since leaving Reinhardt's studio. He had a good reputation among school friends who assisted elsewhere. "I was low key, I did my job," he stresses. "When you're working with these people, like the models, and you're a man, it's very easy to want to make friends." It's wiser, however, to "be very quiet." A freelancer must also realize that "everybody's different," Weckler notes. "When you come into a studio, you don't change it around to your own way. You fit into their pattern."

A freelancer needs to know how to drive, and he'd also better have a credit card. At Reinhardt's, Weckler had one that read "Mike Reinhardt Inc.," listing him as an employee. A freelancer will be acquiring props, supplies, and what-all for a wide range of photographic situations, and he'd better establish a line of credit. It isn't easy, Weckler found, but perseverence can pay off.

"You're creating your own business," Weckler explains, and a freelancer working steady can, in his estimation, make about $10,000 a year. At least one major economic factor works in the freelancer's favor. "Photographers hate to fire assistants," he explains. "They'll have to pay into the unemployment fund. That's why some take freelancers," for whom unemployment compensation does not exist.

Weckler's services are very much in demand nowadays, but two photographers were his most frequent bosses at the time of his initial interview for this book. One is Barbara Campbell, who takes pictures of children for *Parents, American Baby,* and other periodicals. She hires Weckler, he says, because he knows "how to make children smile and laugh, and how to get their attention to get them to look at the camera."

The second is Maureen Lambray, a versatile photographer best known for her personality pictures. Although there are many instances in which Lambray prefers to work alone, conditions sometimes dictate the use of an assistant. In a session with avant-garde musician Captain Beefheart for *Rolling Stone,* for example, Weckler was needed to handle battery-operated strobes on the overcast day at the chosen Central Park Children's Zoo location, since weather conditions made the use of natural light insufficient. "It's nice to have the security of someone to help you, to load cameras and have reflector cards ready," observes Weckler.

The caprices of an editor or art director figure in here as well. For a story on *"Urban Cowboy"* star Debra Winger, *Paris Match* wanted an enormous batch of shots to choose from. When that kind of volume is required, an assistant can greatly facilitate and speed up the proceedings.

Working with Lambray, Weckler has also found that art directors can even create an illusion about how a particular picture was taken. Photographing actor-producer Michael Douglas for *Playboy,* Lambray relied on 2¼ film with its larger negative and finer grain. But the full-page picture of Douglas in *Playboy* had a black sprocketed border to it — an edge you get when blowing up a frame of 35mm film.

Jill Krementz, famous for her portraits of authors and for a series of books featuring youthful heroines like *A Very Young Gymnast* and *A Very Young Dancer,* is accustomed to using available light and working on her own. Weckler believes he is the first assistant Krementz ever used. The occasion was a pictorial spread on members of Jimmy Carter's cabinet. Krementz, says Weckler, wasn't used to light meters, Polaroids, or strobes. He remembers, "The first time a strobe went off, she flinched." Weckler's favorite shot in the series was of Secretary of Defense Harold Brown, a shot he set up three umbrellas to create a "window" effect. "The larger the light source, the softer the light," he explains. "The smaller the source, the more contrasty the picture."

ONE OF THE MORE complicated freelance assignments Weckler has handled was a location shoot at Radio City Music Hall involving seven different setups on various parts of the big hall in just two days. The photographic team was seeking to recapture a Forties look, which in this case meant slight shadows under the chin and nose and a sort of golden aura to the photographs. The latter was achieved with the help of yellow and orange filters, and the mammoth process of illumination required ten different lights. Some desired shadows reflecting off a background wall, says Weckler, could be created by placing cardboard cutouts of the particular designs over the light source aimed at the wall.

Lighting systems like the one this Radio City session required are every bit as complicated as you might expect. "If you have two strobes with two power supplies," notes Weckler, "one will have a sync cord from the camera. With the second you have to have a 'slave,' a photoelectric eye to catch light when the other strobe goes off. Sometimes these slaves don't work quite right. You may have to keep moving things around, because you have to get a certain amount of light on that photoelectric cell for it to function." At best, an assistant must be prepared for all manner of infuriating problems. "A sync cord won't work, slaves don't work, strobe heads blow out"; it's all in a day's work for a photographer's assistant.

As a freelancer, "You do the job and you're gone," observes Weckler. "You never see the end product. I'd like to see it. I did all that worrying." Beyond that problem, the level of disappointment or joy in an assistant's work may be influenced by who his or her boss *du jour* is.

Weckler, whose customary daily rate is $100, declares, "I've heard of a photographer who actually hit an assistant." What is not terribly rare, but is considerably less painful, is for a photographer's studio to be equipped with a punching bag, says Weckler.

While most photographers pay a freelancer on the day of his or her labor, there are a few undesirables who will pronounce, "Well, I decided not to pay you." But someone like that may have a hard time finding a decent assistant again. The photographic grapevine is very much intact, and the better assistants are tapped into it. "You hear rumors [about prospective employers], but I have to make the final decision," Weckler says. He adds, "You can tell by the way a photographer talks over the phone that working for him may not be a good idea."

If a few photographers are bad apples, so too are some assistants. "Some assistants hate a photographer," Weckler has found. "Some are jealous that 'he's getting $2,000 a day and I'm lighting it.' "

"Assistants also cut each other's throats," he reveals. Chad Weckler has been the victim of subterfuge himself; word has been falsely spread around that he wasn't

even assisting anymore, or that he had left town. He'd be a bit stunned when a photographer would greet him "Oh Chad, you're back," when in fact he hadn't gone anywhere.

Some assistants just shouldn't be assisting, whether it be for lack of skill, responsibility, or whatever. If Weckler knew of a particularly bad assistant, he'd spread the word, more for the benefit of the industry than his own career. "I don't want a studio hiring someone on a false basis," he explains, mentioning by way of example one assistant whose resume included the names of several prominent photographers he'd never worked for.

Weckler is one person who certainly won't begrudge the photographer the vast sums of money he or she is making. The risks in the business are all on the shoulders of the photographer, the man at the helm, he points out. "Breaking out on your own is very different psychologically," he says of the fateful move from assistant to photographer. "Being the photographer is a whole new thing; assistants don't realize that. For the responsibility of the setting the camera down and clicking the shot, they deserve the money."

"A freelance assistant can come in and do the job and leave," he continues. "You can work for another photographer. As a photographer, if you've got a nice job and blow it, you may have blown $2,000. If you get a bad reputation, you've got to *move*, to *leave town*. Even if the assistant made the mistake, a photographer can't use that excuse. Who hired the assistant?"

A PHOTOGRAPHY BUSINESS is no minor capital investment. Not only are there the obvious equipment, studio, and perhaps staff costs but there is the need for a reliable bank balance. Before he or she gets reimbursed, a photographer may incur expenses of up to $5,000 on a job. Nowadays, states Wecker, there are more "photographers who aren't making it, who are opening a business too quickly. Some are going back to being assistants to gain more information."

Over the past ten years, the appeal of photography has created an enormous influx into the profession. "More photography programs are being added to schools," notes Weckler. As for assistants, "They're cranking them out and not preparing them. The big cities are overflowing with all these people."

There is a very real problem here. More and more photographers are expressing their upset over assistants who "are coming in unprepared, unqualified, and with a bad attitude." Weckler is among a group of concerned people who, in conjunction with the American Society of Magazine Photographers (ASMP), put together a daylong symposium to attest to an assistant's preparedness and give him "as much information as he'd ever need." This was followed by a series of monthly ASMP programs for assistants, each featuring guest speakers and specific topics. A referral program has been implemented, indicating what photographers are looking for assistants and allowing a photographer to "see as many people as possible so he gets the best assistant." This began as a phone service, with Weckler himself often serving as a middle man between assistants and photographers. Later, Weckler and ASMP assembled a master sheet of assistants looking for work. Finally, on two occasions, the New York chapter of ASMP published a list of full-time and freelance assistants who were all ASMP members. Nearly two hundred names appeared on one or both of the lists.

Weckler is also independently involved in the preparation of an assistant's handbook, which he expects to publish by the end of 1984. It would include "simple things that an assistant doesn't know," such as the correct way to handle lights, the business side of assisting, how to store seamless paper, how to prepare resumes and portfolios, and the basic agitation of film ("Make sure what you think is 68 degrees *is* 68 degrees").

It would also feature a discussion of location scouting. There is more to it than most people realize, claims Weckler. "One's eye is, hopefully, seeing what the photographer sees," he says of the proper scout. The scouting report must include the dimensions of floors, the height of ceilings, where and what the outlets are. A photographer will want to see a good representative set of Polaroids, what the light is like from each direction if he'll be shooting outside, and what clearance has to be arranged for the use of any location.

WE HAVE HEARD from some photographers who aren't interested in seeing portfolios, but they are in the minority. In many cases, the portfolio may be the difference between getting and not getting a job. "It's an open book to the assistant's personality," observes Weckler.

A photographer will leaf through a portfolio rather quickly, but that isn't a value judgment, Weckler explains. "It's the old 'portfolio in three seconds' trip. Photographers have been through literally thousands of portfolios." They know instantly what to look for.

Weckler has several recommendations regarding portfolios. One is that an assistant should avoid leaving them someplace overnight where he or she's not going to be. In many cases, they represent your original and irreplaceable work.

He suggests that a selection of about fifteen prints, about half black and white and half color, is sufficient.

One hundred is absurd — "You don't want to be there all day." A portfolio is also a place where neatness definitely counts. "If a print is getting beaten up, replace it. You shouldn't have *any* excuses about anything."

It's best to make all of the pictures the same size, and he warns, "Don't be overly artistic" with ambitious arrangements or it will look "like you're there for the wrong position. You're not applying to an art gallery." You should be proud and pleased with what you put in the portfolio. "You should only put in pictures you like — not something because you think someone else likes it."

With the portfolio, naturally, comes a resume. Enough information to fit on one piece of paper is sufficient, according to Weckler. The resume should detail "which strobes you can use, what formats you're familiar with, and who you've worked for."

The final and very crucial bit of advice is, "Don't be timid." Some assistants are afraid to call and ask 'Is Dick . . . Richard . . . Mr. Avedon there?' Take a deep breath. If you don't make your presence known, you certainly aren't going to be hired."

Note: After this interview, Weckler did go out on his own, doing still life assignments for Bloomingdale's in New York and a black-and-white ad for Rolm Corporation in *Business Week.* He realized, however, that he lacked sufficient capital to cope with such factors as the initial outlay of expenses needed for his assignments.

Weckler returned to freelance assisting in the hope of accumulating savings and he moved to Hoboken, New Jersey, where "bigger, cheaper, quieter, and safer" apartments lie just a ten-minute subway ride from Manhattan. He was busier than ever. In the week before Christmas 1983 he'd traveled to Salem (Massachusetts), Miami, and Boston on assisting jobs, at one point working forty-two hours straight. Within six months he expected to be back out on his own as a photographer. His new portfolio emphasizes portraits "and anything to do with people."

PEGGYANN GRAINGER

AFTER SIX STRUGGLING months of freelancing followed by a one-year staff position, Peggyann Grainger returned to life as a freelance photographer's assistant and was cheerfully finding herself booked solid. During one recent stretch, she had a ten-week stint at one place, followed by solid work at four different studios over the following two months, and the studio she currently worked at would keep her on for at least another four weeks. There was not a day without an assignment during that entire period. With verifiable skill and experience, Grainger and her $75-day rate were obviously very much in demand.

Grainger, from a small town near Poughkeepsie, New York, is a graduate of the Rochester Institute of Technology with a B.A. in photography. There are two main programs for an RIT undergrad, explains Grainger. One, "professional photography," is "much more stodgy; you take a lot of pictures of cereal and catalog stuff." The second, "photo illustration," is "more art-oriented in that it's more creative," and entails photojournalism, fine art photography, and studio illustration. After beginning as a fine art major and then having a double major, she ended up with a concentration on studio illustration.

"I don't think you have to be an assistant to be a photographer," contends Grainger, but a program at RIT convinced her to take that route. Every year an instructor would bring a class of seniors down to a number of the leading photo studios and art direction agencies in Manhattan. "That made up my mind that I wanted to come to New York," says Grainger.

"Today assisting is one of the most accepted ways to break in," she acknowledges. "But there are people who have never assisted who are very big today. I could have gone to another city and gotten started shooting. But I probably would have had to begin at base one when I came back."

The merits of assisting are undeniable, she admits. "It's a way to get into studios, to find out how the business works, gain confidence, and get a feel for the studio."

Someone looking for an assistant's job in New York or any other large city must live there first, agrees Grainger. "You just wouldn't get work if you didn't live in the city. People want you for a 5 p.m. location at a moment's notice. And you may be working until 12 or 1 a.m."

WHEN GRAINGER first came to the city, it took her awhile to get up the courage to go job hunting. "I was so scared to start," she recalls. "Nobody can tell you how to go about it. If you call, they say, 'We're not looking' or 'What experience have you got?' If you just go to the studios, they say, 'Why didn't you call for an appointment?'" She did have a portfolio, but she thinks that is "sort of foolish because they don't really care about your photography." In her search for her freelance assisting jobs, Grainger's success was instant but not steady. "I got my first job the first week I looked," she remembers. "Then it was a month before I got another."

In time, job hunting became less traumatic and her prospects less dismal. "A lot of it was just feeling more at ease. Once I got experience I felt better." After six months of freelancing, she had toiled for some twenty different photographers. When the opportunity came to join a still-life photographer on a full-time basis she took it.

"I was freelancing and I was not getting much work," she explains. "A full-time position looked very good to me."

It was also just about the perfect time for a staff spot. "When you're working at the same studio, you get to know the clients, the art directors," Grainger observes. "When you get hired freelance, it's because they need you on a busy day. When you're full time, you get the ups and the downs."

The experience as a staffer was indeed broadening; Grainger moved up to become studio manager and was handling the bookings and even some of the bookkeeping. However, she left after a year, having decided that fashion and illustration were the kinds of photography she was more interested in. Trodding the pavement once again, she had more consistent success this time out, and with a solid reputation and a greater amount of knowledge, she even broke a few longstanding barriers. At one place, the studio manager shook her hand. She was the first assistant the boss had ever hired.

There is a certain degree of mental gymnastics endemic to freelancing. "Studios can be extremely different. You have to immediately figure out where things are, and what things you would normally do that aren't accepted there," Grainger says. There can be some trying moments. "Right after I left my staff job, I got a job with a guy who claimed he'd been the third biggest photographer in Los Angeles. The terms he used for everything were different. I felt he was out in the ozone somewhere. He'd ask me for something and I wouldn't know what he was talking about. I asked myself, 'Why did I leave my nice comfortable studio where I ran things?'"

One reason may be that a regularly employed freelancer can earn more than a full-time assistant. Her basic day rate of $75 (up from the $35 she charged when she was starting out and practically begging for work) applies for almost all assignments, although there are circumstances under which she'd vary it. Multiply

PEGGYANN GRAINGER

Peggyann Grainger

$75 times five and figure it out; that's more money than most assistants could ever hope to make.

"I've worked for an awful lot of nice people. I've been lucky," Grainger says gladly. The occasional "bad apple" photographer crops up. "I have one client who still owes me money from a year ago. It was a constant fight trying to get paid," she notes, and a friend of hers who assisted the same guy eventually took him to court. If the photographer is honorable — and he'd better be or his name will quickly be mud — "You usually get paid when the job is done."

SINCE THE BULK of her work has switched from still life to fashion, Grainger has noticed some changes. "It's more social. The 'showing' is more important — the ambiance of the studio. You have to put on a big

show for people. Lunch becomes a much bigger deal." The people coming in from the outside — models and the like — "get bored. There's more of a partylike atmosphere sometimes." The party, however, is more for the benefit of the "guests" than the host photographer, in many cases. "If they (the photographers) are the top people, they're not as interested in the show," Grainger explains. "I worked for some people — it's amazing they got anything done. The ones that are good concentrate on the work."

The degree to which an assistant should be making his opinions felt also varies from studio to studio. "If the photographers are confident in themselves," observes Grainger, "and you tell them something is being done wrong or could be done differently, they'll listen."

Some photographers had better listen, or they'll be up the creek without a paddle. "One photographer I worked with knows absolutely nothing

technically about photography," Grainger reveals. "He just wanted to walk up to the camera and take the shot." He would ask her, "What dilution are you at" in the darkroom and she'd answer 1-to-2. He'd respond, "Make it more punchy, make it 1-to-2¼." Notes Grainger, "To get what he wanted, he should have taken it down, not up."

"This guy at one time had a staff of twelve, including one girl just to change the stereo if there was a station on he didn't like," she remembers. "I soon realized he *needed* that many because he didn't know anything." In fact, one visitor to the studio familiar with the photographer came up and whispered to Grainger, "Just remind him to focus every once in awhile."

Another key difference Grainger has encountered since taking more fashion assignments is time pressure. "In shooting still life, you can check and recheck," she observes. "In shooting fashion, you have to be right there on the ball. If you only have time to take one meter reading, it had better be correct."

FREELANCE ASSISTANTS are expected to know every aspect of their craft. "It's assumed they know what they're doing. A full-timer might not know as much; he might have to be trained," states Grainger.

The rate of exchange in commercial photography is precisely calibrated, she suggests. "Generally people get their money's worth out of you." The price you carry — your day rate — is truly an indication of your worth as an assistant. Grainger began in the business with a $35-day rate "because I wanted to get work and I knew I'd run into resistance because I was a woman." The $35 figure, she notes, was actually about $5 less than the typical beginner.

In 1984, her fee of $75 "is pretty much the assumed rate for a top assistant whom you can rely on." It is a figure that usually means she is going to function in the capacity of first assistant. If a photographer is looking for a second assistant or even further backup, he will hire someone cheaper. Grainger is aware of people receiving a higher daily rate. But she believes "those people don't work primarily as assistants"; they may be part-time photographers or professionals of some other kind. Many of the most financially successful photographers in Manhattan, she notes, become hysterical even at the thought of parting with $75. "Photographers are generally cheap," she has found. "Maybe it's because the competition is so tough." And, she agrees, the photographer faces the prospect of having all of his overhead coming out of his own pocket.

THERE IS STILL MUCH that a woman assistant has to contend with in commercial photography. "You're much more on trial," Grainger feels. "You're treated cautiously and not given as much responsibility at first. People treat me sometimes with a little skepticism. But I do have a good reputation now, and I don't have to overcome that as much."

Grainger vividly recalls one bad experience she had in the office of a "very short" photographer. "It was a bad day for me," she admits; she had been all over the city on an interminable string of appointments and was "at the end of my rope." The photographer's studio manager, "also short," liked Grainger's credentials, but the photographer had reservations, which he attempted to couch in polite language. "It was nothing to do with you or your work," Grainger was told, "but I don't as a rule hire women." He didn't doubt that she could schlepp heavy equipment with the best of them, he assured her, but the prospect made him queasy. "It's not that you can't do it, it's just that I couldn't ask you," he went on. "And when things get hectic, I'd scream at a male assistant, but I couldn't yell at a woman."

Grainger, who was totally unimpressed by the man's genteel nature, remembers telling him, "Your way of thinking has no validity, and it probably comes out in other aspects of your life as well." Pointing to his rather diminutive studio manager, she contended, "If you don't think I can carry as much as he can, you're crazy." Observes Grainger, "Needless to say, I never worked for him."

A staff member of one still-life specialist acknowledged that the often-mentioned lack of physical strength isn't the only strike against females looking for assistantships. "Carpentry isn't something most people know, and neither is electricity," she observed. Many of the women looking for jobs "had nice looking books (portfolios) but they didn't necessarily have the personality. You have to be a little tough, but you have to be charming. That is never required of a male assistant."

Another photographer, supplying all the pictures for a lush color book on interior decor, needed to travel a great deal and thus required the use of an assistant. He placed an ad in a newspaper, and "the phone didn't stop ringing for a week" even though he had stressed the strenuous nature of the work, the low pay, and the long hours.

He whittled the field down at first by asking his applicants, "Do you smoke? Do you drive a car? Can you carry heavy equipment? Do you have your own equipment? How do you develop Tri-X?" After that, he explained, "The ones I discarded immediately were

women, anybody that couldn't drive, couldn't carry anything heavy, and couldn't do darkroom work." He concluded, "Out of 150 people you may find two who are competent. Then you have to train them in your style. Everyone works differently."

Grainger has found that on the question of female assistants, "Women photographers are the most prejudiced." Perhaps it is caused by unpleasant memories of their own assisting days. "They want to hire some big gorilla to make sure they won't have to ever schlepp themselves," Grainger contends.

Despite the occasional obnoxious character and the intermittent setback, Peggyann Grainger would not forfeit her assisting experience. There is one other positive aspect to assisting that people don't often consider, she comments. "You get experience doing things you would not normally do." There were, for example, eight or nine hours spent in the studio with a fully grown live tiger who had four trainers with him but who was not sedated in the slightest. "Stay calm," were the cautionary words of the photographer, but the art director spent seven hours in a chair without moving.

Grainger, who isn't too fond of the sight of blood, had also once worked on a nursing brochure and had to be present while surgery was being photographed. "I do things a lot in working situations I normally wouldn't do because I feel I have to," she explains. On another assignment, she went up in the sky in a cherrypicker over the West Side piers for a Volvo ad. "I'm terrified of heights," she confesses. "As we got higher, I kept sinking lower into the thing."

According to Grainger, some photographers expect their assistants to have lofty ambitions of their own. Interviews elsewhere in the book indicate that a wide range of opinion exists on this matter, but she notes, "I've heard photographers say they wouldn't hire someone who didn't want to be a photographer. There's that drive, that enthusiasm, that really makes a person strive for something."

PEGGYANN GRAINGER has already begun doing some of her own commercial photography; Life Savers was one of her clients. "I'm not really looking for them. They come my way sometimes," she says of these jobs. They may be the result of recommendations from other photographers. "You may work for someone who gets offered a job that is not worth his time," she says. "That's why it's good to work for someone good; you get the good jobs."

She is "wavering between fashion and illustration" as the main thrust of her photography. Her next steps, she says, are "to start testing, get a book together and go

around with it, and work with more fashion people."

"Testing" is a practice of both established and aspiring photographers. Tests are also called samples; they are pictures taken not for any specific commercial assignment but for inclusion in one's photographic portfolio. It is not difficult to entice models, makeup artists, and other necessary personnel to assist in tests. "Everybody gets something out of this," Grainger explains. "Models get prints of themselves."

Grainger frequently assists Nesti, a Cuban-born fashion photographer, and studio partners Tom Wier (still life) and Wilbur Pippin (fashion). Wier and Pippin permit Grainger to do her own assignments and tests on their premises. It's the kind of arrangement an assistant and aspiring photographer dreams about.

The process by which a freelance assistant becomes a photographer is not the same as the process by which a staffer becomes one. A full-timer, often with the complete cooperation of his employer, can keep his assistant's job all the way up until the time he's ready to start shooting.

A freelancer doesn't have such an umbrella of security. Time spent trying to launch a photographic career is time spent away from assisting, which means a loss of income. Taking time to get one's photography going may mean taking oneself out of the assistant market for a spell. That can be fatal, Grainger warns. "It's a risk. I know somebody who took two months off to work on his book and lost all his clients. If you're not around for a while, they find someone else to work for them. Some people make an abrupt change and find themselves not eating for a while."

ANOTHER POINT to keep in mind is the necessity of capital. "You have to have such resources of money," Grainger warns. Photography can be one of those endeavors where you spend money to make money; the expenses on a particular job don't get picked up until it is completed. In some cases, a terribly vicious cycle can be created. Grainger knows of one well-established photographer in the midst of a lean period who said that if she did get a decent assignment, she'd have to sell something she owned just so she could buy film.

"I have some big equipment needs right now," acknowledges fledgling photographer Grainger. "What's nice about this business is that you have a lot of comrades in misery." Some things can be borrowed, others can be rented. She advises, "Don't lose your contacts, don't lose your friends. They can help." And don't worry if your bank account won't cover the cost of giant strobes or an 8 × 10 camera. As a beginning photographer, Grainger surmises, "you make do."

PAUL CORLETTE

THERE ARE FEW more revered or recognizable names in the photography business than that of Hiro, and there are possibly fewer alliances as close and enduring as the one that existed for nearly ten years between Hiro and his studio manager (and first assistant) Paul Corlette. When Corlette first journeyed from Minnesota to Manhattan to join Hiro's staff, Watergate hadn't even happened, and it looked like Edmund Muskie was going to be the next president of the United States. The year was 1971.

Paul Corlette had been "in and out of a couple of colleges" and had spent a little time "roaming around the country" before he returned to his hometown and got a job working for the curator of photography at the Minneapolis Art Institute.

Corlette's timing was auspicious. He was on hand to help prepare Richard Avedon's first major retrospective at the institute in 1970. From this first contact with big-time photography, Corlette thought "it seemed like a glamorous life. I said to Avedon if there were ever a job opening [with him], I'd be interested." A month later, an offer came, not from Avedon but from Hiro, to whom Avedon had passed along a recommendation of Corlette.

As the man from Minnesota tells it now, "I'd never been in a photography studio in my life. I didn't even know they existed. I thought these guys, like Cartier-Bresson, just went around taking pictures. I didn't know what the system was, how the business ran, what really went on."

CORLETTE SPENT a year on Hiro's staff "at the bottom of the heap" and then returned to the Midwest. "I wasn't too sure I liked New York, and my wife was sure she didn't," he recalls. But after being away for about two years. Corlette went back to Hiro's place in the fall of 1973. The prospect of a studio managership was discussed. "Hiro had guys there and he knew they were ready to leave," Corlette notes. "He said, 'Why don't you come back and work into that spot?'" The Corlettes were packing their bags for a return to Gotham, and "work into that spot" is exactly what he did.

He has been with Hiro ever since, he seems content, and does not possess the same aspirations harbored by the typical assistant. "When I started, I thought I was going to be a photographer, but I never thought about being a 'commercial photographer,'" he confesses. "I just liked photography — I liked *pictures,* I should say. I'm not really interested in taking them. I had some ambitions at one time."

As a studio manager for one of New York's premier photographers, Corlette has gone about as high as any-one can go without becoming a photographer himself. He fully realizes this. "That's probably why I've been at Hiro's so long. I wouldn't go to work for another studio. If I left Hiro's, I'd get out of the studio business."

"This job just sort of happened to me," he says. "And when the next one happens, I'll take that one." Sometime in the future, he expects to return to the curatorial end of things, which is where he began.

When he first came to Hiro, Corlette didn't even know what a strobe or a light meter was. "I was completely baffled when I saw the first assistant taking readings." Today he hopes that any aspiring assistant would know enough "so he won't blow himself up when he plugs in a strobe." But Corlette somewhat surprisingly states, "None of the people that have worked at Hiro's under me have been experienced." However, he is talking about real commercial experience here; he has had someone coming from a catalog studio and another from photography school.

ALTHOUGH HE'S BEEN through the process so many times, Corlette considers the hiring of assistants a very imperfect science. "You never know when they're going to be good," he insists. "It's kind of a relationship that just grows. It's never love at first sight." He contends, "It's very difficult looking for an assistant. It's almost impossible; they seem to just come along."

He has pile of resumes a foot high, but argues, "It's impossible to judge somebody from a resume, to pick one out of a stack and say 'Your resume looks good, we'll give you a shot.'" The solution, he says, is to "put the word out, and it travels fast in this town." Despite his suggestion that hunting for an assistant is a gamble, Corlette can say, "We've never really had any failures."

What he hopes to get is someone "who has a sense of what's going on without being told. There are a thousand things going on everyday." The job requires "people who pick up sensations that are floating around, who have a sense of the other human beings around, who know how to interact. It really gets down to personality rather than knowledge. Knowledge can be taught. There are clients, models, hairdressers — all kinds of personalities come in and out of the studio. An assistant has to react to all of those in the right way and in the right proportion."

While Hiro "knows all the things going on and feeds out information to everyone," Corlette notes "most of it comes through me and I filter it out. We generally work together; there's no hierarchy."

As studio manager, Corlette says, "I have my finger on everything but I don't *do* everything. Hiro has a good sense of who has to do what. For example, I don't ever go in the darkroom. I haven't been in the darkroom in years."

In a studio situation, states Corlette, "I make the readings and set the camera and Hiro comes in and takes the picture. A lot of it can be set up without his being there. He says what he wants and I set it up that way. My relationship with him is a little bit special. Because I've been with him so long, I know exactly what he wants. He knows if I say it's *f*/11, it's going to be the right exposure." Hiro, he explains, has an uncanny knack for seeing ahead to the completed product. "The picture is viewed as a picture on paper at the outset." Looking through the lens, Corlette and his boss can decipher "what should be lighter or darker, what color we want, and you adjust accordingly."

THE DEVELOPMENT of a photographer's assistant, observes Corlette, is largely determined by expediency. "Everything has to be done *right now,*" he explains. "Until the day the guy who was above me left, I had never read a light meter. Suddenly one day he wasn't there, and I did it." There must have been quite a few of those tests on the firing line over the years, because Corlette claims, "Right now I can do anything there is to do in the studio — getting the exposure right, booking models, taking care of bookkeeping. I've done it all at one point or another. One day it just needed doing."

A new assistant coming into Hiro's studio may face a rather unique predicament. With Corlette seemingly so firmly entrenched as studio manager, a new person may never rise above the rank of second assistant. "There's a danger there," he admits, and he cites the case of Carolyn Jones, who came to Hiro as an apprentice volunteer before being put on staff. Corlette valued the high quality of her work, and was extremely sorry when she left. "Carolyn got frustrated. I know that. It's no secret." She departed to become first assistant to photographer Neal Slavin.

Jones is part of an expanding crop of female assistants who have "made it apparent that they can do anything," Corlette says. More and more women are coming out of photography schools, and he also believes that by their example, "the women who are good photographers have opened it up."

The main problems confronting a photographer and his assistants, according to Corlette, are logistical. A client, he explains, "will say 'We want a picture, we want it basically to look like this and have these things

in it.' The technical things, like the lighting, are Hiro's contribution to the picture."

Getting the picture to "basically look like this" often involves finding the proper milieu, and by now Corlette is a highly experienced location scout. On a recent job, Hiro needed to shoot at a cattle ranch with a very specific look to it. Corlette talked the matter over with his boss, called a few pertinent contacts, hopped on a plane, and finally tracked down the perfect ranch in New Mexico. "There was nothing to taking the picture," he stresses. "It was very straightforward. The challenge was organizing it, getting all the elements together."

As a studio manager or first assistant, "You're responsible for tens of thousands of dollars" in this kind of location shoot, Corlette comments. "The real talent is making sure the goddamn cattle are in the right place on the day you want them there." Photographers, assistants, and clients will be flying in from all over the United States, and if they don't see some contented cows, you may have to seek employment elsewhere.

Scheduling has become a major portion of Corlette's workload, and he is usually well ahead of the game. He was being interviewed in the winter, about to depart for an assignment in a sunnier realm. "This Virgin Islands trip has been set for two weeks," he notes. "We're leaving in two days and I'm already on to the next trip" — finalizing the itinerary for a job in New Orleans.

At this point in his tenure in Hiro's employment, Corlette's tasks during an actual shooting in the studio may be minimal. The other assistant or assistants get the necessary lights and other elements in order. "I go in at the last few minutes to balance them, and to make sure the exposure is okay. By the time Hiro is shooting the picture my job is done. I'm sometimes not even on the set."

Hiro, who is highly respected for both his fashion and still-life work, actually uses 35mm cameras for most of his assignments, according to Corlette. "He likes Kodachrome, he likes the format, he likes the effect he gets from all the lenses. He's become a master of it. A lot of times people are surprised at what you can achieve with 35." But the studio manager hastens to add, "We use whatever is necessary to do the job."

CORLETTE ACKNOWLEDGES that payment for assistants has "always been very low, based on the tradition that what you're learning is more valuable than what you're getting paid." However, he personally insists "I'm well taken care of." His benefits include medical and life insurance and "all those funny things

that in the flexible world of photography you don't find." His hours are perhaps longer than the average working stiff, but far more regular than many photographer's assistants. From Monday to Friday he is customarily on the job from 9 a.m. to 7 p.m. and rarely gets out for lunch. But he does have a life outside of the studio; he hardly ever works on Saturdays or Sundays and seems to put some distance between himself and his profession. He may be one of the few assistants who can say of his boss, "I don't know what he does on weekends." Nevertheless, theirs is a friendly relationship, and a dinner together after work is not an uncommon occurrence.

As far as the "glamorous" world of commercial photography is concerned, Corlette claims, "The most interesting thing for me is the travel. I don't socialize with anyone in the studio. I don't know any models. I wouldn't know one if she walked in now."

Corlette insists that "nothing we do is very complicated," but Hiro and his employees can create some convincing illusions. "A lot of things are faked; there are tricks," acknowledges Corlette. "We've taken pictures in the studio that look out of doors. Hiro has an understanding of what the outdoors looks like and how to duplicate certain kinds of landscapes in the studio."

There are cozier and more comfortable illusions as well. For a sheet and pillowcase company, Hiro seemingly went to a number of different apartments to photograph bedrooms; in fact, all the photography was done in in his studio. "It's a matter of understanding what the camera sees," notes Corlette. "What you stand and look at is not a room." But a skilled photographer can frame a picture of a makeshift set in such a way as to make it look like an intimate glimpse into a lady's boudoir.

Note: Corlette, the only interviewee in this book who professed no interest in being a photographer, is now training horses in Pennsylvania.

FOOD AND STILL LIFE

EVERY AMATEUR pastry chef knows how difficult it is to make a Grand Marnier souffle rise properly or make a lemon meringue pie come out looking airy and fluffy. You can be assured, dear cooks, that making such delicacies look delectable in print is a more complicated and exacting science indeed.

Magazines devoted to food, like Gourmet, Cuisine, and Food and Wine, are salivated over by hundreds of thousands of readers each month, and advertisers pushing their edible and potable products are always looking for new ways to make a visually appealing presentation to the print audience. The way food looks in an editorial or advertising spread may not be the way it looks on your dining table, but it's how it would turn out if everything went exactly right. It is, in other words, the ideal every cook strives to attain. It is, therefore, the ideal every professional food photographer must attain.

Food shots and other forms of what is called still life photography are usually done in controlled studio environments where, under optimum circumstances, everything can be at least theoretically perfect. A good food and still life specialist has to make everything look easy when it may be quite far from simple. This can be an expensive, complicated production, involving a great deal of manpower.

A single food shot, for example, can require a "home economist" to prepare or cook the food, a "stylist" to then make the food look additionally delectable, and perhaps a "model maker" to make some beautiful illusion out of wood, Styrofoam, and other materials. There are also assistants to handle complicated and precise lighting arrangements and help operate a very costly camera, usually a 4×5 or 8×10 view camera.

And there's the photographer who has to understand what everyone else is doing and execute an assignment perfectly while the client may be breathing down his neck on the set. It's very difficult work, all right, but it can be extremely rewarding. Each assignment can involve the creation of a controlled environment that is the photographer's invented universe. There's a lot of power and creativity to be exercised, and a lot of leeway for the exercise of them.

Because of the amount of money involved, because of the cost of equipment, and because no advertising agency is going to spend tens of thousands of dollars on an untested rookie, food and still life photography isn't something one can merely walk into. It's highly recommended that anyone interested in this kind of photography consider an assistantship to someone who already does it successfully and well. There's really no other way to learn how to master the art and to make the contacts necessary to give you a chance at your own assignments.

Four of the men in this section — Lynn St. John, Charles Gold, Donato Leo, and William Pell — are primarily food specialists. Michael O'Neill, who is now also known for his fine magazine portraiture, first earned his reputation as the creator of some of the most ingenious and memorable advertising still lifes in the '70s. All of these men have worked with and as part of photographic crews involving assistants; their stories should nourish the curiosity of any aspiring photographer.

LYNN ST. JOHN

LYNN ST. JOHN was an art student in Detroit with a plan to study architecture at Yale when he first saw the photos of Irving Penn and decided "photography was the way to go." As fate would have it, St. John ended up as an assistant to Penn for three years before launching his own successful commercial photography business twenty years ago. In a spacious loft on the top floor of a building near the East River, St. John has shot numerous covers of *Cuisine* and major spreads for such mass circulation magazines as *Good Housekeeping, Redbook,* and *Cosmopolitan.* Although best known for his food photography, St. John, who does other still lifes, was preparing an ad for Estee Lauder on the day he was interviewed.

"You want to perpetuate talent when you see it," claims the soft-spoken St. John. That's not an idle statement; very few professionals are as actively developing young potential as he is.

St. John participates in a program run by Manhattan's High School of Art and Design. High school students, judged largely on the basis of portfolios generated by school assignments, have the opportunity to serve half-year internships with commercial photographers for credit in lieu of classes. At the time of this interview, St. John had had four or five such interns, and noted that one of them already had established a successful photography business in Dallas, Texas.

Education is something Lynn St. John considers a must for photographers or assistants, and he isn't just talking about a "technical" education. "The technical thing I think anyone can acquire on the job," he suggests. "And it has to be applied *on the job.* School teaches hypothetical problems. Why not see some real ones?" Those are the kinds an intern will witness in St. John's studio. His studio manager, Bruce Nichols, had originally served in St. John's studio as an intern while he was still a student at Pratt Institute. Having proven his mettle, he was invited back to the staff after his graduation.

When he talks about education, St. John advocates something a bit more well-rounded. He is not, as we shall see, the only man in the upper echelons of commercial photography who originally came from an art background. He still believes that preparation for photography should include courses in art history, design, and drawing. Knowledge of photographic technique is probably less than half the battle; these other subjects can greatly enhance one's understanding of the way to compose any visual image — specifically, a photograph.

The kind of internships photographers like St. John provide can be important in one additional and perhaps unexpected fashion. That period of time spent in a professional's studio may in fact teach a teen-ager or young person that photography is not for the squeamish. One high school senior confessed that what

he had seen had convinced him that he didn't want to be a photographer. What changed his mind? "The pressure," he explained, almost trembling at the thought of it. "I had no idea there was so much of it." The weight of deadlines, big budgets, and the hovering presence of art directors and the like were too much for this fellow. What would he be instead? "A home economist," he declared. That way he'd be "in one place all the time," with a particular job to do each time and without the burden of ultimate responsibility. Clearly, life in the studio was still appealing enough for him to want to stay in it in some capacity, albeit one that is further down the chain of command.

LYNN ST. JOHN'S own career began as third assistant at Irving Penn's studio, "very happily doing the most menial tasks, like washing dishes." He never became studio manager, because Penn at that time had the same man in that position for about twenty years. Nevertheless, by the time he left, St. John had "learned enough to be of benefit to him as an assistant."

His years in the business have convinced St. John that a commercial photography career could not begin without an assistantship. "I think it's impossible in the kind of work I do," he maintains. "General Foods or Estee Lauder is not going to take a chance on someone unproven or right out of school. The make-believe problems of putting together a portfolio aren't the same as you face on the job."

ST. JOHN SAYS he would never take someone just out of school and make him a first assistant. Yet he prizes "non-photographic talents such as personality and the ability to get along with other people" in his assistants. He adds, "It's a benefit to me if someone wants to learn something from me, to ask questions. I like to teach. Trying to explain why I do something helps me understand it, and maybe improve on it."

"Nobody realizes until he's doing it how involved it is," he says of still-life photography. Among the key things for an assistant to know are "how to work in a mirror (images are reversed) and how to work within type requirements" for such editorial assignments as magazine covers. There are also a myriad of small matters to deal with. St. John motions to one set, where an Estee Lauder cosmetics ad is in preparation. Bruce, his assistant, has covered a small compact mirror with a sheet of white paper. Done properly and carefully, the small mirror will still look like a mirror in the final photo but it won't cast undesired reflections on

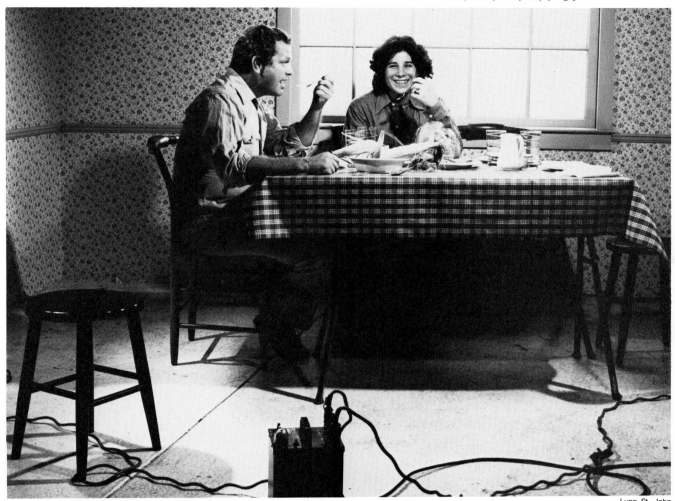

Lynn St. John

the other items in the picture. The Estee Lauder lipstick is in a gold container with the company name embossed in the same color. Since those letters would hardly show up in a finished picture, Bruce has to carefully insert a dark dye into the "nooks and crannies" to make the logo legible.

"I try when I interview people to find out what other talents they have," St. John explains. When told that a female assistant to another photographer had mentioned that St. John required assistants to do a lot of carpentry, he smiles. "She probably said that because I asked her about carpentry and she didn't get the job." The fact is that, for him, carpentry is more of a code word than anything else; what he wants to know is if an interviewee has "manual dexterity. If somebody does carpentry, that means that person is good with his or her hands." In St. John's studio, an assistant will be working with a plethora of small objects and will have to maneuver them adroitly, and the potentially cumber-

some business of loading and reloading film must be done smoothly and quickly. "All of these things are somehow related to carpentry," he suggests. There will be mats and frames to cut, but what's important to St. John is how skills that abet a carpenter can be applied to pertinent photographic chores.

"I've never had someone who was a professional studio-manager type," says St. John, who feels that the era of such individuals is coming to a close. "All of my assistants have wanted to be photographers." When examining their portfolios, he hopes to see "enough in their work to make sure they understand and appreciate what I'm doing."

Some of the changes St. John has seen in his field were dictated by economics. One of the major developments of this kind was the rise of the freelance assistant, who he believes came into abundance "as overhead grew and the fee structure didn't go up with it." Many photographers elected to contact and hire

43

assistants only for those occasions when their presence was absolutely essential. St. John sees freelancing as "a great road to go. They get an inside look at a lot of operations, which may tell them which way they should proceed with their own work." It may be great for those who choose it, but St. John himself would rather use staffers than freelancers. "I'd rather have continuity," he stresses.

THE MOVE FROM ASSISTANT to photographer was one that Lynn St. John was understandably anxious to make. As far as picking the proper moment is concerned, he maintains that "people know that about themselves." St. John, who spent four years working as a photographer in London, has observed that it is actually much easier for a commercial camera operator to get started in the United States than in England. The extensive amount of work and the heavy concentration of competition in New York, for example, make the necessary equipment both plentiful and less expensive than in London. There are other factors as well, such as that great Yankee fixture, The Installment Plan. St. John, who borrowed money from a bank to finance his first strobe lights, notes that very decent second-hand equipment is also available in quantity.

St. John remembers Penn, his own boss, as "obviously an intelligent, creative person. In addition he was a very generous and sensitive man. He did not have any airs of pretension, of making himself important by artificial means." Penn was accessible, and willing to share information; he did not remain an aloof, superior figure, St. John adds. "The more talented someone is, the less they put on airs of this kind of hierarchy."

Penn's example is followed by his former underling, who encourages his experienced assistants to use his studio facilities for their own purposes in their off-hours. "As soon as someone knows how to use it," notes St. John, "all of my equipment is available on weekends."

"I don't have a big turnover," he declares of his assistants. "Selfishly, I'd like them to stay forever. Real-istically, a couple of years is about normal." He hires a stylist "as I need one," which is quite a bit of the time. Certain responsibilities he keeps to himself, specifically the securing and arranging of props. He won't just hand someone a list of needed items and a handful of cash and send him out the door. "I can never understand how a photographer can have somebody do that for him."

An assistant to Lynn St. John will work in a very specific area of commercial photography, but he or she will be extremely well-versed in that area. St. John's forte is studio still life. "I myself am not good at directing people," concedes St. John. "Penn is the exception in that he does fashion and still life." Moreover, St. John's work rarely takes him out on location. "I like the control of the studio," he states.

THERE ARE PLENTY OF problems to solve in the studio. As a food photographer, St. John is dealing with an often perishable camera subject, and decisions regarding how to proceed have to be made well before the foodstuffs go under the lights and in front of the lens. Most of this is actually worked out the day before the shot. As we watched, for example, St. John was contemplating a concoction of cherry Jello and Cool Whip. Tasty enough, and not bad-looking, to be sure, but a photographer has other things to consider. "One is translucent, one's opaque. One's dark, the other's light," observes St. John. "If you light from below, will you get reflections through the transparent Jello?" That was one of the questions he had to answer before this dessert would be properly photogenic.

Lynn St. John has occasion to use an 8 × 10 camera, but his editorial covers are actually shot with a 2¼ Hasselblad. He likes the 50mm lens and, even more, he likes the proximity it gives him to his subject. "With the Hasselblad, I'm within reach of the food," he explains. "I can touch it and move it if I have to." And wolf it down right away when the shooting's over.

CHARLES GOLD

FOOD AND STILL-LIFE photographer Charles Gold, whose *The Gold Touch* and *The Gold Standard* are among the best and most effective self-promoting sampler booklets in the business, has a staff comprised of a "secretary/stylist, a studio manager and/or first assistant, and a second assistant." He gets three or four calls a week from people wishing to join his studio team. "If the economy were better," observes Gold, "they'd be settled somewhere."

His "batting average" is something about which Gold is proud. "I once sat down on a day when I didn't have anything else to do and listed all the assistants who had worked for me. Of fifteen names, twelve had gone on to become successful photographers." That is a very high percentage in anybody's ball park, and especially in the photographic big leagues.

"I love to teach on a small level," says Gold, who holds mini-seminars for his assistants when the work load is less than staggering. "I give them assignments that are constructed in ways that would teach the realities of this business." If, for example, his assistant is "a woman deathly afraid of 8 × 10," he'll make sure she experiments with that format.

GOLD'S TYPICAL ASSISTANT stays with him for from eighteen to thirty months. Eventually, "it just comes time to move. They start eager, they want to learn your methods." But after awhile, "they're no longer contributing; they're lazy, or they're not on the ball like they once were. It's not a put-down. It's a psychological indicator of boredom."

Gold has no hesitations about hiring a woman assistant, although that may be partially because he customarily has two assistants. "I am not a sexist. I love women. I would really rather have a beautiful woman around than an ugly guy." Knocking the air out of one of the most frequent anti-female excuses, he states, "Melissa (his current second assistant) can lift 4 × 8 plywood planks with the best of them." He concludes that to be liberated, "there should be no differentiation economically or in terms of the work."

Economics are always a consideration for assistants; a desire to live better than a pauper motivates many of them to move on. "A lot of assistants think they should end up millionaires from that job," Gold has found, but "it isn't that kind of job."

The compensation at Gold's studio is better than the norm. "I wouldn't consider (hiring) anybody I would pay less than $175 a week to start," he declares, noting that salaries can go considerably above that level. "When I feel that I am entitled to charge overtime to the client, they'll get overtime too. The other compen-sations are wine with lunch and drinks after work. And this is a fun studio to be in."

For someone to be a first assistant, Gold would expect them to know how to load a sheet of film, how to take a lens off a Hasselblad and put it back on, what a strobe is all about, what a meter is all about. But certain credentials do not impress him. "Who cares about the Toronto School of Photography in New York?" he asks. "Who cares if you worked for Samuel Kaputnik in suburban Toronto?" He also mentions a certain New York photography school and states he would never hire anyone who went there because its "the kind of place that advertises in the back of photography magazines."

He never looks at an assistant's portfolio. "If they show me they can mop a floor, it's more important to me than what kind of picture they can take." Someone trying to impress Gold with his alleged darkroom wizardry had better be prepared to back up his claims. "Sometimes I will give them a negative and say, 'Go make a print,'" he says of his applicants.

Gold has occasionally had an unsuccessful assistant. Most of them (as is obvious from his batting average) were quite certain that photography was the sport for them. However, one fellow, as he recalls, "really wanted to be a rock singer." While he actually announced his intentions to leave and set up his own photography business, it was clear that he wasn't cut out for it at that time. What he did announce was, "I want to go out and fail." And he did. Now, says Gold, he is "doing very well at something else."

GOLD KNOWS there will be an occasional attempt by a former assistant to wrestle a client away from his ex-boss, but he's hardly frightened by the prospect. "I'm not threatened. I have tremendous confidence in my skill and ability," he proclaims. If such thievery does transpire, notes Gold, "I think the client is stupid and the assistant is unethical."

He details what he believes is a more typical situation. A solid account of Gold's called and told him he had been contacted by a one-time Gold assistant, who now wanted to take his ex-employer's business away. "He said he can do everything you can do for half the price," the client told Gold. But the client then explained how he'd laughed at the upstart and sworn he'd never use him.

CHARLES GOLD is adept at all camera formats, but his most common choices are 2¼, 4 × 5, and 8 ×

CHARLES GOLD

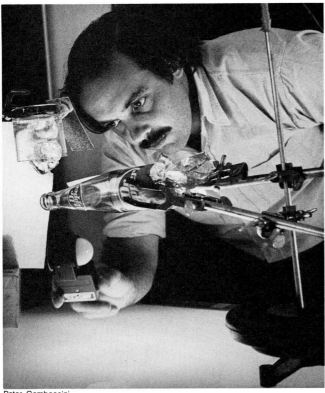

Peter Gambaccini

Gold was the photographer of this famous Dr. Pepper ad, right, in which the soda heads up into the sky instead of down into the glass. Some of his tricks of the trade are shown above. Note the convincing droplet of moisture at the top of the bottle—a concentration of glycerine, transparent *and* sturdy.

Charles Gold

47

10. He has a Deardourff 11 × 14 he loves to work with and once used for the bulk of his assignments. However, he notes, "The cost of film for it is prohibitive. And it's cumbersome. It's a two-man operation with walkie-talkies."

He rarely does a finished shot with 35mm. "That little thing in your hand is not the way to shoot a picture," he maintains. "I set up a camera and I design what's in front of it."

When asked if food photography should be totally authentic or should rely on artifice or techniques to achieve the desired appetizing effects, Gold answers very precisely. "I believe that as long as you aren't creating an effect that never was or never could be, you're not cheating," he states. Oiling a turkey to make it look plump and juicy, for example, is only "bringing it back to look like it did once." Cheating, he says, is "to take Bisquick and make it into sherbert."

Some of his clients are very touchy about this area, and if they are terribly concerned with what is "real," he will honor their wishes. One company, he reveals, always has "a semi-lawyer on the set. Because they're so uptight, they won't listen to reason and logic."

Gold's comment about his place being a "fun studio" was thoroughly corroborated by the behavior of his two assistants. Out of sight on the other side of a partition, they waited to tell their part of the tale. But they didn't greet the interviewer in the normal fashion. As they said hello, they were wearing bags over their heads. Clearly this is a tension-free place; Gold's assistants were confident that their prank would not elicit the vengeful wrath of their boss.

GOLD'S FIRST ASSISTANT John Uher, who attended New York's Fashion Institute of Technology, and second assistant Melissa Burtner, a graduate of the Rochester Institute of Technology, who has since left Gold to become an art director for an ad agency, were both convinced that the positions they had taken were an essential step toward a career in commercial photography. "The only other way is to be rich," said John, "to have an enormous amount of capital and set yourself up in business."

He had hung around with a photographer while he was in school. "I basically knew how to print. They showed me how to use a broom." A broom or a boom? "A broom. Booms came later."

The Fashion Institute of Technology might seem like an unusual place for a chap working for a food and still-life cameraman to have gotten his training, but John Uher knew he preferred commercial photography over newspaper work. The emphasis on edibles over wearables came later.

Naturally there was much to be learned at FIT, including a basic set of darkroom skills. The most valuable thing about going to college, however, is the contacts it gives you, John explains. And they are not contacts with people who have jobs to give, for the most part. They are, rather, connections with fellow classmates who have gone out and *gotten* jobs.

The time spent in professional preparation obviously gives a person a better idea of where to go to launch a photographic career as well. "Does a kid out of high school know where to go? Does he even know what *The Black Book* is?" John notes.

Uher's first New York assistantship was a very brief stint with Frank Moscati, who actually "had more people than he needed" but took on John as a favor (he did, however, work for free). Uher then gained valuable experience as George Hausner's one and only assistant and signed on as Charles Gold's first assistant two and a half years ago.

That is about the maximum length Gold would expect an assistant to stick around. But John smiles ironically, "I'm going to break all kinds of records." He acknowledges, "My only step from here is to go into business for myself. It's not an opportune time. The industry isn't ready for someone as great as I am."

He laughs at that line, but insists that it be kept in the interview. The crux of the matter, the reason for postponing his bid for independence, is financial. Although there are ways to reduce costs, such as renting or even sharing studio space, Uher figures "$15,000 is the minimum to go into business."

In the meantime, until the economic factors are improved or the time seems right for some other reason, Uher will try and shoot a little more on his own. He has done a few assignments ("simple shots," he calls them) for *Good Housekeeping* when Gold was out of town.

Melissa Burtner was originally from Pennsylvania and while she did not consider it essential to come to New York to be a photographer, she surmises "if I could make it here, I could make it anywhere." Indeed, in sizing up the geographic markets for commercial photography, John and Melissa contend that 75 percent of the work is done in New York and that the only other cities with any considerable amount of intriguing opportunities are Los Angeles, San Francisco, Chicago, Miami, Atlanta, and Dallas — and, of course, Detroit for car advertising.

MELISSA'S DEGREE was a B.F.A. in photo illustration. After graduation she worked as an assistant at Kodak's mammoth Rochester headquarters, where

she had a chance to work on portraits, industrial locations, and illustrations for in-house use.

She came to Manhattan and worked briefly for Arthur Beck. "I was there mostly to sweep floors and do what a second assistant does," she recaps. She then freelanced for a year. While some fashion assignments did arise, she didn't really enjoy them; her photo illustration major had concentrated on large format cameras, and she wished to stick to that. One of the photographers she free-lanced for was Charles Gold; later, she was offered a staff spot.

Melissa has "run across a few photographers who wouldn't even look at my resume" because she is female, and she believes "Women assistants work harder at trying to prove themselves." But no such problems exist for Gold, who says that as far as duties and abilities are concerned, John and Melissa are "interchangeable."

GOLD IS WELL-KNOWN for his trick photos. His shot of a capsule spilling open to unleash a flood of tiny time pills, is an illusion of size. The capsule is in fact enormous, and the pills are gumballs. This is one of the more elementary "tricks" of which he is master.

Gold was also the photographer of the renowned Dr. Pepper ad in which the soda pouring out of the bottle into a waiting glass somehow heads in the opposite direction — toward the sky. A little ingenuity, engineering, and tricks of the trade accomplished this bit of stupefaction. The Dr. Pepper is not in fact defying the laws of gravity; the picture was intentionally printed upside down. The glass is actually hanging upside down, held in place by tongs with plexiglass "ice cubes" glued together inside. What made the illusion most convincing is the droplet of moisture at the top of the bottle hovering over the glass — pointing up in actual fact and not down as it appears. A fragile drop of real water wouldn't stay in a glass waiting for a photographer under glaring lights. The drop is actually a concentration of glycerine, transparent but a lot sturdier than the real H_2O.

Certain food and beverage shootings can border on the perilous. One assignment called for chicken to be boiled in twenty gallons of Wesson oil at about 400 degrees. No one wanted to be anywhere near the boiling oil; they didn't even like the idea of it being on the premises. Gold had some thoughts about using a camera with a hand trigger and a long cord and shooting it from about fifty feet away. "But when it came time," he grins, "I was the one up there on the firing line."

There are also some bizarre import requirements in this trade. One European vodka distillery wanted an ad stressing the allegation that it's the water that makes the difference in the liquor, so they shipped tons of the stuff to New York, and part of it ended up in Gold's studio. Even after all that, the shot was a perplexing one. The finished product consisted of three images — a drop of water falling through space, its impact as it hits water below, and a sort of mini-mushroom cloud of spray the moment afterward. But the water was not responsive to regular ambient light. Here, a scientifically minded assistant saved the day — a special infrared system was devised to accomplish the shot.

DONATO LEO

WHEN IT COMES to assistants, still-life and food photographer Donato Leo has seen all kinds. "You get the guy who's very timid and the guy who wants to take over your studio," he has found. The latter types may "want to know what their privileges are" as far as use of the studio for their own photographic purposes is concerned. But he's not too anxious to tender such "privileges," claiming that assistants have broken and even stolen equipment. "It isn't his equipment," Donato says of the assistant," and he doesn't treat it as if it is." Donato remembers one morning when "nothing worked," and the assistant could only offer a sheepish know-nothing grin. Another fellow, whom he found printing in his studio at midnight, was, out of frustration, actually attacking his enlarger with a drill.

DONATO LEO would hire a full-time assistant if he found one to his liking, but he has relied on freelancers for about five years now. Leo is also unusual because he performs many of the tasks one would normally associate with an assistant "because time is of the essence and I can do it better and faster." However, he believes that there are, in fact, fewer full-time assistants of quality available. "Instead of working five days a week, they work for two or three," he says. The reason is not laziness; it is a desire "to work for different people, to learn as many styles as they can."

Like many a man or woman who has been listed in the leading photographic directories, Leo gets a slew of calls from assistants; "they may like the page you have" in *The Creative Black Book.* He says, "I try and stick with people I'm familiar with." Donato theorizes, "As a rule, the guy who comes in and asks for a lot of money usually knows his job. But when you have to hold his hand, it's bad news." He adds, "I'm not impressed when they say they'll come in and work for less. That may mean they're not going to do anything but take up your time." His feelings about schooling are mixed. "I interviewed a couple of RIT guys. Their qualifications appeared better rounded than other photography school graduates."

Leo thinks "Fifty dollars seems to be the going rate for an assistant's daily labor. "I would agree that we're all entitled to more, but that includes the photographer," he states. He is aware that assistants are getting paid $100 to $125 by some employers. "To me, they're not worth that much," he contends. "What I need is hands. Give me your hands and stay out of my way." He adds after a pause, "They should also anticipate what your next move is going to be. A lot of them can't do that." If he thinks the high end of the pay scale is out of line, he is visibly perturbed by the assistants who will work for "the big name photographers" for less than he's paying, figuring they'll learn more with a more illustrious boss.

Leo is one of those who subscribe to the notion that Europeans make better assistants than Americans. "It goes back to the old system of apprenticing, of getting in there and learning something," he comments. His all-time favorite assistant was an Englishman who "was unbelievable. I'd explain something to him and he'd know exactly what to do." Donato has encountered this, a rare combination of attitude and aptitude, just that one time. "It was like he'd been there with me for years," the photographer marvels.

The qualifications Donato mentions for a prospective assistant are notable for what's missing. He doesn't even require an assistant to do darkroom work. I'm a better and faster printer than anyone I can hire," he argues. Since all expenses are billable, all jobs are sent out to a professional printer. "Everything is a rush. The agencies pay for darkroom work and bill it to the client."

A while back, one assistant remained on Leo's payroll for four years. He was the only underling Leo ever officially tabbed to photograph an assignment. Leo was on vacation "in snow country," when an art director wanted a job on a certain deadline, and the boss decided it was a simple enough task to bequeath to his assistant. "You know how I'd do it, you know how I light things," Leo told his assistant, "and if anything really goes wrong I can rush back." But as Donato tells it, "he wouldn't do it. He was afraid." The amazed Leo asked him why, and the assistant explained, "It's your reputation." Such loyalty may have been touching, but it may also have been misguided. "There was nothing he could not have handled," affirms the photographer.

Donato Leo can handle any of the major photographic assignments, but he shoots a surprising amount of them with a 35mm camera. In his still lifes he often relies on a 20mm or some other wide angle lens to "give perspective, make it look three-dimensional." And most of his shots — including a sumptuous array of grapes and assorted cheeses which he included in his *Black Book* page — utilize edge lighting. "It's far more dramatic," he insists.

STILL LIFE AND FOOD photographers all have their own tricks of the trade. Pointing to one ad, he explains that the reason the bar of soap is still totally intact with its trademark still legible after vast quantities of water have been poured over it is that the soap had been coated with a clear paint, a lacquer, or any number of watertight and transparent substances to prevent its dissolving.

The delectable sandwich cookies in another photo actually arrived at the studio in a dried-out condition. For a "zesty-looking sandwich," Donato replaced the filling with caulking compound, and neither the client nor anyone else ever noticed the difference.

To photograph an array of candy bars still in their wrappers, Donato opened up the back of the packages and removed the candy. He then filled the packages with the trusty white caulking compound. The effect was twofold. First, having the white substance behind the white-script brand names actually allowed the script to look white, and not gray as it would have if a real chocolate bar were beneath the ever so slightly translucent wrapper. And secondly, the use of the compound let Donato fill the wrappers almost to the bursting point. The resulting "candy bars" were not just succulent, they were positively voluptuous.

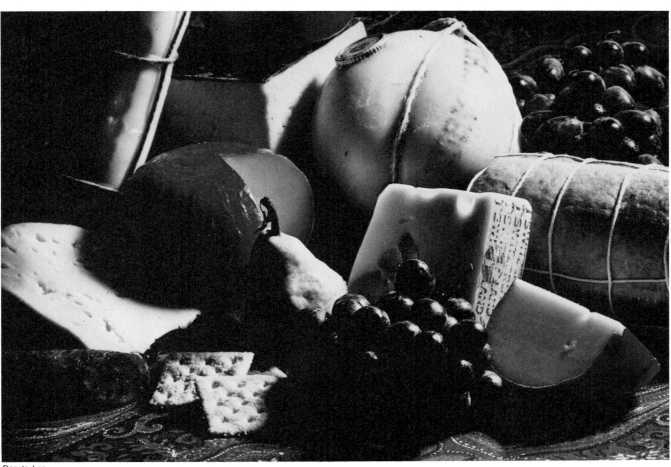

Donato Leo

To get the flat foreground he needed for this Nabisco ad, Donato Leo used a 300mm lens.

BILL PELL

BILL PELL'S first professional photography assignment was a national campaign for Chesterfield cigarettes. His advertising clients have also included Tide, Jaguar, and Coca Cola; he has published a book of photographic observations taken from a twenty-seventh floor Manhattan apartment; and his editorial work has appeared in *Redbook, McCall's, Good Housekeeping,* and *Ladies' Home Journal.* His pictures have also graced the covers and pages of many a cookbook, and today it is for food photography that he is best known.

Pell's situation is an unusual one. The woman who prepares and styles the articles of food for his shots is his wife Betty, whose skills are in demand with other photographers as well. On a typical assignment, then, the only duties that might be left for an assistant are loading film and moving lights. Pell says, "It's a question of habit. I'm used to doing things myself."

He notes, "My only need for an assistant is when I require a big background and someone with brawn." He adds, with a smile, that he would employ an assistant on "some agency jobs. The agency pays a high rate, and the art director, account executive et al show up. I have to put up a front for it." Then he may take on an assistant more for appearances than out of necessity.

Of course, it is necessity that determines his staffing decisions. "When I was working all the time, an assistant was essential," says Pell, who is more selective nowadays. "I required someone who would double-check me. I'd be looking at the entire picture, and so it's good to have someone to observe details. There may be a fly on a piece of food. And an assistant could also double-check my meter readings and *f*-stops, and be rather quiet."

PELL BELIEVES he may be the only food photographer in New York with a food stylist — his wife — on staff rather than freelance. The terms "food stylist" and "home economist" are sometimes used interchangeably in photographic circles but they in fact describe rather different functions. Betty Pell is both. As home economist, Betty may actually cook the food, garnish it, and otherwise get it into what would be a final edible form. The food stylist's job is to pick props, dishes, tablecloths and other items to be included in the finished shot, and also arrange an assortment of foods, in the most photogenic fashion. In studios where the volume of assignments is great, an assistant can expect to be working in tandem with the home economist or food stylist.

In her dual role, Betty actually goes out and buys the needed foods at the more specialized New York markets, keeping in mind at all times that freshness is of optimum importance. Her search for props is undertaken with color coordination and specific sizing as priorities, and to find the right-sized oval plate with the desired floral blue border may take her on a meandering path to department stores and antique shops. Bill Pell praises his wife's "unique color sense," and one of her tasks is to peruse the manuscript of a cookbook and decide which is the most photogenic food for the cover. Once everything is established, notes Pell, "I'm not allowed more than fifteen minutes" to get a good picture. "She's on top of me saying 'the parsley is wilting.'"

ALL OF THE MAJOR camera formats are utilized in Pell's work at one time or other. For a twenty-four-sheet poster — a billboard to laymen — he would rely on his Deardourff 8 × 10, chiefly because of the degree of enlargement involved. But he also has a 4 × 5 and the less common 5 × 7, and usually leans to the 2¼ Hasselblad or a 35mm when he needs lots of exposures or is required to work fast. Indeed, he has a hand trigger on his 35mm which will give him a shot four times per second. For cookbook jackets, his usual choice is the 8 × 10; the negative he gets will be close to the actual size of the cover. Combined with a knowledge of where the type must go and what lettering will be used, the 8 × 10 shot gives him the most complete notion of what the finished product will look like.

PELL'S FREELANCERS are hired from among people who come in to see him or from the resumes he has on file. To work for him, an assistant must be familiar with a view camera, which has "a lot of controls designed for specific purposes," mostly to regulate its movements. The assistant must also "understand light meter readings and Ascor and other strobes, even ones with motorized systems." And he must be able to hook up Pell's main lights and also the "kick lights" he uses behind a setup to provide illumination around the rim of a subject.

And then there are the special tasks that vary from assignment to assignment. The wishes of a client must always be honored — such as the beer advertiser who insists that between each shot, all beer glasses must be emptied, washed in a chemical he supplies, and rinsed in distilled water before being refilled for the next picture. The idea is to avoid "fish eyes," the unwelcome bubbles that appear when a glass or tap isn't truly clean.

Brewers are also extremely precise about the size of the head they want on their beer, and that can cause an assistant's chores and a photographer's concerns to be rather outlandish. Here is where a keen eye and a steady hand are essential. For one ad campaign, Pell was photographing seven glasses of various shapes and sizes all meant to contain beer with similarly desirable heads. Pell required four different people to pour the beer into the glasses at staggered intervals and then get out of the way so he could shoot the picture. The consumption of food and beverage in commercial photography can be immense. Pell and crew utilized seventy-five bottles before getting the desired shot six hours after they'd begun.

Pell has been generous with assistants he has had in the past. One fellow, dispatched by a mutual friend, arrived with "an exciting portfolio" at a time when Pell didn't really need another assistant. But the man "couldn't get himself arrested, he couldn't get himself a job." Pell put him on a minimum salary, let him use the studio and equipment whenever Pell himself wasn't using it, and at the end of six months the man "had a portfolio that was absolutely beautiful."

Pell warns, however, that "the problem with assistants is you try to help them. I worked with one who didn't know anything about photography. I taught him and he became proficient." Pell pauses and smiles wryly. "He was a good deal younger than I am. He retired eight years ago; I'm still struggling. If you have a good assistant, you can be sure he'll leave you."

The photographer has also seen the other kind of assistant, who is perhaps more uncommon — the fellow who is happy with his current lot and is disinclined to being the master of his own fate. "I knew of two assistants who for practical purposes could do the assignment," Pell recalls. "I used to work for a studio specializing in room settings, where an assistant would learn the technique of lighting rooms and would supervise construction of a room with carpenters. The assistant would light it, the decorator would prop it, and the assistant would be at the camera to make sure the pictures were centered from the camera point of view. I only made final refinements. He would also have taken a reading and set the exposure." But that was as far as it went with this assistant; he avoided the final picture-taking. "I guess it had to be a psychological problem," speculates Pell. "He felt secure, without responsibilities."

Pell voices a certain wariness about reliance on assistants. "There's a danger to depending on them. If you make a mistake yourself, you know who to blame. If he takes the wrong reading, you're still at fault."

"In most cases, I have use of an assistant in a negative way," adds Pell. "On location, they *have* to be

right. You can't do it over again." He is not particularly interested in an assistant "doing anything that has to do with composition or lighting of the picture. But they can do the physical work — go up and down the ladder."

SOME OF THE FOOD arrangements in Pell's pictures are triumphs of construction as much as anything else. A cornucopia of fruit or vegetables is placed in a manner that defies both logic and gravity. How do they stay so perfectly in place? Well, it isn't glue, swears Betty Pell. In a mountain of food, the loftier edibles in the background are skewered in place, with the skewers thoroughly disguised and unseen. Handling such long needles with such consummate skill brings to mind a picador, or an acupuncturist.

Betty Pell trembles when asked if any artificial means are used to achieve the succulent effects in her husband's photographs. In almost every case, what you see is what you get with the Pells. The most Betty would do to touch up strawberries is paint them with water, not Red Dye No. 2. She does believe in "a constant glazing with something edible," such as a coating of Wesson Oil on a turkey.

Some of the occupational hazards of food photographers and their staffs are the same as those of household cooks. If you have trouble keeping your souffle from falling, take solace in the fact that even the experts don't have a way of preventing such a horror. In this case, while the exterior of the souffle remains a souffle, the interior needs a bit of doctoring for photographic purposes. Betty Pell suggests that a deflated souffle can be rescued by "cutting off the top and stuffing anything in the middle — paper toweling, perhaps — to keep the top from collapsing."

Baking seems to create severe problems for home economists. Ask Betty Pell what drives her up the wall and she'll answer, "Pancakes. They might look good to eat, but not to photograph. I've made hundreds to get one good one."

There are a number of things people involved with food photography have to be cognizant of that the rest of us food-lovers can ignore. For example, to properly show any kind of effervescent tablet, be it Alka Seltzer or Fizzies, you must make sure it is toward the front of the glass; if it isn't, the liquid will be cloudy and will obscure the tablet.

When a bed of ice is involved, says Pell, "You have to light the ice from underneath to get its character. When you light it from above, the light shows through." And obviously, this is another instance when

the photographer must work fast; under studio conditions, the life of ice is brief.

Pell holds up another ad, this one for toothpaste, with a joyfully grinning model extending a hand which holds a toothbrush. It is in fact two separate shots photographed to scale, he explains. Lacking three dimensions, it "would be impossible to get the relationship of the hand to her head right" in one shot. As a result, the hand and toothbrush must be "stripped" in, meaning that a craftsman who has the precision of a surgeon must cut out the image and superimpose it onto the existing photograph of the model without leaving a trace of his work apparent to an unknowing public. In advertising, "stripping" is quite a common technique.

Betty Pell warns photographers, stylists, home economists, and assistants that certain foods provide additional problems. When purchasing hams, for instance, "You don't know what fat will be inside," and you may be stuck with a not-at-all photogenic slab of meat. On other occasions, she has had to buy as many as ten lemons to make sure she can get one that when sliced in half, does not reveal a proliferation of seeds. There's one consolation in all this, she says. Typical clients aren't about to pinch pennies. "They don't mind money at all. You can spend anything."

MICHAEL O'NEILL

IN HIS MID-THIRTIES, still-life photographer Michael O'Neill stood at the head of a $500,000-a-year business he had built up over a decade. But he was starting to make a bold and rare career decision. He was deemphasizing his still-life work (although not totally eliminating it), and moving into portraiture and travel photography. His portrait work is now a fixture of the *New York Times Magazine,* and his portraits and innovative still lifes frequently appear in *Life.*

A beginning photographer has to be aware of a financial reality that changes drastically and frequently. As O'Neill explains, "It used to be that a rep got 25 percent of what came in, and if a photographer got as much, it was a properly run studio." That was in the early years, he observes, leaving the distinct impression that it's difficult to maintain those figures today. Clearly, the $500,000-a-year figure becomes far less astonishing in light of these facts. Equipment is also becoming more of a burden on the budget. "You used to be able to buy a Leica for $200," says O'Neill, who is talking about 1970 or so. "Now it's $1,500."

A MEASURE OF O'Neill's success must be his wisdom as far as putting together a staff is concerned. "One art director told me there are very few studios where the relationships get to total teamwork and anticipation, where there's a total respect on the assistant's part for the photographer. He said he'd seen it only at Avedon, Hiro, and here."

O'Neill was an assistant for four years; the last of those was spent as Hiro's first assistant and/or studio manager. "Assistants try and move up a scale of talent — a good photographer, then a better one," observes O'Neill. "When you got to the 'Hiros' and idols, you're faced with a psychological trauma, which entails believing that you can do it better. It's rarely the case, but you have to think it."

"The applied world is like graduate school," O'Neill believes. "It is a context in the day-to-day reality of earning an income, rather than the illusory aspect of the ivory tower." Photography, he suggests, "is truly still a guild system of master and apprenticeship." None of those words are meant to be misinterpreted, he cautions. "Master is teacher."

An assistantship is essential, he says, "to understand the art form, the machinations of business. It goes way beyond the mechanics of the camera. It's more the diplomacy and the mechanics of being in business. Just because you can shoot beautiful pictures doesn't mean you'll make a good photographer." One must be accustomed, he says, to facing the prospect of being "never on schedule, always behind time, and never having enough time."

O'Neill, who began with one staff person in 1970, eventually grew to have a crew consisting of his rep, a producer, a bookkeeper, the studio manager, and two or three additional assistants. When he spoke to us, he was scaled down, "still on a sabbatical." As far as commercial work went, he claimed, "If I shoot a day a week it gets me through." His staff consisted of just one assistant.

"I HIRE PEOPLE according to their attitude," he states. "If someone's attitude toward working cooperatively was good, they could learn almost everything they need to here." They should also possess "the basic quality of aggressiveness, the desire to make it." O'Neill would be on guard, however, against "supertalented people who are in too much of a rush to do their own thing."

While his preference was for "people I could trust, who were willing to learn," the weight of his own personal preference was not much greater than anyone else's in O'Neill's studio. "If I liked them (the assistants) and they couldn't get along with other people, and the majority of the people so ruled, they were out the door," he explains. This democratic method "worked like a charm."

Because of this approach and other O'Neill characteristics, his studio saw "very little of the backstabbing bullshit that goes on in other places over who's going to outdo the next person, who's going to climb higher." But people *could* climb high at O'Neill's studio. "Some of the people who became studio managers didn't have a lot of technical merit when they came," the boss recalls. "I didn't have to hire anybody who was a high-powered studio manager so he could teach me. I didn't mind teaching, and I knew what I was doing on my own."

O'Neill, whose still-life work was largely done with an 8 × 10, had plenty to worry about without getting too involved with preliminaries on the set. "My assistants will do everything, but they do it from notes and diagrams from me," he says. Assistants would "put the elements together, build sets, and shoot color tests even with an 8 × 10. The fine tuning and shooting I did."

"THERE WERE NEVER any formulas in the studio," stresses O'Neill. Each new assignment could be a revelation for assistants. "Obviously, the assistant did everything under my guidance," the photographer notes. "The education they got was fantastic." There were few other studios where more advanced techniques

© 1981 Michael O'Neill

assistant does have a brainstorm, he should remember that any such stroke of genius should be applied for his boss's benefit.

Paul Christenson, Rod Cook, Hashi, Cynthia Johnson, and Marti Umans are a few of the assistants who have graduated from O'Neill's feifdom to become photographers in their own right. There was certainly plenty to learn in his Broadway studio. O'Neill might have four assistants on staff, and he might be going to four different cameras in the course of a single day, shooting tests and making corrections in one place while sets were in preparation elsewhere. "Assistants would be stratified according to how long they'd been here," notes O'Neill, and it was always expected they would grow in the position. "There was always an upward mobility," the photographer stresses. At the bottom end, there always had to be "somebody to get coffee and run errands." Nobody, however, was treated like an outsider; O'Neill never discouraged contact between assistants and the art directors, account execs, and whoever might pass through. "That's pretty much insecurity," he says of photographers who minimize such contact. "I didn't mind. It kept them off my back. I didn't feel threatened."

"Assistants' heads are oriented to six months to a year in one place," O'Neill has found. Recently, their tenure would be prolonged, however. "I made more of an effort to keep the group together. I paid them well. I took care of them." A studio manager, for example, got $300 a week plus overtime, pension, profit sharing, and Blue Cross coverage. "It made it a good job," he insists.

"When I was an assistant everyone was against hiring women assistants," recalls O'Neill. "I've hired them since the very first couple of years in business. I've had two women studio managers; sometimes I've had three women assistants at one time."

He doesn't buy any of the arguments against having females on that job. "I don't think there's any difference at all. Women's rights, cranky periods, the sexual attractions that crop up here and there, and they're not being strong enough — that's a crock of shit," he says of the common excuses. O'Neill's one qualifying statement: "If you've only got one and you're traveling all over the country, she'd better be a strong lady."

No one is infallible, especially an assistant, states O'Neill. "I've shot jobs that came back black because the camera wasn't synced, and exposures have been way off because strobes were set improperly." He adds, "Every assistant who's worked for me has at least once blown something heavy. None made the same mistake again."

Alertness and arithmetic ability are absolutely essential in assistants, suggests O'Neill. "That person has to count frames so I'm not pushing the button down on

were being utilized. "In the last year, I began to use multiple upon multiple lighting arrangements to create the illusion of one lighting source," O'Neill explains. "The math ratio and balance became very complicated." But what an assistant learned about lighting was valuable and unprecedented.

"Imagination is rarely important when there is a time-bind problem," says O'Neill, but he adds that a photographer will be gratified if "an assistant can come up with a solution to a *component* of the problem. I don't think people very often like to see a major problem solved by someone they've hired." But it is acceptable for an assistant to make "a contribution to the resolution and the process of getting things done."

O'Neill understands the complexity of the dynamics between assistant and photographer. "The assistant is trying to keep the photographer on his toes — a challenging process is going on." In some small measure, the assistant is "validifying his own need to go out on his own. Imagination is terrific," concludes O'Neill, "but it has to come with the right attitude." If an

Henry Davis & Associates, Art Director Henry Davis, Photographer: Michael O'Neill (liquor bottle)

nothing. Who knows how many brilliant shots went down on the thirteenth frame of a Hasselblad?"

HE WILL USE 35mm or Hasselblad for the bulk of his portraiture; 8 × 10, he believes, gives a look that is "very specific," which he seems to use as a synonym for constraining. And he has discovered "It's much more exciting working with people." Doing two still-life jobs a day five days a week for a decade, he frankly admits, "I got bored."

"In the best photography, the key is the use of light and the graphics," O'Neill stresses. "The tricks are like dozens." For example, those watches standing on their backs with bands so perfectly cylindrical and the clockfaces pointed up to the sky are in fact glued to a table surface, and the band is so round because unseen wires are holding it in that position.

One of O'Neill's most famous performances is the photography for the ad that features two stately mansions at dusk, with the lord of one visiting the squire of the other and inquiring, "I was wondering if I could

possibly borrow a cup of Johnnie Walker Black Label." The ad is visually striking, humorous, and altogether effective.

In this shot, however, nothing is as it seems. The ad was actually a composite of six separate pictures. The two houses, so close as to seemingly provide an intimate glimpse of milady's private chambers next door, are in fact miles apart, and one of them is a school. The lush well-manicured lawn of the "neighboring" manses is in reality a golf course. The golf course, the sky, the house, the school, the people in front of the school, and the trees around the two buildings were six strips put onto the same dye transfer.

That wasn't the only logistical problem to surmount. By the time O'Neill was able to photograph one of the buildings, the sun was on the verge of disappearing. As a result he had to "paint" the building with light. The object and the frame of the camera remained constant as an assistant moved a strobe from one spot to another over the building. In this case, the strobe was triggered to provide illumination in twenty different spots. By this method an entire edifice could be lit uniformly, or with whatever variations are deemed desirable.

PHOTO ILLUSTRATORS

WHAT PEOPLE in the trade refer to as "photo illustration" may seem to be a broad term. It is meant to be distinguished from fashion photography or from the kind of still life shot that is a straight pictorial representation of a product.

Photo illustrators attempt to convey a particular idea about their subject, or to discover some unusual milieu in which an aspect of that subject is best represented. The shot on the cover of this book — bathtub in the desert — is an example of this kind of work, since the notion of "wet" is made more emphatic by its juxtaposition with "dry."

Photo illustrators tend to go on "safaris." Much of their work is done outdoors, with loads of equipment, ambitious sets, and sometimes complex lighting arrangements. Although photo illustration is labor intensive and capital intensive, it may also be one of the most creative areas of photography. Photo illustrators approach their subjects in a rather elliptical way at times. Besides the obvious, straightforward representation of a product, there are a number of <u>less obvious</u> ways of treating it. The photo illustrator has to come up with one, and it had better be brilliant and original.

Photo illustration often embraces aspects of both still life and portraiture. There may be people and products in a shot, and they all have to look good. If it all seems very challenging — well, the top photo illustrators wouldn't have it any other way. The very innovative photo illustrators who speak in this section do not lead mundane lives. The range of their work is so vast; let <u>them</u> explain it to you.

KLAUS LUCKA

KLAUS LUCKA went to photo school in Germany before serving his two assistantships. The first was with Malak Karsh of Ottawa, a still-life cameraman and the brother of the internationally famed portraitist Youssef Karsh. The second was at an advertising studio in Montreal. He was a year at the first place, six months at the second. Looking back, Lucka believes, "all were too short. I was just too quick." To really get his own studio going strong thus "took a lot longer. I made mistakes," he confesses. He was not as sharp as he should have been from a business point of view, he believes; he could have used a greater depth of technical information. He might have avoided "not handling jobs as professionally as I should have." Pausing, and grinning sheepishly, he shouts, "Goddamit, I wish I were an assistant to myself now!"

Whatever problems Lucka had at the outset have long since been obliterated. He has been in business now for fifteen years, and today he operates a studio that brings in over $1 million annually and has lately expanded to take on video projects. "I don't think there's any other single photography studio that's billing more than that in New York," Lucka maintains. He makes sure his name gets around; he estimates that his annual advertising budget is over $30,000 ("This business is not any different from any other business"). But far more than that, his success is based on professionalism, on an ability to handle very ambitious production needs, and on an ease at working and relating to human beings. "We do a hell of a lot of cigarettes," he admits, but even tobacco is not as constant a factor in Lucka's work as people are. He is able to make folks look like they're having a swell time *because of* the product, whatever it may be.

Lucka estimates that only 30 percent of his work is done in the studio; his location shooting includes a good amount of European travel. Therefore, there would be major problems if the personality of his assistants clashed with his own. "You're more with an assistant than with your wife," he declares. "You're much closer with them than anyone, especially the first assistant."

LUCKA USUALLY HAS three assistants, although when he was interviewed for this book he had just two. His first assistant, who must have an extensive background of technical know-how and experience, receives about $300 a week. The second assistant gets perhaps $200, and the third about $150. Lucka is quick to point out that thirds, who can be purely beginners, have worked their way up to being firsts.

He began his business with a $375 bank loan, but Lucka's people-oriented productions now may require him to spend over $20,000 on arrangements and supplies before taking a single shot. His productions involve a great deal of equipment, and one thing he needs in his assistants is common sense, a not so common quality. "Assistants are usually young, and it's hard to find common sense in a twenty-four-year-old kid," he feels. "They're so naive they think the world is at their feet."

One of Lucka's pet peeves is what he calls "jumpers" — guys who go from one studio to another after just a few weeks or a couple of months at each place. "I refuse to hire anyone like that," he affirms, and he doesn't think it's all that healthy for an assistant either. "He'll see how people shoot different things," concedes Lucka, "but he wouldn't learn the background of each place."

That is not to say that Lucka doesn't believe assistants should work in more than one studio. He believes very strongly that they should, while at the same time demonstrating some responsibility to their employers. In fact, Lucka will often tell a trusted assistant who's leaving, "Everybody does things differently. You've got to work with someone else."

Lucka says, "I'm hard sometimes on assistants. It drives me crazy if I have to tell them things too many times." He also is no particular fan of freelancers. "They're lugging equipment around, but they really don't know what's going on."

"I never have anything to hide," claims Lucka, who is one of those photographers without qualms about passing information on to his assistants. "By the time they're to where I'm at, I've already been there long ago." Some of his studio practices truly make an assistantship a kind of formal education. Lucka keeps a very comprehensive lighting book, for example; his assistants enter into it diagrams of the lighting arrangements of every job they do. In this way, says Lucka, they retain a strong impression of how different situations are handled.

Lucka makes an arrangement with his assistants, allowing them to develop their own film at cost, and he supplements their salaries with a stipend they can use for their own photographic experiments. Encouragement is built into his system. The assistant can borrow against the subsequent month's stipend, but if he doesn't use a particular month's amount by the end of that month, the remainder cannot be carried over. It is lost.

LUCKA'S CHOSEN CAMERA formats are 35mm Nikons, Hasselblads, and a 4 × 5. He even drags the 4 × 5 with him on location, and he has made his own modifications on it. He built a special shutter which

AGOSTO 1975—L. 1500

L'UOMO
VOGUE

NUOVE PROPOSTE
PER UN NUOVO
MODELLO DI VITA:
PER VESTIRE PIU'
SEMPLICE E NATURALE
GLI ABITI DA LAVORO
LE MAGLIE
ARTIGIANALI

I BEST-SELLERS DI
SAINT LAURENT

TUTTOTRICOT:
70 FOTO DI PULL
PER CAPIRE
COM'E' LA NUOVA
MAGLIERIA

SCEGLIERE LA
CAMPAGNA:
CHI E PERCHE'

JACK NICHOLSON

L'Uomo *carried Klaus Luckas's image of a mysterious and macho Jack Nicholson.*

An assistant will sometimes find herself, or himself, doing funny things. Lucka's photography for a campaign introducing Chrysler K cars was a "Super K" takeoff on the Superman theme. The model was shown only from the neck down and the waist up; thus the semi-casual attire and a little trickery with his necktie were possible.

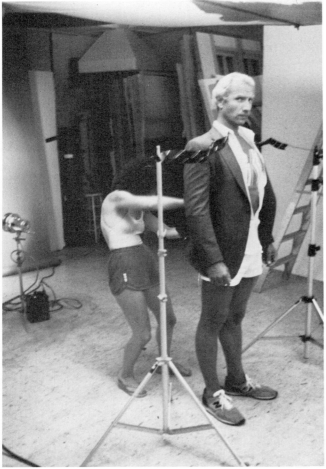

Klaus Lucka, Photographer

allows him to shoot a figure in blurred motion, culminating in a clear image of the subject's frozen action. That isn't revolutionary in itself; the difference is that Lucka has developed a way to take these shots not just indoors against a solid one-color background, but outside against any kind of background.

He is obviously a technically adept photographer, and although he doesn't make a major point about requiring an assistant with a multitude of skills, he doesn't seem to feel such skills are so hard to come by. "An assistant should have common sense about carpentry and electricity," he maintains. "I don't think there's anything to using a hammer and nails." He adds, "If you're a photographer, you need to know how to solder. You're faced with these situations." One never knows when an extra amount of rapport with mechanisms will save the day, he has learned. During his assisting days, Lucka was in the frozen Canadian north, "2,000 miles away from anywhere," when a Hasselblad broke down. Few Eskimos or sled dogs can repair 2¼

cameras, so it was either head back to Montreal in defeat or fix it himself. He fixed it.

"Everybody becomes very close in the studio," notes Lucka. "It's like a family." His first assistant delegates the work to the others, but "it's very important they work together." One time, the staff's closeness led to a bizarre turn of events. They "knew how much money I was making," Lucka recalls, and, in resentment, "everybody turned against me. I had to let them go."

LUCKA HAS HAD women assistants. "There were some good ones [among them], but not as many as guys." Whether he will hire female assistants depends on the makeup of the rest of the crew. His nine-member staff includes a full-time stylist, and he tries to "keep an equal balance between men and women on the staff." That may mean that if the stylist, the secretaries, and just about everyone else is female, the assistants won't be.

An unskilled person does have a chance to join Lucka as a third assistant. The number three person must be "a devoted hard worker. You have to do a lot of crap. I don't like anybody loudmouthed, but there are a hell of a lot of people like that around."

Although the bulk of his photography involves human subjects, Lucka says his assistants won't really have much in the way of contact with the "talent." He observes, "Often talent doesn't come on the set until the last minute before the picture is taken. The only time the relationship [between assistant and outsiders] is important is when the job's away for a long time." In those cases, one's mastery of social amenities becomes paramount. Lucka had to let one assistant go because "he just picked fights with everyone."

Assistants' resumes come into Lucka's office in bunches. He mentions his discovery that Rochester Institute of Technology graduates have a habit of sending fairly ambitious and slickly produced foldouts. "I just want to know the facts," Lucka notes in perfect Jack Webb fashion.

Lucka will look at portfolios to see if assistants will "have an interest in what's going on and an understanding of it." He wants them to "take a personal interest in the job, not just be workers." What Lucka wants most of all, if he is looking for a first assistant, is someone of significant tenure. Leafing through his stack of resumes during the interview, Lucka was particularly gratified by a young man who had spent fourteen months — a good bit of time — as a first assistant to a major New York commercial photographer.

No one should think, however, that he can pull a fast one on Lucka or any other photographer whose eyes and ears are still open. False resumes will get you

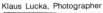

Klaus Lucka, Photographer

nowhere; in one instance Lucka discovered a genuinely "fishy" credential. The applicant claimed to have been a first assistant to, let's say, Joe Dokes from March 1979 to September 1980. Impressive, perhaps — except that Lucka happened to be very familiar with Mr. Dokes' first assistant during that period and it wasn't this guy. There would be no job for that mendacious character.

IN MID-INTERVIEW, Lucka got on the phone with a former assistant who is now a photographer himself. The boss wanted his former charge to tell the interviewer how rough he could sometimes be, but the other fellow (call him Tom) didn't really think Lucka was a candidate for villification. The worst he could say was that for part of the year he'd been with Lucka, the photographer "had a habit of not getting a second assistant." Tom remembers "five weeks of solid work" with no letup and understandably frayed nerve endings, at the end of which, as is "human nature," Lucka would yell a bit. But the genuinely appreciative ex-assistant called it "a pay your dues situation that paid off in the end."

Tom was not as kind in his comments about some of his other former employers. "I know all of the mistakes, because I've seen five famous photographers make them." He lists the names, two of which I have heard other assistants speak of with similar distaste.

Tom was low man in the studio for one fashion lensman, and once committed the unpardonable sin of asking his boss if he'd like a cup of coffee. The photographer slowly turned to him with a look of fervid loathing. "NEVER talk to me!" he thundered. "Talk to my first assistant." Tom considered that a fairly ungenerous attitude in view of the fact that "I'm working for him, he's making $2,000 a day, and I'm making $15."

This particular photographer "could not care if you were green or blue," Tom continues. "A friend of mine worked for him for three years, and asked him if he'd come to his wedding. The guy's answer was, 'I never liked your wife-to-be.' The assistant retorted that he wouldn't be back on Monday. The photographer had to close the studio down for three weeks."

Another photographer Tom worked with found it necessary to have his assistant "drag his entire studio [all of his equipment] to every shot, and he only uses a little bit of it." This same menace "takes pleasure in getting the client standing next to him and laughing when I trip over a cord." Rather than be thankful for dedicated helpers, this photographer made it clear to Tom that "if I didn't take the assistant's job, ten others would have it." Tom understandably came to prefer more personal relationships between employer and employee. A photographer, he believes, would do well to "take the assistant under his wing and really respect him. Get involved with the assistant, don't alienate him."

JIM SALZANO

THE FIRST MOMENTS spent in Jim Salzano's Fifth Avenue workspace give a vivid indication of just how much trust he has in his assistants. A print advertising campaign requiring eight very diverse characters was being launched, and models of all shapes, sizes, sexes, and ages were streaming in and out of the studio. A Polaroid test shooting of every one of the aspiring models had to be taken. And all of the tests — dozens, it would seem — were being taken by Salzano's assistants, a man and a woman. "There's just no time," Salzano explained. "I just want to see how the models do, how they relate to the camera." Obtaining the necessary photographic evidence was responsibility he confidently delegated to his helpers.

Salzano, who has handled people-oriented accounts for KLM, Travelers Insurance, and Barney's clothing store and who also specializes in corporate portraits for annual reports, attempts to achieve a true rapport with his assistants. "That's an attitude I got from my father," he notes. "He said there would be no prima donnas in his family."

SALZANO'S YOUTHFULNESS may have something to do with his close camaraderie with his staff; in his early thirties, he is not much older than the people who work for him. But his sense of his assistants as colleagues is quite genuine, and few photographers are as anxious to boost the careers of their hirelings. "I encourage people to shoot," reveals Salzano. "I have some small clients and I sometimes let my assistants handle those jobs."

In an unofficial manner, he has acted as a kind of "rep" for his trusted aides. Two of his former assistants have gone into business as still-life photographers; one of them had been an assistant *with* Salzano at another studio before Jim went off on his own. Both of these still-life specialists were encouraged to use Salzano's studio for whatever shooting they needed to do, and Salzano himself would check their work and then call art directors he knew to ask "who do you have doing still life?"

The fact is that Jim Salzano doesn't do a lot of still life himself, so by bolstering these two assistants, he was not really creating competition for himself. Would he have behaved the same way if they were doing the same kind of photographic work he was known for? "Yes," he responds after a bit of hesitation, adding that a woman who'd just left his staff fell into that category.

"There is a funny feeling about it," he admits. "It's the kind of business this is. You're here today and gone tomorrow. It's not as true of my part, but in fashion particularly they use you and then that's it. People like

you now, but if there's this ingenue, what happens then?" Yet he affirms, "I'm confident about the photographs I take. They're unique to me. If people want that, they'll come to me."

SALZANO HAD DONE photography for his high school yearbook and his college literary magazine, but he was a chemistry and biology major planning to be a doctor when he discovered at St. Peter's College in New Jersey that he hated chemistry. The summer after his junior year he had no job, no money, and no girl friend, but the pantomime act he did on the street between Carnegie Hall and the Russian Tea Room was called the best free show in town by the "Best Bets" column in *New York* magazine.

A commercial film producer caught the act, introduced himself to Salzano, and later ended up hiring him as a $40-a-day production assistant. Salzano spent about a year in that capacity and was striving to earn an assistant director's card when he admitted his dissatisfaction to himself. If he couldn't be the director — the boss — he didn't want any of this. He wanted to do still photos instead.

Over a period of two years he assisted four photographers, with Joe Toto, who does "the same type of thing I do," being his most important mentor. Salzano has now been in business for himself for six years.

He has always preferred to have two assistants on staff, but he emphasizes that "there really is no first and second assistant. I am the person both will deal with. It's a democracy. I'm the president. The other two have equal standing."

"Women are still a minority among assistants," he observes. "They sort of have to overachieve to prove they're as capable as men." The result, according to him, is that "women generally do a better job," and don't seem offended by the more meager tasks. "I get lunch made and coffee made" willingly by female assistants, he suggests. "I did that when I assisted. Some guys come in here and say, 'I won't make coffee.' Listen, *I* make coffee; *I* take out the garbage. I wouldn't ask anybody to do anything I wouldn't do. Everybody does everything."

There are, unfortunately, still some restrictions involved as far as female assistants are concerned. "I'm married and I travel a lot," Salzano says. "A lot of times the client won't pay for two rooms." He adds, "It's a very gossipy business." He makes it plain to women assistants at the outset that they may be left behind on his sojourns for just these reasons. In individual cases, there *may* be other mitigating factors. It would, for example, have been totally impractical for

Salzano to have brought a woman assistant on an assignment in Saudi Arabia considering the limitations placed on the movements of females there.

Salzano, who uses "Hasselblad mostly and some 35mm," takes Polaroids of anyone who comes in looking for an assistant's job; it is an idea he got from his old boss, Joe Toto. It helps him "remember what they look like and see how they react."

Although he has a sheaf of resumes an inch thick, Salzano usually prefers personal recommendations when he's filling a staff spot. "I try to get someone who directly knows someone else. There is a lot of expensive equipment here, and I give a lot of responsibility." There is a great deal at stake every time a staff selection is made.

He will "always need one person who, when I'm out of the studio in an emergency, can print and evaluate a print, and I can come back and look at it and send it out to the client." (No picture leaves the studio without Salzano's personal okay.)

He is among the photographers who believe personality is the most vital factor in picking assistants. He looks for someone who is "courteous, bright, funny. Humor is important to me, for generally pleasant working conditions."

ESSENTIALLY, SALZANO is looking for folks he's not going to mind being with twelve hours a day. "People who've worked here have come in the first time and said 'I love the studio, I love the furniture, where'd you get that poster?' A conversation starts; you get to know someone."

There are certain technical questions Salzano will ask an applicant, and by their responses he "can tell whether they're willing to put themselves out the way you want them to."

"Another question is 'Do you take any drugs?'" he adds. "I put it to them very plainly — 'Would you ever be high on the job?' As wild as this business is, it can also be very conservative. I don't want people to see me as 'stoned out.' Your people are *you*. I take full responsibility for everything. If an assistant screws up, I take the blame."

Salzano states frankly, "I don't like them to be here any longer than a year and a half. I wonder what their goals are if they're here two years or more. I don't want a lifetime assistant. It kind of depresses me that someone stays that long."

"Essentially, my belief is there's a job to be done," he concludes. "In the Orient, the commanders of the battles stood right up at the front line with their troops. I feel like someone who stands right up there in

the battles with the people. I don't sit in a chair and say 'Move this.' If everybody does their job, there's no need to overadministrate, to yell and scream."

During the interview a dashing gent, probably in his fifties, comes in, chats with Salzano, hands him a brochure, and leaves after a few minutes. The brochure, it turns out, is his model card; the man had come to New York from Boston, and Salzano had given him his first modeling gig in the big city. The finished product is featured prominently on the model card — a shot of the man in a very nice suit, standing in an assertive posture by his executive desk. By hooking up a strobe behind the model, Salzano had framed his head in extremely bright light — a heavenly glow, perhaps. "They wanted someone authoritative, almost god."

SALZANO OFTEN augments his regular staff with freelance assistants, who can earn between $50 and $80 per day (a full-timer gets $150 to $175 plus bonuses, overtime, and days off).

For a Barney's men's store ad being produced at a townhouse on Manhattan's East Side, he employed four assistants. There were more than enough tasks for four persons on the job, as he described it. Someone had to drive the van, and there was an enormous amount of equipment to unload and set up. The interior of the room had to be lighted, but in this case, the most challenging and perilous duty involved climbing out a window and rigging up a strobe that would project atmospheric light into the room from outside — possibly like the sun might have done if the sun could always be relied on to cooperate.

For this shot — a black and white newspaper ad featuring a distinguished father and his piano-playing daughter — Salzano and his crew may have spent three hours setting up. But when the session begins, "You only have two hours with models, and you have to work fast." Having at least four pairs of helping hands would appear to be crucial.

After replacing the picture of the townhouse wall, rolling up a rug to reveal a marvelous wooden floor, and moving the piano to a more advantageous position, the four assistants got ready to help Salzano during the actual shooting.

One assistant's main responsibility was the loading and reloading of camera backs. Another acted as a kind of script person: "Every roll of film gets notes with it like 'girl sitting by piano', just so we know later what the shot was," explains the photographer.

Another assistant literally stood by the camera and watched closely to make sure it was functioning properly — to see, for example, that the *f*-stop doesn't

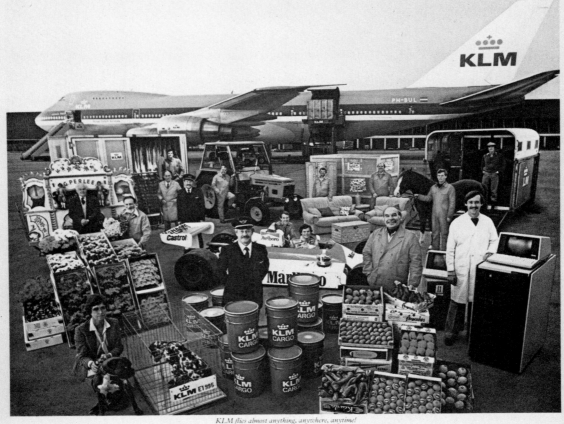

KLM flies almost anything, anywhere, anytime!

You want cargo service tailored to your needs.
You can rely on KLM.

As the world's most experienced cargo carrier, KLM will design its services to meet your needs.

KLM regularly carries everything from medicines and veterinary supplies to machinery, textiles, fresh flowers, fresh foods—even live fish. And all KLM aircraft have climate control.

KLM also offers special services like cool-containers for blood plasma. And a unique padded stall for horses. All designed for better protection and fast, reliable, door-to-door service.

KLM even set up a Publication Distribution Service, right at Schiphol Airport.

So whatever your cargo is, we will develop a transportation system to meet its special needs.

Call KLM or your Cargo Agent for more information. KLM is committed to cargo. We've been flying cargo longer than any other airline in the world.

KLM CARGO

© James Salzano

An assignment for KLM's Combi 747, a cargo and passenger plane, required Salzano to show the aircraft next to all the persons and objects that could fit inside it. Using 60,000 watt/seconds of power, 50 strobe heads and 30 strobe boxes, Salzano photographed the burgeoning cargo in an Amsterdam film studio with a Hasselblad equipped with a 40mm and Ektachrome 64 at f/16½ at 1/250 second. The plane itself couldn't fit in the studio, so Salzano used a couple of airline personnel to give him the person-to-plane perspective he wanted, then combined his studio and airport shots, which form the composite on the facing page.

move. The fourth assistant was situated by the side to give him a different vantage point of the proceedings; he might also be consulting with the stylist, and be ready to rush onto the set if anything had to be changed or moved. When the session was over, Salzano and the four assistants had "to put the apartment back the way it was."

SALZANO TAKES PICTURES of all his major studio or location setups so he can "remember how I lit something. Sometimes you forget." There are also pictorial records to be made of some fairly ambitious assignments, such as the one he did for KLM.

KLM had hired Salzano to provide pictures for an ad that would demonstrate all the things you can fit in a Combi 747, a passenger and freight plane. The capacity of the plane must have been large, because Salzano had to hire a 160-by 60-foot film studio for the occasion, and his crew of nine included three electricians.

Because of the uncertainties of Amsterdam weather, the main shot (involving the various people, perishables, and other commodities) was taken indoors. But the film studio could not accommodate a Combi 747. Salzano demonstrates how that problem was circumvented. He holds up a second picture, taken at the airport with a Combi 747 in the background; one man stands in the foreground of the picture and a second is near the plane. They will not be in the finished product; they were merely positioned to give Salzano the proper human-to-airplane scale.

In the ad that would be used, the people and objects in the studio would appear exactly as positioned. But the plain white backdrop of the studio would disappear. Instead, the Combi 747, and a piece of the sky would be stripped in. No one seeing the finished ad would know that it had not been taken out of doors on a sunny day.

The KLM assignment didn't end in Amsterdam, though, and is a good illustration of how far afield a photographer and his assistants' work can take them. After leaving Europe, Salzano and his helpers went to Saudi Arabia. There they were to shoot an ad which noted that wherever you go, there's a KLM office. The same, apparently, could be said for a photographer and his assistants.

AL SATTERWHITE

FEW MEN OR WOMEN carry on simultaneous careers as photojournalists and as commercial photographers as successfully as Al Satterwhite, who has moved his base of operations from Florida to California, and finally to New York as his reputation continues to grow. Satterwhite got an early start working behind a camera; he was taking pictures for the *St. Petersburg Times* while still a teenager. As far as an education in photography is concerned, Satterwhite swears, "My school was *there*. You made a living taking pictures. If it didn't run, you went out and tried to improve it."

Even today, Satterwhite firmly believes that the hometown newspaper is a good place for the eager young photographer to begin. "There's a lot of excitement right now in newspapers," he contends. "A lot of local little bitty newspapers run pictures big, in Sunday sections or whatever." Newspapers can make a more encouraging forum than the all-too-frequent magazine assignment, where you take twelve rolls of film and end up with only a single one-column picture.

AFTER HIGH SCHOOL, Satterwhite stayed in his home state, studying engineering at the University of Florida while doing a good deal of shooting for UPI (United Press International) on the side. Finally, he decided, "I didn't like aerospace that much and I wanted to be a photographer. My roommate said 'Are you crazy, do you know how much money you're giving up?' It didn't matter if I made $7,000 a year as a photographer. I was doing something I enjoyed."

Setting out on his chosen course, Satterwhite enrolled in photojournalism courses at the University of Missouri. He tries to temper his comments about the place with kindness, but he found out "I did everything they were teaching two years before."

He recalls, for example, being told by one instructor that he couldn't use HC 110 ("a developer, very concentrated and syrupy") on 35mm film because it was meant for 4 × 5 negatives. But, in fact, many of Satterwhite's UPI colleagues were using the stuff on 35mm regularly because of its reliability and speed. "That really pointed out the difference between practicality and school," observes Satterwhite. One problem with schools like Missouri, he notes, is that "they're not using active photographers [as teachers] anymore. After ten years, they've expired. They're not shooting the way they're teaching anymore."

Satterwhite didn't stay at Missouri too long, and after going back and forth between various schools he had an associate of arts degree after five years. After another brief stint at the *St. Petersburg Times*, he became personal photographer to Claude Kirk, then governor of Florida. "He wanted to be vice president so bad," Satterwhite recalls. In various Lear jets lent by a number of companies, Satterwhite and his subject covered about 250,000 miles in nine months. The greatest value of the experience to the photographer was what he was able to learn about color. "I shot lots and lots," he explains, "because they could afford it."

From 1969 to 1974, he freelanced for magazines from his Florida base. For the first three of those years things could have been better. "I wasn't starving," he claims, "but my income was so low I was embarrassed to report it to the IRS." After he had "shot everything in the state of Florida twice," he moved to Los Angeles, his home for six years.

ADVERTISING WORK became a big part of Satterwhite's professional life in Los Angeles. "Florida had zilch," he notes, although he did get his first national account while still living there. In Florida, his interest in advertising was sparked because "at that time I was seeing images in magazines by people who were doing editorial work — Pete Turner, Jay Maisel." He assumed the pictures were editorial pickups for ad purposes, but it was clear that a new and different way of making money with his camera existed.

From Los Angeles, however, New York was "the next step up in the ad market." Satterwhite had a New York rep and the photographer was going from coast to coast, "sleeping on airplanes a lot." Finally, his rep told him to move to New York or get a new rep. Good reps are hard to find, so Satterwhite moved his headquarters 3,000 miles eastward.

He had been in New York about a year when he sat down to be interviewed. "Things are a lot more professional here," he notes. "New York is a still photography town; LA is a movie town. Here you call and ask, 'Bring me some seamless' and you get it that afternoon. In LA they'd say, 'Huh, how about next week; can you come pick it up?'"

Satterwhite is also becoming more aware of the key operational difference between advertising and editorial photography. "In advertising, you *control*. In editorial, you control nothing. It's a matter of luck, experience, and timing. It either happens or it doesn't. In advertising, it's *yours*."

His commercial specialty is location work, and Satterwhite began taking advertising assignments without having a strobe or a studio. "It's pretty easy," he maintains. "If the sun's shining, you're shooting." That level of simplicity didn't last long, however, and Satterwhite realized he had to have strobes. In 1971, on a $1,500 "little tabletop job," Satterwhite coaxed an ad-

vance out of his client and used the money to order strobes from New York. Now his equipment includes a four-foot-square bank of lights he built himself.

As HIS WORK BECOMES more sophisticated, equipment needs become much greater. Now, when he goes on the road, Satterwhite and his assistant "fit the whole studio in twelve cases." He travels with "three power packs, four or five heads, polecats, black velvet backgrounds, reflectors, tripods," and whatever else will fit. He'll also tote along two camera cases and a shoulder bag. His cameras include "two bodies with motors and two straight bodies. You always have to have at least one backup."

"Now I refuse to do a job without an assistant," Satterwhite affirms. "Anytime I say I'll work without one I end up juggling something. He can stop traffic, he can hold your lenses." What's more, Satterwhite has discovered, "I can't fly on a plane without an assistant." He needs someone to split up the luggage and the carry-on camera cases with. With such an over-the-limit load, it's tough enough for two people to flimflam airline personnel. But one? "Not a chance."

"For a long time, I didn't know assistants even existed," confesses Satterwhite. He was covering sports for *Time, Newsweek, Sports Illustrated,* and other magazines. "I'd walk around the golf course loaded to the gunnels with lenses and stuff," he remembers, and he'd note that the *SI* guys weren't carrying much of anything. They were always accompanied by these big-shouldered bearers called assistants, and Satterwhite decided he'd get himself one of those. Many magazines, however, were unwilling to cover an assistant's airfare, says Satterwhite, "so I hired a caddy. I'd pay him $15 a day, which is more than he'd make in tips." In his early days of hiring assistants, Satterwhite would give them a day rate and usually billed it back to the client. If the client wouldn't pick it up, he took it out of his own fee.

"I don't really care about somebody's book," says Satterwhite, discounting the importance of a portfolio. "I'm not looking for ego, I'm looking for somebody to get my job done."

Satterwhite suggests that an assistant may not learn a lot about photography from him; there's no time to teach or even to answer questions. But the experience will not be without value, he emphasizes. "They learn the business — where to find things, how to get things done, how to travel around the country, how to do expense sheets."

Satterwhite will pay an assistant $75 a day and use him on a reasonably regular basis. If he were using a full-timer, "he'd probably get $200 a week and inch his way up."

"I can get people who are big and brawny and stupid," he observes, but instead he is more partial to "a superservant" who is "intelligent and can think. If I say meet me at dawn and it's pouring, he's got to know what to do — if he should call me and check, and not be waiting out in the rain for me."

An assistant also needs a sense of humor. "You're shooting at 11 at night, you've been up since 6 a.m., and you didn't even have a decent lunch," is the scene Satterwhite sets. "An assistant must ask himself, 'Why am I doing this? I'm not getting rich at this job.' He's got to have the proper attitude about it."

It also helps if he knows the moods of his boss, and when that boss needs to have his feathers unruffled. "I try to be reasonable, but sometimes a tripod will break and I'll rant and rave," admits Satterwhite. "He'll come over and pat me on the shoulder and say, 'Don't worry about it, we'll fix it.' It takes the sting out of it."

Satterwhite has had the benefit of a couple of assistants who were unusually enterprising. "My last two assistants kept logs. Everytime I said something, they wrote it down — what *f*-stop we shot that job at, what lighting we used. I could say to them, 'You know that warehouse we shot with the dark background?' and they'd tell me how many strobes we had, what the power settings were, what we shot at."

Because he does journalism and location work, Satterwhite doesn't even have a studio — he shares the rent of one and keeps his bank lights and booms there. By his own estimation, he only goes after "four or six or eight" jobs in a studio each year. "It's cheaper to rent," he insists. The main drawback of lack of access is that he "would like to be able to do more testing. It's hard without it."

Satterwhite HAS been mentioned by someone else's studio manager as being a photographer who was willing to grant his assistants enormous responsibility, and his own comments reflect a healthy faith in the people who work for him. He does not have any reservations, for example, about contact between assistants and clients. "My assistants know them and get along with them. It's not a caste system. An assistant isn't some moron who has to stay in a room because he can't carry on a conversation."

"I may want to go to bed early. I've got a dawn shot," Satterwhite hypothesizes. "But the client still wants to party. I give my assistant money and the keys and say, 'See you later.'"

"I like having nice people around," he continues. "I don't buddy-buddy with them off the job, but I do

Satterwhite is pictured above in his studio with art director
John Lee Wong before shooting commenced on a publicity folder
for Puch bicycles. The finished product, unretouched, is shown
on the facing page. The gritty cyclist is superimposed against a
portion of the bike. The photograph almost resembles a painting,
thanks to Satterwhite's lighting genius.

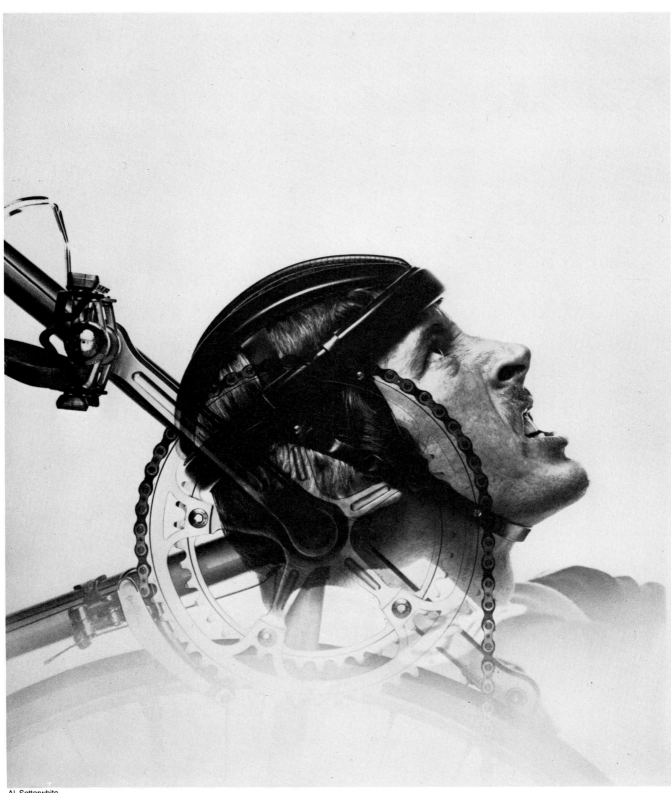

Al Satterwhite

buddy-buddy with them *on the job.*" He notes, how-ever, that it isn't uncommon for him and an assistant to go to dinner or a movie together.

Satterwhite also wants someone with a mind of his own, with some kind of personal streak. "What I don't want is 'Yes sir, yes sir, yes sir,'" he stresses. "If that doesn't end soon, they don't have a job very long."

People applying to become assistants will talk first to Satterwhite's current assistant. "In the beginning, I'd look at a book, spend two hours talking to them, and I'd have blown the whole day," the photographer explains. "There's just no time for that." If the current assistant has a good feeling about an applicant, his name will be put on a list and Satterwhite may use him as a second or third assistant when extra help is required. "That's the way we find out if he's any good," he explains. "You can find out if he's got brains or if he's just lurching around."

Satterwhite wants someone who will stick around for at least a year. "If I'm educating someone, showing him my whole operation," he says, "I don't want him to work three months and skip off to someone else."

An assistant ought to tailor his choice of employer to his choice of career direction. As Satterwhite explains, "Someone who wants to be a tabletop photographer shouldn't come work for me." But the proper profes-sional marriage of assistant to photographer can have unexpected rewards. One of Satterwhite's former assis-tants is now taking his own shots in Los Angeles; he gets the jobs his old boss is offered if Satterwhite doesn't think they're worth flying out to the Coast for.

Prepping for location shooting is an important part of Satterwhite's assistant's duties. "I tell him what we're going to be shooting and what we will need, and he packs," the photographer explains. "I don't want to arrive 3,000 miles away and find he didn't bring clamps or power cords."

SATTERWHITE IS a successful photographer to-day without having ever served a day as an assistant. Does he think it's essential for a young hopeful to go the assisting route today? "No," he answers firmly. "I know a guy who was a telephone lineman, and [now] he's working for *National Geographic.*" The fellow is also beginning to take on commercial assignments. "It's a field virtually anyone can get into," maintains Satter-white, "and that's why unions and heavy-duty organizations don't work."

"You pick your level and you do it," he says, "for the rest of your life, whether it be $50-a-day or $5,000 an assignment. You can start at forty or at eighteen. I feel like I've taken the long spiral up because I did it

the roundabout way," he says. Yet it is a journey that got him where he wants to be, and nothing leads Satterwhite to believe others couldn't take the same course.

As far as Satterwhite is concerned, there is nothing that should stand in the way of an assistant's honing his own photographic skills. "You should do it on week-ends, or get up three hours early and shoot. Just because you work fifteen hours a day seven days a week is no excuse to say 'I'm too busy.'"

There are opportunities for Satterwhite's assistants to shoot on location. If there is action involving cars, for example, Satterwhite may take the primary pictures while an assistant may shoot from another location. Even though the assistant's photos may actually end up on the magazine pages, he won't get the credit. Satter-white observes, "I've known cases of photographers having covers that were actually taken by their assis-tants." Those, it seems, are the breaks. But one consolation, and no small one at that, is that the assistant can include such a cover in his portfolio when he goes out in search of his own photography jobs.

Portfolios should always be geared to a specific pur-pose, warns Satterwhite. "You don't go in to a guy who shoots coffee cans with a book full of nudes. He'll say, 'That's interesting, but what's it got to do with me?'" Satterwhite used to "have everything from insects to fashion" in his portfolio but now, if the occasion warrants it, he'll show twenty shots of bumblebees and none of bathing beauties.

Now he's got a multitude of portfolios. "The car people see the car book, the motorcycle people see the motorcycle book, the beauty people see the beauty book. There's a bit of overlap. You show them a few other things so they say 'Gee, you do this, too?'"

AN ADDITIONAL ADJUNCT to Satterwhite's career is art photography; he expects to get more and more involved with it as time passes and is heartened by the increasing acceptance of photography as collecti-ble art. "I hope within ten years I can sell enough dye transfers to be significant. It's lucrative for photog-raphers now," he says. "There are a couple of guys no one's heard of who are making $200,000 a year."

There are many things an assistant can learn from Satterwhite, but he won't become well-versed in all kinds of equipment. Satterwhite knows very much what he likes, and in over 90 percent of his shots he uses one kind of camera, 35mm, and one kind of film, Kodachrome 25.

"I've had tons of magazine covers in 35mm," he notes. "I shoot 35mm because I know it, I know the

film and the optics and what I can get away with. Even on a tabletop, I can try lenses and move around and get if fast." A 4 × 5, he says, takes "too much time to move. You move it six inches to the left and you have to change everything."

He prefers Kodachrome 25 to 64, observing that the latter is "grainier and contrastier. I relate to 25. I really like sharpness, and I like color saturation. Kodachrome saturates, particularly in underexposure."

Like other prescient photographers, Satterwhite likes to keep himself well-covered. On an assignment for Puch bicycles, for example, he set up three cameras to capture the spectacle of models riding through puddles on their bicycles.

The use of three cameras means three different lenses, and three different positions, and Satterwhite can give an art director "a little variety, give him something to play with." He can also please himself and the folks who are picking up the tab. "I shoot real tight for myself," he reveals. But "for art directors, I give a little space. It gives them some leeway. It's their money."

It's perhaps unfair to ask a photographer what separates him from others in his profession, what would make someone come to him with an assignment instead of giving it to Joe Dokes. Pondering the question for a few seconds, Satterwhite replies, "I have a design graphic approach." He also knows how to use color most effectively; 95 percent of his pictures are color shots. "I try and inject some kind of mystery in it, some kind of design," he adds. And he is cognizant of every element of his pictures. "I don't want things in my backgrounds I don't want in them," he declares, positively bristling at the prospect of unwelcome visual intrusion. "It drives me crazy if I can't control [everything in the picture]."

JOY AUBREY

JOY AUBREY is a personable young woman who rose from lowly assistant to studio manager for Robert Dunning, a versatile photographer whose clients have included *TV Guide* and the cruise ship *Aquarius*. Her social skills are often put to the test when Dunning and crew go on location. "Some of what the assistant does is to keep the account executive and art director happy," she explains. "He [Dunning] counts on me to handle things socially so he can concentrate on the work."

For a campaign called "America Reads TV Guide," those traveling to location included photographer, art director, writer, and photographer's assistant. "When you're on location," Aubrey says, "a big part of the day is to go to dinner. My photographer saw me as the fourth at the dinner table."

Dunning, apparently, is among those who believe that an assistant's personality is every bit as important as his or her manual skills. Aubrey says Dunning "gets me to stand right behind him and talk to whoever he's photographing." Part of the *TV Guide* campaign, she notes, involved "real people," noncelebrities who were "not used to being photographed. I have to make them feel at ease."

Aubrey's resume indicates the extent of her functions as studio manager: "Photographer's Assistant and AV Preparation, Supply and Maintenance of Studio, Proofreading and Secretarial, Client Liaison and Rep, Location Hunting and Stylist, Model Booking, Media Buying, Travel Coordination and Bookkeeping." Handling such a plethora of tasks, she is undoubtedly accurate when she lists as her notable achievement: "helped the partners (Dunning and his wife) to use their time more effectively by continually enlarging the responsibilities of my job."

Dunning, whom Aubrey is quick to note is "personable himself," often elects to load his own cameras, "which is the prime thing an assistant usually does. I hand him the film and he loads the camera while I talk to the subject. His confidence in me has developed my ability to keep the rap going."

While many photographers will not hire females as assistants because of their lesser physical strength, Aubrey believes her boss "is very wise to have chosen a female." Flirting with the proper personnel can move luggage through airports more quickly, she has found.

"He treats me as an equal, and that's so nice, but I know when not to open my mouth," notes Aubrey. She has heard horror stories of photographers "whose assistants aren't considered human" and of hopeful young folks toiling for master lensmen for only $10 a day.

Aubrey, whose own pictures have appeared in *American Photographer, Dance,* and *Oui,* was looking for work as a freelance photographer when she joined Dunning's staff. She is aware of the competition even for assistantships. "If you take out an ad in the paper now, you'd get hundreds of answers," she affirms. But bring some expertise with you, she advises. "Many of the ads say 'RIT (Rochester Institute of Technology) grads only need apply.'"

Speaking of her duties, Aubrey says, "If we're going out for a few days, when we're leaving I'll get a cab, load it up, coordinate the schedules of the other people coming with us, make plane reservations, keep track of who's in what hotel room, and wake them up in the morning. The amount of details I keep in my head is staggering," says Aubrey.

In indoor situations, it's her job to "find an electrical outlet and find a garbage can, because we use a lot of film. I turn up with cushions to raise people up and keep track of things like 'is that painting hanging too low?' Dunning is aware of most of this, but I make a list and I may catch *one* thing." She also has to make sure that Dunning's power pack has power; "If you shoot too fast, it won't recycle." In many cases, Aubrey has to get photo releases from the photographer's human subjects.

AUBREY HAS DISCOVERED that an assistant is expected to know "what films exist and when to use them, how to process black and white and color, and have a slight knowledge of filtration. If he just gives you a box of equipment, you ought to be able to set it up. You should have had your hands on every piece of equipment he owns." An assistant is expected to catch on fast. "If a photographer shows you anything," she states, "he wants to show it to you only once and that's it." And an assistant should not have lofty pretensions. "Anything that qualifies as art they'd rather you keep to yourself."

If Aubrey were looking for another assistantship, she would "think up a clever little postcard and mail it to every name in *The Madison Avenue Handbook,* the Bible of commercial photography, and follow it up with a phone call. Have a calling card, have something you can leave with them," she suggests.

As far as she's concerned, a food or fashion photographer almost has to serve an assistantship first. "You've got to learn the tricks. They're not written anywhere. You have to see how someone else handles the pressures of being a photographer in New York."

"There's so much politics and gameplaying," she has observed. "If you didn't have a sense of that, how could you possibly survive?"

Note: Aubrey recently left assisting. She now works in a photo lab and is abetting her husband Steve in his burgeoning 3-D photography career.

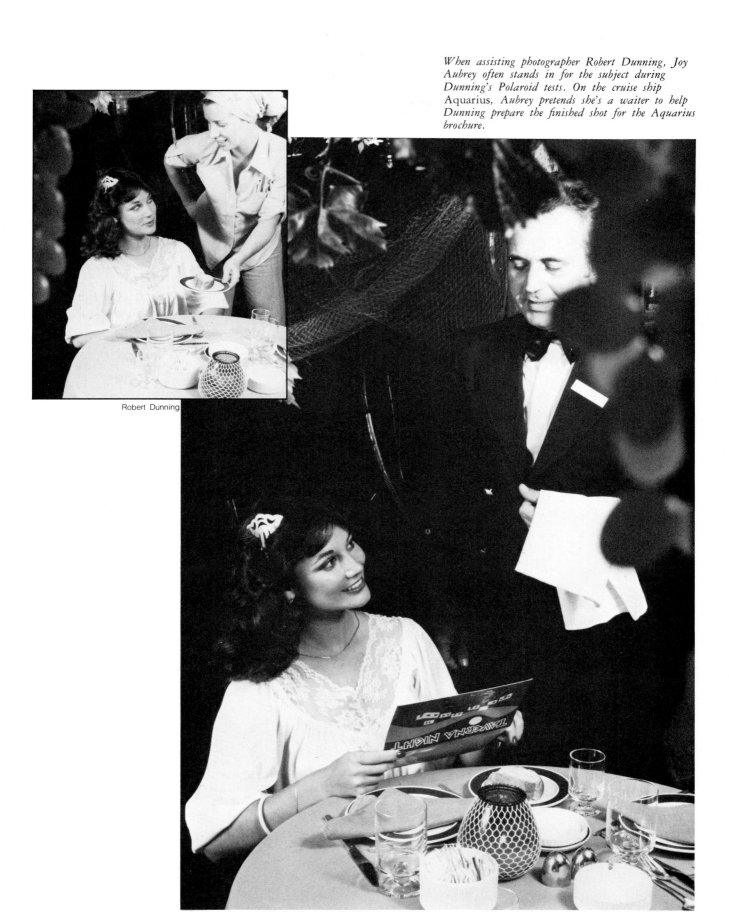

When assisting photographer Robert Dunning, Joy Aubrey often stands in for the subject during Dunning's Polaroid tests. On the cruise ship Aquarius, Aubrey pretends she's a waiter to help Dunning prepare the finished shot for the Aquarius brochure.

Robert Dunning

JOURNALISTS

"**J**OURNALISM" may be the first thing that comes to mind when we think about photography. The first pictures we ever became aware of may have been those grainy black-and-white prints in the local newspaper; the people in those pictures may even have been us. Journalistic photography has always had an enormous effect on our lives.

The black-and-white picture on newsprint is the first building block of the photojournalistic career — a career that may begin by covering a school board meeting and climax with the witnessing of a war in Central America or the Middle East. The ever-increasing demand for information in the global community makes the photojournalist a more important person than ever before. The opportunities for such a photographer, and the capabilities he's expected to demonstrate, are both expanding rapidly. Photojournalism is an exciting and growing field; it is never stagnant.

From the local newspaper to the top echelons of Time, Life, or Sports Illustrated may seem like an impossible journey, but it is a voyage that has been accomplished and can still be done today. Two of the world's top photojournalists, Harry Benson and Walter Iooss, differ in temperament and modus operandi, but are "troubleshooters" who always get the job done. Iooss, a sports specialist who also does many Sports Illustrated swimsuit layouts, may not risk life and limb as much as the intrepid Benson, who has visited his share of war zones.

Both men deliver first-quality work, usually in color. Both work with the finest equipment available, and both work fast. They both record and interpret events. Their range of subjects is great, but at all times they are supplying news and information in as cogent and complete a manner as possible.

They are at the top of the photojournalistic profession, and their work often requires the use of assistants. Interviews with Benson and Iooss should provide a glimpse at the elements that make up an excellent photojournalist, and how an assistantship might help you join the elite ranks of photojournalism.

WALTER IOOSS

WALTER IOOSS' pictures are a staple of *Sports Illustrated (SI)*, which he calls "the best weekly magazine a photographer could work for." Under its current editorship, it is not uncommon for *SI* to run a twelve- or fourteen-page photo spread, and a goodly number of those fall to Iooss. The magazine is heralded for its sports action photography, but as Iooss explains, it is by no means limited to traditional *sports* photography. "A good portrait's a good portrait," he observes, whether it be of the president of the United States or the coach of the Dallas Cowboys. "A good landscape is a good landscape," and there is plenty of that kind of photography at the magazine.

"You learn the basics of good journalistic photography," Iooss says of the *SI* experience. "You learn how to use long lenses, how to fight for position in crowds, and how to handle five-minute deadlines." Indeed, he argues it may be the *best* photojournalistic challenge extant. He mentions one longtime *Sports Illustrated* photographer who has switched to news photography for *Time* and who, by virtue of the enterprise and aggressiveness honed at *SI*, is miles ahead of the pack of news photogs over and over again.

Sports Illustrated has two staff photography assistants. "Assistant" is usually the position at which they join the magazine, but Iooss throws out a couple of names of people who have graduated from assistant to become contract photographers (a set number of pieces per year) and eventually staff photographers.

There *is* glamour for a *Sports Illustrated* assistant. Iooss has shot many of the magazine's annual swimsuit features, which appear in a January issue that is the publication's biggest seller every year, and has helped make Cheryl Tiegs and Christie Brinkley household names. In addition to the women, the appeal of the coverage is based on the remote and exquisite foreign corners which serve as the photographer's locations.

AN *SI* ASSISTANT can get the chance to travel with Iooss and the models to an unpopulated area of the Amazon River in Brazil, or to the beautiful off-the-beaten-track Seychelle Islands. Iooss remembers the Seychelles trip, when his assistant "was great. He was right over my shoulder whenever I needed him."

But the assistant did something that made the editor traveling with the *SI* crew apoplectic. The assistant, when Iooss didn't specifically need him at a given moment, was shooting over Iooss's shoulder with an extra camera. "The editor got really upset," Iooss recalls. "She said, 'If he ever publishes those pictures, we'll be sued. The models are under extremely strict contracts,'" agreements which forbid any unauthorized use of photographs. Iooss, who figured the guy was just gathering material for his portfolio, wasn't so upset about it.

He had seen assistants become the victims of someone's wrath before. "Sometimes they have to blame somebody if things go wrong," Iooss has found. "It may even be *their* mistakes which caused it. But the assistant is the one they'll take it out on."

Iooss, who shoots for a number of clients besides *SI*, also recalls, "I did a job for a company where they really didn't like the assistant. He was a good worker, but his personality grated on them." It was one of those situations where everyone existed in close quarters for a week, and the clients found Iooss's assistant made "too many suggestions and was too loud." Their adverse opinion of the assistant "may reflect on me. They may not use me again," Iooss realizes. But when asked if that would discourage him from using the same assistant again, his response is a firm "no."

IOOSS PUTS ASSISTANTS into three categories. The first, unabashedly, he explains is his best friend, a thirty-six-year-old fellow named Mike who is a sports junkie with no regular job and a girl-friend in medical school. When not assisting Iooss, whom he's known since the age of nine, Mike's major source of revenue is his frequent winnings in the New Jersey Lottery.

Mike, explains Iooss, "has no knowledge of photography. He doesn't load cameras or take light readings." Indeed, in a majority of cases Iooss isn't concerned with having an assistant do these things. "What if he loads it incorrectly?" wonders Iooss, who knows that most of the time there are no second chances at sporting events. To document most sports, Iooss brings along three or four 35mm cameras, each with a different lens because "you don't want to change lenses at all."

Despite his lack of technical ability, Mike, according to Iooss, "has actually given me picture ideas. He's spotted things." His greatest value is "an incredible knowledge of sports, a third eye, a special insight into sports, and an opinion worth listening to."

When they are together at a football game, for example, Mike has been known to state, on the basis of his instinctive feelings, that the next play will be a forty-yard pass downfield. He will reveal his hunch to Iooss, who will then be prepared to get an in-focus, nicely framed shot forty yards from the line of scrimmage. Sure enough, the next play will be a "bomb," and Iooss will have a terrific action photo.

"He knows everything," Iooss says of his friend and assistant. "I don't follow these things as closely anymore, but I'll ask 'Who's the third baseman' and he'll tell me. 'Who's his backup,' and he'll know that, too."

Sports Illustrated

JANUARY 27, 1975 75 CENTS

CANCÚN:

MEXICO'S SPLASHY
NEW RESORT

Sports Illustrated's *annual swimsuit features in January are often shot by Iooss, who helped make Cheryl Tiegs, above, a household name.*

Walter Iooss

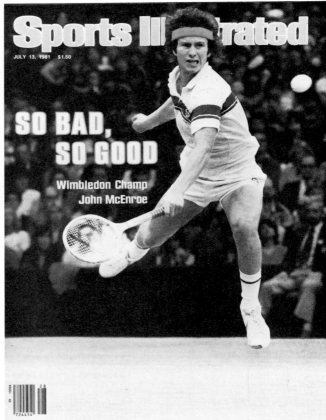

Walter Iooss

The range of Iooss' work from the fastest sports action shot to the flimsiest swimsuit can be seen in his Sports Illustrated *covers. His quick, perceptive eye never seems to miss. Iooss is shown standing in the picture at right, setting up strobes with assistant Louis Capozzola in the Philadelphia Spectrum before photographing basketball star Julius Erving for* Sports Illustrated. *This shot is from William Jaspersohn's upcoming book* Magazine *to be published by Little Brown.*

© 1981 by William Jaspersohn

80

Mike's other assets are the "mental support" he provides as a trusted friend, his constant availability, and the fact that, like Iooss, he plays tennis.

When good fortune comes his way, Iooss will share it with his pal if that is possible. His interview for this book was conducted shortly before he would leave for Florida, where he would photograph for a local client and also peddle the subject to an Italian publisher. Such double billing would be fortuitous for him, and also for Mike. With his own combined windfall, Iooss figured he'd be able to pay his pal $150 or $160 a day.

"He's amusing," Iooss declares of Mike. "He has an immediate rapport with people; he's a very humorous guy. If I'm doing something else and am away from the subject I can say, 'Mike, keep them loose.' He can talk to anyone. He'll be cracking jokes in a second." But he can tailor his demeanor to suit the occasion. "He doesn't intrude," adds Iooss. "He knows his place — if there is a 'place.' "

The second kind of assistant Iooss may use must have some technical knowledge. "I want someone who's going to be a consummate professional," he says, "who tells you 'f/8' when you're zoned in on the subject." Iooss gets a number of calls to do fashion shots that are oriented toward sports; he had done such a session for *L'Uomo* just before being interviewed. "Here's where I need an assistant who knows strobes," he explains. "I need someone who'd worked with reputable photographers."

This second category of assistant will also figure into some of Iooss's *SI* assignments, and in such instances he is encouraged to use the staff assistants wherever possible.

BASKETBALL IS the sport that presents the biggest technical challenges to a sports photographer. Iooss uses a 2¼ format camera on "sports strobe jobs or anything where you need to freeze action," and for basketball he'll mount a Hasselblad on a monopod. For this sport, Iooss stresses, "You have to have an assistant, maybe even two." A great deal of strobe lighting is added by *Sports Illustrated* to the regular arena illumination. "The arenas are pretty inflexible," notes Iooss, who observes that the design usually mandates "four box lights in four corners." If he brings two assistants to a game, he'll have one upstairs with the strobes and the other downstairs with him, helping out by the camera and watching to see if any technical problems develop from his vantage point.

Iooss is a little distressed by the normal limitations of arena lighting, and he's hoping to engineer some changes. For a planned feature about Julius "Dr. J."

Erving, he was talking about something more along the lines of spotlights, although he wouldn't want to bring the lights down so close as to interfere with the actual basketball game. But there are moments when such special lighting wouldn't create consternation — the pregame warmup, for example. "If Erving knows I'm going to be after this picture, he'll do something dramatic," Iooss states confidently.

One of the advantages of working for *Sports Illustrated* as assistant or photographer, it would seem, is that sophisticated equipment is available to aid in getting a picture that is *that much* better. When asked, Iooss acknowledges that with the possible exception of the two or three largest dailys in the country, a newspaper photographer is not going to be able to use strobes to help get the lighting effects he desires.

THE THIRD TYPE of assistant, Iooss notes, is "a guy who's a schlepper," and he is usually hired at the sporting event. "I just go there before the start, and look for someone friendly, young, strong, and willing to take orders, who'll be impressed I'm from *Sports Illustrated*, who'll be in awe and do whatever I tell him." At a golf tournament, Iooss may choose to have his equipment lugged around by a caddy, since "a caddy has a badge that lets him inside of the ropes if we're short of credentials."

At a college football game, for example, Iooss may pick out a student on his way into the stadium. Often the student is grateful for the opportunity to work and observe the game from the coveted sideline position. But their reliability can vary. "One guy at Oklahoma said, 'I want to go see someone,' and he never came back," Iooss remembers. "He abandoned me. He never even said goodbye," adds the photographer, who seemed a bit chastened by the incident.

IOOSS MAY HAVE one of the more enviable positions in photojournalism, and no doubt it would be exciting as well as educational to be his assistant. In fact, one of his January swimsuit models, a bit of a photographer herself, has begged him to let her come along and assist on some of his sports assignments. He has always said no. "You're too beautiful," he tells her. "You'll cause a riot."

Note: Iooss spent much of 1983 and early 1984 working on a 128-page color book on the Olympics under the auspices of Fuji Film. Prints from that project will be exhibited at the National Geographic Society in Washington and in seven other cities.

HARRY BENSON

WHEN *LIFE* was still in its original incarnation, Harry Benson claims, he was one of the few photographers making an excellent living solely from editorial assignments. He branched out when the magazine went under, and his current repertoire encompasses annual reports, fashion (including a long association with French *Vogue*). Nevertheless, Benson remains one of the world's foremost photojournalists. He estimates he has created more *People* magazine covers than any other photographer, and his versatility and ingenuity are very much in evidence in the newly revived *Life, The New York Times Magazine*, and many other publications. His *Harry Benson on Photojournalism* is an impressive and essential book on that subject.

BENSON HAS never had a full-time assistant. "I should have," he concedes, "but I've always been an absolute loner." He blanches at the notion of "having someone with me all of the time." But his need for an assistant is often quite pressing, and he may be working with a freelancer four or five times each week. Indeed, Benson notes, by the time this book appears, he may have someone on staff.

Many things distinguish Benson's attitudes about freelancers, but a prominent distinction is his attitude about payment. "I often pay my assistant $100 a day, never less than $75," says Benson, citing rates that are certainly on the generous end of the scale. As does any professional of his stature, Benson frequently gets calls from people who would work for him for nothing, but he would not have it that way; such an arrangement might change the nature of the photographer-assistant relationship. "I don't become too friendly with them," he states. "I don't want them to open their mouths; I don't want their opinion." This is business, he realizes. "I'm working my peripherals very wide, and I'm aware of what's going on around the room." What he doesn't want to see is an assistant who is "waiting to hustle the picture editor with his portfolio."

THE FREELANCER Benson trusts and employs most often only wants to be an assistant; he does not aspire to set up his own photographic practice someday. The fellow wishes to avoid the attendant costs and pressures and "his personality is one that follows orders." What makes him valuable, Benson stresses, is that "he knows exactly what he's there for. That covers a hell of a lot."

Benson requires that his assistants "be polite and not turn up looking like a mess." They must also move quickly, "go into a room, find out where the plugs are and get the lights up." They must also know the *extent* of their function. "I want their opinions if they see something obviously and blatantly wrong," Benson notes. "But I want them to get out of the way if the conversation becomes embarrassing," as in a sensitive and possibly even contentious discussion with an art director.

Assistants should "only talk through the photographer," Benson believes. He adds, "You want them to believe in you just a little. You don't want them there with a sneer on their face saying they could do better." And when a discussion is under way in the studio with clients, he doesn't want an assistant "agreeing with the editor, being with the other side. They've got to be with *me*."

"I want someone to be camouflaged," says Benson, suggesting that an assistant should be conspicuous only to the photographer. "I don't want them to smoke. If they're offered a drink, they don't drink."

It's also crucial that an assistant not be too fearful of his boss. "If he makes a mistake, he should tell me — right away," says Benson. "We all make mistakes. He might break something or forget to load a camera." Benson remembers being handed a Hasselblad by one assistant and being able to tell by the feel of it that it was without film.

An assistant clearly must be cognizant of his employer's working methods. "I'm often taking pictures I know *are* bad," claims Benson. It may be a technique for warming a subject up to the idea of being photographed, and an assistant shouldn't be alarmed. "In order to get to home plate," observes Benson axiomatically, "you've got to get through first base."

An assistant must comprehend the urgency of time. If Benson is photographing a president of the United States — as he has on quite a few occasions — he is lucky if he has even thirty minutes to accomplish his task, and not a second can be wasted. Indeed, on a visit to Jimmy Carter, and perhaps now Ronald Reagan, Benson may even show up by himself. A chief executive "doesn't want to think it's a big production," he feels. "He'll say 'What am I getting myself into?'"

There are other instances in Benson's work when spontaneity is most key, and the presence of an extra person might be more destructive than helpful. On an assignment to photograph Dolly Parton, he explains, "everything depended on my first introduction in terms of how far I could go." A moment's hesitation, or the slightest bit of tension caused by a company of three could cause the eternal forfeit of the effect Benson sought to achieve.

Benson isn't interested in seeing a would-be assistant's portfolio. "I don't want someone who's just a groupie and into photography," he adds. He even sug-

gests "the fact that they went to school might be a strike against them. I might be getting a smart ass."

Calls from assistants looking for jobs are screened by Harry's wife Gigi. "I feel I have the intuition to tell who Harry can get along with," she says. She wants to examine their resumes, see who they worked for or where they went to school, but more significant is their familiarity with the Balkar, Minolta, and Hasselblad systems Harry Benson utilizes. Gigi observes, "Some applicants are so self-centered that they're counterproductive. They're out there for themselves."

BENSON SAYS of a lot of the aspiring assistants wishing to work under his wing, "They're a rather pathetic little bunch. They're about twenty-eight years old and rather sad. They really want to be photographers. They should go to Dayton, Ohio, and learn to be a photographer in the provinces; learn their craft!" And although he is generous in his payment for services, Benson comments, "I would have given anything to have worked with a photographer of my caliber at their age. If I was twenty-eight years old I'd *pay* David Bailey to go into his studio for a week. I'd pay Avedon, too." He's also received calls from the children of celebrities he has photographed, kids who either just want to tag along or who have an extraordinary unrealistic view of what an assistant's job is. "They're misfits; they've tried everything," Benson sighs. "You photograph their fathers, and they want a favor."

"I know my equipment and I can tell my assistant what to do," he maintains. Before a fashion assignment, he will sit down and talk with his assistant for fifteen minutes, explaining how he wants the session to be lit. "If he can't do it, I'll tell him to go ahead and do it anyway," Benson stresses. "Every time I've been messed up on a story, it was when I wasn't assertive enough." While he confesses, "I'm still learning," he's very aware of what it takes to get what he's looking for. "Guy Bourdin and Helmut Newton — they know how to make the picture. The others, the mediocre ones, don't."

Benson believes in finding out quickly what an assistant is made of. "I like to put upon them, to test them

as far as I can. I'll say, 'You're gonna carry all the equipment, and I'm not going to carry a thing.' " He is adamant about the fact that an assistant "has to take the good with the bad." Once he called an assistant to say that their client had canceled an assignment, and there would be no work for either of them. Shortly thereafter, the assistant billed Benson for his services anyway. Benson never hired that fellow again.

Ask him about female assistants, and he is aghast. "A girl would be the last one I'd employ. Perhaps it's my Scottish puritanism. People would automatically assume I was having an affair with her." He emphasizes that he has "to get as close as I can" to his photographic subjects; to permit them to speculate as to the nature and extent of the photographer-assistant relationship would adversely affect the work. Besides, he believes, "They (females) couldn't carry the heavy equipment they've got to schlepp!"

An assistant must be totally adaptable to his employer's modus operandi. "I've worked this way for thirty years," Benson states, "and anybody who is off of it would be an aggravation."

BENSON LEAFS through two recent issues of *Life*, pointing out which photo spreads he did solo and on which ones he was accompanied by an assistant. A lengthy pictorial on treatment for shock cases, including a hospital room picture shot with a wide angle to show the full extent of activity throughout the entire room, was a solo performance. Quickness and unobtrusiveness were key factors in getting the proper selection of shots here.

For an eerie candlelit photo of a heroin addicts' "shooting gallery," Benson, of course, went on his own. He was using a 35mm camera on a tripod, but he obviously had to get in and get out with haste, as an extra outsider could only cause problems. But for a more formal portrait for a profile of bird maven Roger Tory Peterson, taken under calmer circumstances, Benson brought along an assistant. His hireling reloaded cameras for Benson, who was shooting a large quantity of film very rapidly, and also held cards to reflect light onto the subject.

PORTRAITURE

ANYONE WITH ACCESS to even the simplest of cameras has taken some type of portrait photo. Indeed, for the average person, photography's main purpose may be the chance it gives us to record the features and expressions of the people we know and care about.

Portrait photographers are interpreters of history. They capture the strength and stature of the people who shape world events. They illuminate the genius and talent of persons who produce great works of art. In more modest instances, they can demonstrate the dignity and soulfulness of the most typical and ordinary citizens.

Human beings are complex, and close photographic examination will reveal innumerable bits of information about them. The three outstanding portrait photographers in this section — Timothy Greenfield-Sanders, Arnold Newman, and Frederick Ohringer — take different approaches to their craft. They use different equipment, they study different human subjects, and they are themselves of three different ages. They each took a different route into the world of photography, and they've had different experiences working with assistants.

Portraiture is not as simple or one-dimensional as you might imagine. It's not just pointing the camera and clicking. There's much to be learned about equipment, settings, and lighting. Most importantly, a premium is placed on how well the photographer can deal with people — how he can make his subject feel comfortable and confident in front of a camera. Portraiture is an art. In this section, three approaches to that art are revealed for the reader.

TIMOTHY GREENFIELD-SANDERS

TIMOTHY Greenfield-Sanders earned an M.F.A. from the American Film Institute, but quickly tired of film-making, which required "working with forty or fifty people at the very least." He made the switch to still photography, where the relationship can more often be one-to-one, and his success has been considerable and almost instantaneous. He has mounted major portrait shows of "The Club," a New-York-based group of abstract expressionist artists, and of most of the leading art critics in America. Greenfield-Sanders has held ten one-man shows across the country and his work is in the collections of fifteen museums including the Metropolitan, the Museum of Modern Art, and the International Center of Photography in New York, the National Portrait Gallery in Washington, the Victoria and Albert in London, and the Australian National Gallery. He takes weekly executive portraits for *Barron's* and has photographed for *Vogue, Esquire, Fortune, Horizon,* and *Art News.* He was an *American Photographer* "New Face of 1983." Nine of his portraits illustrate Mark Strand's book, *Art of the Real.*

Greenfield-Sanders also has an astounding collection of antique cameras, including the Robot Vollantomat Star II, the first motordrive in history, dating back to the First World War era in Germany. It is no surprise, given his background, to learn that Greenfield-Sanders' techniques and equipment are drawn from the cinema and from antiquity.

His lighting, when he is working in his New York studio, is not strobe but what he calls "hard lights," the very bright banks often seen on movie sets. They can be 2,000 or 5,000 watts, and he admits "they get very hot."

POSING FOR Greenfield-Sanders may not be the easiest chore on the planet, but the results are uniquely intriguing. He used a six-foot-long and six-foot-high 1905 Folmer and Schwing view camera, with an eighteen inch diffused focus Wollensak Verito *f*/4 lens. It is a camera designed to shoot ten-second exposures. The pictures it takes are "sharp in the face, with everything else dropped off, and a controlled depth of field." In this quite different photographic setting, Greenfield-Sanders' subjects are concurrently patient and intense, with a strikingly deep and different range of expression. Some unexpected details also appear. After a lengthy bit of posing, the ash on the cigarette in the hand of Elaine de Kooning, a prominent member of The Club, is at least two inches long and totally intact.

Greenfield-Sanders stresses, "This camera gets a different look; it's not the lens, or the film, but the camera itself." The camera, which is operated with a squeeze ball triggering the shutter, works well with black and white ASA 100 Ektapan fitted into its 11 × 14 film holder. For color Greenfield-Sanders relies on Ektachrome 64 "or whatever I can get."

In his studio, Greenfield-Sanders believes "the portraits are a one to one thing. It's just me and the subject and that's it." On location, or shooting color fashion pictures, however, he will often acquire the services of an assistant. "I would do it all by word of mouth, not by answering a small ad somewhere," he says of his hiring preferences. "I can't do makeup, I can't do hair, and I would use an assistant to free me from loading film and setting lights if I were working fast."

He does get assignments to cover a subject for a day — he mentions, for example, a session with actor Dennis Christopher for *People.* In a case such as this, where the shooting situations are bound to vary significantly, Greenfield-Sanders would definitely hire an assistant. "I would have to be carrying a lot of equipment," he comments. "If I'd be shooting in a park, I'd need someone to carry the white card and bounce a little more light on the subject."

ATTITUDE in an assistant is important. Greenfield-Sanders would be looking for "someone who doesn't feel bad because he isn't looking through the camera — someone who realizes the assistant's job is important."

Greenfield-Sanders suggests, "The really good photographers don't take assistants off the streets. They hear who's around, or they go to the school and get the top of the class or someone who has an incredible portfolio."

He is a portraitist who always overdevelops his film to get a stronger, thicker negative image, which is easier to print from. His large-sized portraits are usually shot at *f*/11, unless he is looking for a soft focus, in which case he will try *f*/4 and overexpose.

"The slower the film, the less grain you have but the more lights you need," Greenfield-Sanders contends. For what he hopes will one day be the definitive image of Orson Welles, Greenfield-Sanders equipped a Nikon with "a very wide angle" 24mm lens and shot from 2½ feet away on *f*/5.6 at 1/125th of a second. The picture was taken on the set of the motion picture *Thief* in Toronto, and was essentially lit with the film studio's lights. He used "a soft light — a big light bounces into its box and then comes out. It's once removed." It could be further softened by employing scrims, for example. "A hard light would give severe shadows. Soft lights are more flattering," believes Greenfield-Sanders.

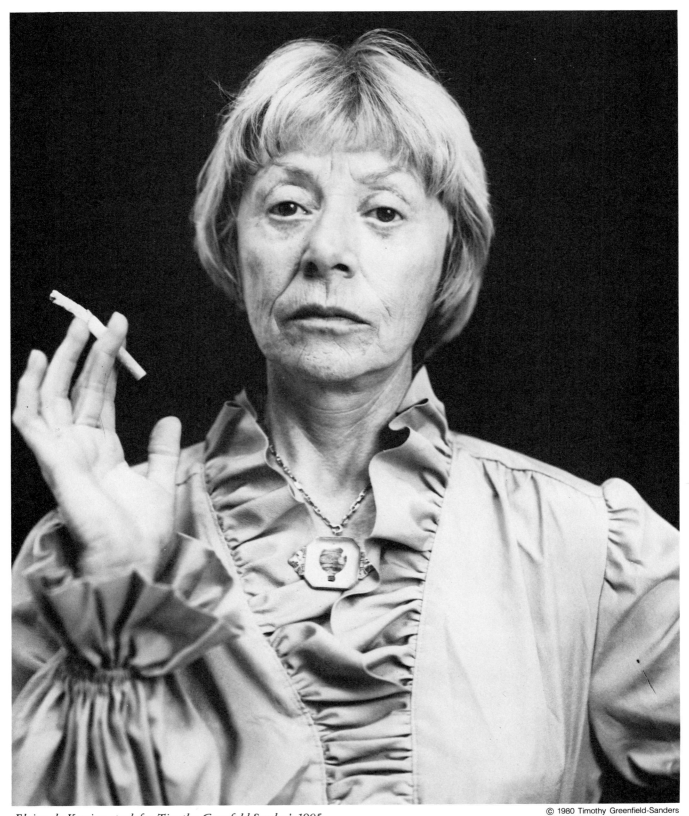

Elaine de Kooning stood for Timothy Greenfield-Sanders' 1905 Folmer and Schwing, a huge view camera with a diffuse focus lens. The camera shoots ten-second exposures and creates pictures that are "sharp in the face, with everything else dropped off, and a controlled depth of field." It also requires a lengthy bit of posing, as the ash on de Kooning's cigarette attests. This portrait is a part of Greenfield-Sanders' acclaimed series on The Club, a New York—based group of Abstract Expressionists.

TIMOTHY GREENFIELD-SANDERS

Greenfield-Sanders used a Hasselblad, a black seamless background, and a soft, single source light to make a Cecil Beaton-like portrait of The Naked Civil Servant, Quentin Crisp.

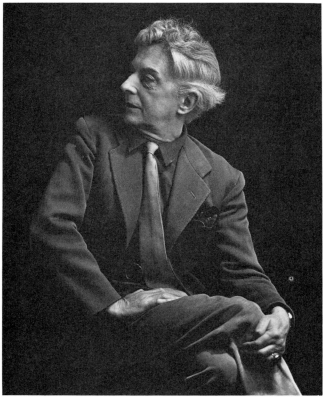

© Timothy Greenfield-Sanders

The man with the very unusual methods and equipment warns that assistants "are not going to have a career as a photographer after being with me. They're going to learn techniques that no one uses anymore, but techniques that are interesting."

Qualified assistants do occasionally turn up in the most unexpected places, however. Greenfield-Sanders told about visiting the California home of one of the country's true acting giants and the actor's wife, who is an accomplished woman with a camera. He had brought a color slide of the couple. The woman loved it, and wanted to make 8 × 10 color prints of it. So, much to the photographer's surprise, she called in her two maids, who had just prepared the lunch everyone was eating. The maids took the slide, went into the darkroom, and emerged later with two 8 × 10 prints.

"They were superb," marvels the photographer. "They were as good as any I've seen." If good help is hard to get these days, it's because some people are working at two jobs.

ALONG WITH HIS classic portraits, Greenfield-Sanders formerly did New Wave fashion spreads for the now-defunct *SoHo Weekly News*, capturing these bizarre spreads in the most stunning of colors. He preferred Kodachrome for its "wonderful vivid colors, especially beamy reds," and noted that Ektachrome tends to "flatten colors out and go a little blue." However, since Kodachrome must be shipped to Kodak for processing, he used Ektachrome "when I needed it in six hours, or the next day."

The benign expressions on the models Greenfield-Sanders used bely any inclination toward punkness, and that's the way the photographer wanted it. "Their clothes, and hair, and everything about them says it all," he explained. "I told them 'Think Inaugural Ball. Your expression should be almost no expression. Think Republican or Conservative.' "

Most of his fashion work was done with a Nikon at *f*/8 against a seamless background, which may often have been a very bright color. Whether they were closeup shots of weird headgear or a full-length shot, Greenfield-Sanders preferred to use a 105mm lens. It may seem strange to use on something that is definitely not a close-up, and many of the pictures were taken from as much as forty feet away. But he explained "105 is a much nicer lens. The problem with fifty is you get *too* much in focus. You could tell the backdrop is paper." In Greenfield-Sanders' shots, the backdrop didn't have the quality of paper at all; it seemed more like a field of pure light.

"Pushing" film is a technique he often utilizes. "Essentially you push film when there's not enough light, or you want an effect you can't otherwise get," Timothy Greenfield-Sanders explains. Pushing can be accomplished in the developing process by alternating the time and temperature. Pushing ASA 100 film to 600, for instance, can be accomplished by developing it two-and-one-half times the normal requirement.

ARNOLD NEWMAN

ARNOLD NEWMAN is a former art student (his classmate was David Douglas Duncan) who, out of economic necessity, switched to photography in the late thirties. He had his first one-man show in 1941 and his career has been highlighted by long associations with *Holiday, Life,* and *Look* magazines. Newman has also handled commercial assignments, but it is his portrait work which has contributed most significantly to his reputation as one of America's giants of photography. His stunning collections include the books *One Mind's Eye* and the more recent *Artists.* Many of his pictures are considered the definitive photographic studies of their subjects; indeed, he took the official presidential portrait of Lyndon Baines Johnson. Newman has been working with assistants for forty years.

AT THE END of 1980, Newman advertised for an assistant in the classified pages of the *New York Times.* It was only the second time he had resorted to doing so. Customarily, an assistant who was moving along will pass along to Newman information about prospective assistants he knows and respects and can recommend as successors. However, notes Newman, his recent assistants have often been non-New Yorkers and thus not so well-connected to the photo grapevine. Not being able to handpick a new assistant, Newman went looking for one.

The first time he'd taken space in the *Times*, he put in a blind ad, one that did not include his name but instead offered a *Times* box number to which resumes and queries could be addressed. This time his ad identified the Arnold Newman studio but, as he explains, "my ad was based on Avedon's idea that telephone inquiries are disqualified instantly." He would limit his considerations to those submitting detailed resumes and "a letter outlining their goals in photography."

He had spelled out very specific requirements, and he received about eighty replies. "I was able to take only one-third of them seriously," Newman explains. "I couldn't interview all of those people. My studio isn't large enough to accommodate them all."

Newman does not wish to publicize the fees he pays assistants, but they are very much at the top end of the scale. Still, he suggests that his is "not like a corporation with a huge studio" and an unlimited amount of capital to spend. "When you are young, you should be ready to make sacrifices," he suggests, and his assistants would most likely be people "young enough to be able to live on less." He doubts that an assistantship is at all feasible for a married man with two children.

Newman feels a photographer has a genuine responsibility to the person he hires, and this, to him, creates an additional restriction on the potential pool of talent. "There are problems with people who come in from out of town," he reveals. "They'll quit a job to come to New York. They're all excited, and if they don't work out, what do you do? Either the photographer is stuck, or they are." Newman will no longer hire people with out-of-town addresses. But he adds, "Once they move in to town, they're here, they're committed, and they'd be considered."

He has one other prohibition. He's not keen about people who are working elsewhere but say "I can leave tomorrow." That may be an indication of enthusiasm, but it might mean the assistant would desert him just as readily. "I refuse to interview anybody who's leaving without having given some notice, or whose boss doesn't acknowledge that he's leaving and can recommend him," affirms Newman.

An applicant is also expected to be familiar with Newman's own work. "That's not a matter of ego," the photographer contends. "I have been around a while and I've been written about, and if they know about photography, they should know that."

"My studio is fairly unique," Newman states. "Over the years I've purposely kept it small and limited the amount of work that went through it. My wife and I were talking, and came to the conclusion we could have made more money. I wanted to restrict myself to the kind of photography I wanted to do. If I had a large studio, I'd have to build up and seek out a lot of work."

THUS, ALTHOUGH Newman's reputation as a camera artist is among the largest, his staff is of merely average size. "I've always had only one or two assistants," he comments. "I prefer it that way. If you run a studio, you have to face financial realities. One is that you just can't have two or three assistants sitting around while you're doing your thing." He was employing two assistants and an intern at the time of this interview. *Artists* had just been released, and he and his assistants had to fill a demand for prints at collectors' museums all over the world.

"My assistants have to be very good, all-around, with a personality I can get along with," he stresses. "They have to be able to walk into the Oval Office or the board room of any number of the biggest corporations." They also have to be capable of working in a darkroom (Newman likes to do his own printing), but there is spotting to be done afterward. "These kinds of people with a desire to work are few and far between," he believes.

Newman emphasizes that with a smaller staff, the requirements take on a whole different aura. It becomes

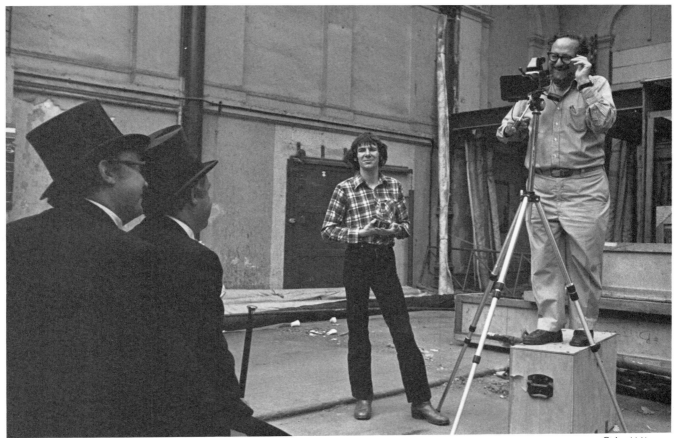

© Arnold Newman

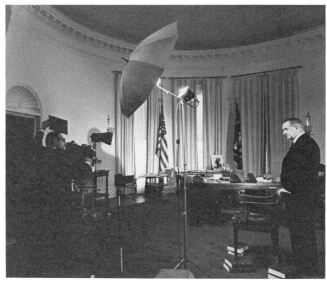

© Arnold Newman

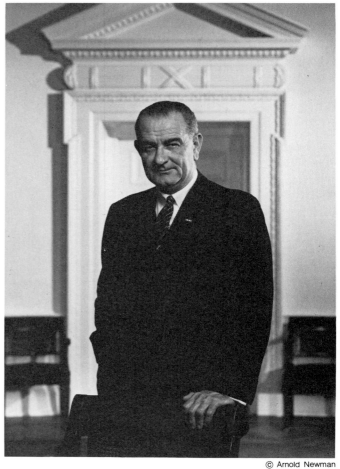

Arnold Newman endeavors to put Lyndon Johnson at ease in the Oval Office while preparing to shoot LBJ's presidential portrait. Newman feels it is important for an assistant to be able to fade into the background when necessary so he can deal with his subjects. "Even the president of the United States is self-conscious," he says. But the comedy team Morecabe and Wise, above, appear to have created a more relaxed atmosphere when they posed for Arnold Newman's book The Great British.

© Arnold Newman

mandatory to find someone who has the social graces to go out for coffee or a drink with a client plus the ability to work effectively in a darkroom. "In a large studio, you can keep these people in different compartments," the photographer notes. But in his studio, and probably in over ninety percent of the solvent studios in U.S. cities, an assistant *has* to be a jack-of-all-trades.

Newman has seen several of his assistants go on to become successful photographers; Greg Heisler, Greg Booth, and Dana Duke are among the better-known Newman grads. "I'm a tough guy to work for," says the boss, who despite his self-deprecation seems genuinely kindhearted. "I'm so intense I sometimes get absentminded."

Nevertheless, he adds, "If people stay for awhile, we remain friends for a long period of time." And he will not stand in someone's way. When the *New York Times* called Newman to ask if his assistant could be hired away to do his own photography, Newman's reaction was "My God, why should I hold him back?"

He feels his assistants should understand "I'm like a future client. If they can't please me, they won't please a client later. They always tell me it's going to be different — but it's not. The ones who do well with me do well for themselves."

Newman claims that his "depression work ethic" is not shared by everyone who's worked for him. "It's not that I'm a slave driver. There are guys who say they want to get ahead. But it's that group of guys who are enamored of the glamour and don't realize there's a lot of work to do. I know guys who say, 'Why bother even to do darkroom work?' It's not economically feasible for a young photographer to send all his film to a lab." That statement, Newman is quick to add, applies to black-and-white film. With color, it may not be economically feasible *not* to send it out. "Everytime there's a new process, what are you going to do, go out and invest $150,000?" Still, he believes, "They ought to know the process, even if they aren't going to do it themselves."

"I believe in teaching my assistants, because they can teach me in turn," Newman states. "They'll say 'Why don't you try this product?' They're up on it." At the time he spoke, Newman was experimenting with new Ilford and Polaroid processes, and he was holding fairly frequent meetings with officials of both companies. His assistants were urged to sit in on such confabs. "The more they learn, the more they can be of help to me," he maintains. "And even if they're going to be leaving, they deserve knowledge."

"A very good outgoing personality" is one of the things Newman desires in an assistant. The nature of the people working for a photographer does not go unnoticed by clients, who do comment about his assistants, Newman adds. Therefore, an assistant must be "presentable in all circumstances. Personality also includes being able to put on a tie and jacket. You don't thumb your nose at someone whose cooperation you need." And there is a balance between pleasantness and friendship that an assistant must maintain. "If you get into too much conversation," warns Newman, "the sitting shifts."

In his days with *Life* magazine, Newman might find himself involved with "huge color setups that required one and a half days to put together." In those situations, he would always request the presence of an assistant. It was essential that his own concentration, first and foremost, be on his subject. What it came down to, he says, was, "Do you want a packhorse or a one-to-one photographer. My being able to deal with these people is more valuable than saving a salary."

In many instances, an assistant must appreciate the merits of being inconspicuous. "An assistant learns that it isn't a matter of my being the all-important person because of ego," Newman explains. "It's necessary for him to fade into the background because even the president of the United States is self-conscious."

There are a few telltale signs a photographer can be aware of when evaluating possible assistants, notes Newman. "I always ask them, 'What's reciprocity failure?' Only one out of fifteen can really answer." He further suggests, "When they come with a two-day growth of beard and filthy clothes and dirty fingernails, they won't get the job." And Newman believes that a good portfolio is not necessarily a reflection of a good assistant. "To be a good assistant doesn't mean you have to be a good photographer. The twain doesn't necessarily meet. An assistant is a technician — a supertechnician in my case."

Although Newman uses interns to supplement his staff, he realizes they present some problems. They can be less than realistic in their approach; one intern "didn't understand why he wasn't taking over more. He wanted the responsibility of a full assistant's job without the knowledge." Furthermore, if university student interns are "a problem, and you dismiss them, they'll lose credits."

NEWMAN, whose workload includes editorial, commercial, and art photography plus private portrait sessions, uses all camera formats but considers the 4 × 5 "indispensable. It's simply a creative decision." As is appropriate to a person with his artistic background, he conceptualizes pictures "in the tradition of a painter who thought out individual images very carefully." That approach is certainly apparent in his finished products. The entire composition, especially of a Newman portrait, gives far more of an indication of the subject's

character than a simple "head shot" ever would.

Asked to describe his lighting systems, Newman states, "There are no lighting systems. I make up my lighting, if I use artificial lighting, as I go along." He says his use of strobe is very infrequent. In fact, he doesn't own strobes; he rents them when the need arises.

"I have absolutely no secrets — except what I earn is mine and my wife's business," he explains. "I have people, when I give workshops, accuse me of holding back information. Just because I tell them how I make a picture doesn't mean they're going to make my pictures."

ONE THING an assistant must always remember is who he is working for, whose side he is on. Newman recalls one *Life* assignment depicting how an architect decorated his own home. He was having a discussion — a reasonable, unheated one — with one of the magazine's editors about how a particular shot should be staged.

Suddenly an assistant loomed over Newman's shoulder. Newman, who seems still astonished even now as he recalls the incident, explains, "He said 'Arnold, listen to Vivi. She's the boss, she knows better.' " The editor, as appalled as Newman was, told the photographer he'd better get rid of that guy right away. Newman did not have to be told.

"A chief assistant comes in contact with clients frequently. He has to be discreet," Newman maintains. One of his assistants was "bitter that he didn't get work," and went around offering his photographic services to some of the same people who hired Newman. "He didn't have a sense of proportion. He didn't realize that by going to them without checking with me, they'd be resentful."

That form of resentment need not arise, suggests Newman. He is fully aware that an assistant is going to have aspirations about setting himself up as a photographer. "I'm not running a slave plantation." He tells his assistants, "When you're ready to go, let's discuss it. It's better for them and for me." One assistant who'd announced his eminent departure agreed to stay with Newman for two more months "at higher salary" because of the unusually large workload in the studio at that time. The fellow agreed to postpone his own aspirations. "This is the kind of loyalty the guy will eventually get from his clients," Newman stresses.

When Newman takes on someone new, he first gives him a one-day trial; if that works out, the assistant gets a one-week trial. At that point he determines whether he'll retain the person. "I get my other assistants' views," he explains, "and they almost always coincide with mine."

He understands that there is a frustrating element to being an assistant. "Some assistants can't handle the fact that they don't have control over the work." For his own part, he affirms "I'd make a lousy assistant." And perhaps it isn't the route to photography everyone should take. When Newman was in his twenties, he went to see photographer Irwin Blumenthal with his portfolio. Blumenthal told him, "I'll give you the job. But don't take it."

Above all else, Newman emphasizes the value of professionalism among both assistants and photographers. "Being a professional is just as important as being an artist," he theorizes. He recalls a conversation he once had with a *Life* editor.

The editor told Newman, "I don't want these artists who say 'I don't feel like working today' or 'I only shoot five-year-olds and you gave me a seven-year-old.' Give me the everyday down-to-earth professional." And then, continues Newman, "He proceeded to name some of the biggest photographers, Eisenstaedt, Gene Smith, Mili." They were people who always understood that above all there was a job to do. If due to some extenuating circumstances "they couldn't come in with a great photograph, they'd come in with a useable one."

NEWMAN'S OWN photographic beginnings were in a Philadelphia studio in the late thirties, where he photographed up to seventy subjects a day for a weekly wage of $16. The owner had studios in Baltimore and Allentown, Pennsylvania, and Newman worked at those, too, making what he called "49-cent portraits." He would later manage a studio in West Palm Beach, Florida, before making his move to New York in 1941, but in *One Mind's Eye* Newman was quoted as saying that, at his first job, "Before I was allowed behind the camera, I had to know every phase of the darkroom and know the use and meaning of every chemical that lined its shelves. A chemical mixture did not merely do something — I had to understand why and how."

In his appendix to *One Mind's Eye*, Newman discusses his preference for 4 × 5 but notes that technical developments have caused him to use SLR 35mm cameras to an increasing degree. "The principal reason," he writes, "is that it enables me to be freer while retaining a 'view camera' image, even when working handheld in fast-moving situations." He also mentions his preference for the infinite varieties of natural light, but notes, "When I use 'artificial light' exclusively (floods, sometimes a spot or two), they are generally bounced (reflected) off walls, ceilings, or, when color is important, sheets. Bouncing is more 'natural'; it makes the lighting effective but unobtrusive."

FREDERIC OHRINGER

FREDERIC OHRINGER was an attorney and then a State Department official in India before deciding that what he really wanted was to be a photographer. He got a 35mm camera and spanned the globe, capturing "war, famine, death, and destruction" on film for numerous newspapers and magazines. "Eventually I found what I was good at and focused in on that," he explains. While advertising accounts and corporate annual reports are part of Ohringer's portfolio, his true love is the kind of work to be found in his book, *A Portrait of the Theater*, a record of studio moments with 129 of the medium's luminaries.

"I LOOK FOR SOMEONE I can learn from," Ohringer says of his ideal assistant. "If they're good, they've gone to photography school or worked for another photographer, and I didn't do either of those things. They know all kinds of things I may now know. They may know more about paper, toning, chemicals, platinum printing, using distilled water and where to get it — little things." In this case, the photographer is not shy about asking questions. "If someone worked for someone good," he says, "I'll ask them 'What kind of lights does he use?' "

Ohringer raised an eyebrow when he was told about ads offering assistants a weekly wage of $135. "You can't get anyone who's useful for under $200 or $250 to start," he maintains. Freelancers working with him get $50 to $75 per day, and he observes that some are beginning to expect even more. "The better ones are always booked," he has found. "If they're doing freelance work, they're probably doing their own photography, too. It's probably to get a little extra money so they can buy film for their own work."

"If I were assisting," Ohringer hypothesizes, "I wouldn't work for someone for more than six months. You wouldn't necessarily learn to photograph like he does, but you may learn *how* he does it."

Ohringer not only doesn't expect an assistant to be around too long, he doesn't want one to be; the longest he has ever had one on his payroll is a year. "They level off after six or nine months," he discloses, "In a small operation, you can get very friendly with them. You get to know them and they somehow take advantage of that. The quality of the work goes down. They start to think it's not their film, it's not their camera. Most of them want to be photographers; they get frustrated. I usually get smarter with each one. You watch for those bad periods, or hope to avoid them."

The first assistant Ohringer ever hired was a friend he took on just to carry and set up equipment, mainly strobes, "which is fairly easy to learn." The second one

was a person he discovered by contacting the employment department of New York's School of Visual Arts. Most of his other assistants have been recommended by other photographers; "You just let it be known you're looking for someone, and word gets around."

Ohringer will examine a prospective assistant's portfolio "for orderliness, quality of the printing, and concern for detail." His assistant will mainly function in the darkroom but must also have familiarity with strobes and with a 4 × 5 format camera like the Sinar he uses. "Most people who've gone to school know that stuff," Ohringer asserts. He will also be looking for someone who can process 4 × 5 sheet film and know how to load the film holders, "and I don't want to teach them."

Bizarre wizardry isn't required in Ohringer's darkroom; he is looking for "good, straight, quality printing." Over the years his assistants have committed the occasional major blunder. Once an assistant turned a light on while the film was open. And then there was the time that an assistant used old fixer, the film didn't fix properly and it "got all jellylike." Ohringer surmises that his aides "must have had their minds on something else." Undoubtedly he would prefer their undivided attention.

Ohringer's assistants have been able to do the odd photographic job themselves. When putting together an annual report, for example, he might dispatch an assistant to do "a shot in a store, or people on line — reportage, real simple stuff." Of course, he would always let the client know who was taking the pictures.

In his early days, Ohringer recalls, "I used to do a lot of young actors' and actresses' pictures. When my prices went up and they couldn't afford them, I'd give them over to my assistant." That assistant has since been able to establish himself as a portraitist in his own right.

Ohringer prefers that his assistants be "articulate and presentable, and well-dressed. I'm dealing with a lot of famous people. They've got to be relatively comfortable around them." He adds, "They've got to work fast. I *speak* fast, and assistants don't always tend to listen."

LIKE MOST well-established photographers, Ohringer gets unsolicited calls from would-be assistants. "Some of them may have had schooling, or they may have worked for someone else, but they're not good," he has ascertained. "It's the difference between school and the real world; what was acceptable in school may not be good out here. They think they know it all, but they don't know that much. Sometimes they learn very classical things that aren't applicable in commercial

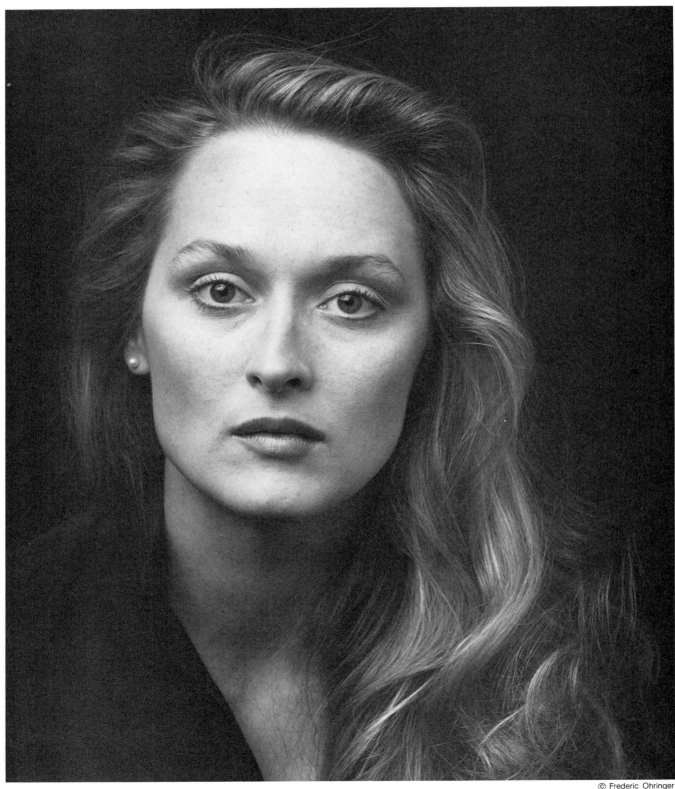

photography. It depends on where they went to school, who their professors were."

"There's a limit to what you can teach in photography," reflects Ohringer. "A high percentage of those coming out of the schools will never make a living in photography. It comes down to seeing something, having a sensitivity, and I don't know how much of that can be communicated."

It isn't the route he took, but Ohringer believes an aspiring photographer would do well to serve an assistantship. "There's a lot to learn, if you can afford to live. If you spend six months with three or four different photographers, that would really complement the education you got in school. What better apprenticeship than to work with people who are doing photography every day." What they can pick up, he believes, is knowledge about "how to run a business, how to find work, how much money you need, and what equipment you should get. If you work for real good people, you learn real good things."

When Ohringer is photographing a corporate executive in his working environment, he customarily brings an assistant along to "set up lights and cock the camera." The number of strobes and umbrellas Ohringer utilizes varies depending on the design and size of the room and how many people are in the shot.

For the sessions for *A Portrait of the Theatre*, Ohringer used Tri-X and a single 1,200-watt strobe. He did not employ an assistant. "I'm only shooting twenty to twenty-five frames on each person, so I don't need anyone to load my camera. I'm dealing with the subject. I don't need another person there."

Ohringer is among those who will tell you that the most important elements of portraiture are more metaphysical than technical. "You have to be adaptable to who's coming into the studio. You have to flow with it. The idea is to make them feel comfortable, not threatened. You don't do something to make it that way. You *are* that way. Those that are good have that capability without attempting it. It's a sincerity of purpose. Your objective is not to abuse them, but to make something good out of it."

Meryl Streep impressed Frederic Ohringer as someone who "knows what she's doing" and "is always prepared." Those are qualities that could be attributed to Ohringer himself. His session with Streep for the book A Portrait of the Theater *required a mere dozen frames of film, and one of them was this definitive glimpse of the elegant and acquiline features of one of America's best actresses.*

FASHION AND BEAUTY AND THE HIGH LIFE

WITH EACH PASSING YEAR, advertisers and journalists give more attention to "beautiful people," to the lives they lead and the styles they set. Fashion and glamour are now topics of conversation in places where such matters once elicited blank stares. New fashion advertising campaigns can become cause célèbres, subjects of urgent national controversy. Fashion photographers are becoming increasingly important communicators, and their impact on the public consciousness is greater than at any other time.

To many people, the kind of fashion photography appearing in Vogue or Harper's Bazaar holds the promise of a dazzling, glamorous world one gains entry to with a camera. The locales are exotic, the clothes are stunning, the models are beautiful. What an ideal life, it would seem, to be a fashion and glamour photographer.

It's actually a life of very hard work, enormous responsibility, and meticulous attention to detail. A fashion photographer works with enormous crews of assistants, makeup artists, and other personnel, and he often must produce excellent work under trying circumstances. The deadlines aren't just established by ad agencies and magazine editors; sometimes the deadlines are meteorological, as the perfect light of day disappears behind a cloud or below the horizon.

Each new fashion collection is worth millions of dollars. Pressures can be extreme — and although fashion photography produces "stars," they must not exhibit "star" behavior. In the fashion business, the utmost professionalism is demanded at all times.

The people interviewed in this section have witnessed the world of fashion photography from many angles — as assistants, as photographers, and even as models. They know the effort that is expended behind the seemingly idyllic façade of the fashion world. They know the elements of fashion and beauty photography, and they know how to commence a career journey that might lead to the loftiest echelons of the fashion world. Making something look so simple can be very complicated. Read on, and pay attention to detail.

DARLEEN RUBIN

DARLEEN RUBIN'S association with Fairchild Publications, the publishers of *W* and *Women's Wear Daily*, has in large part helped determine the direction her photographic muse has taken. She is adept at capturing the best moments of glittering galas and runway fashion shows. She is now attracting her own commercial fashion accounts and has always had a fondness for portraits, some not so formal, and is much in demand with actors looking for the perfect portfolio shot. She is also a regular contributor to the "Home and Trends" section of the *New York Post* and her own syndication service circulates her photos in Germany, Spain, France, and Italy.

Rubin, who as recently as 1977 was getting $5 per photo from a Greenwich Village neighborhood newspaper, worked as an assistant to three male photographers. One was Joel Brodsky, a fashion and beauty photographer who has also done a slew of record covers, including several for The Doors. The second was Frank Kolleogy, who she calls her mentor (Kolleogy was an assistant for Brodsky before venturing out on his own.) The third was the peripatetic Harry Benson, who was, in one of his many capacities, a photography director for a number of Fairchild publications and was present when Rubin shot her first job for Fairchild — a Stephen Burrows fashion show at Henri Bendel.

DARLEEN RUBIN'S ENTRY into professional photography was the result of one of the more bizarre coincidences imaginable. She had wrecked her car, and the owner of the auto repair shop where she took the wounded vehicle was up for a part in *The Godfather*. He needed a portrait for his acting resume. She offered to take it, he got the job, and she had her first client.

"Somehow word got around about my doing portraits," she remembers. Most of her clients were actors, and in the early days she charged very little. "For an actor to get a good photographer is very important," Rubin explains. While standing on call lines from New York to California, actors wouldn't just be rattling off theatrical credits to each other; they'd also be comparing pictures. Rubin's reputation grew like Topsie.

With little capital or equipment to her name, she "did available light on location where I thought theatrical people would be comfortable. I'd make tea for them, create a whole social situation, find out about their work." This put the subject at ease, and it gave Rubin a better idea of what she wanted to capture about each person. The results, more often than not, pleased everyone.

RUBIN MET FRANK Kolleogy the day after she'd bought her first 35mm camera. She was still singing in New York clubs at that time, but later, as her interest in photography grew, she arranged to become third assistant at Brodsky's studio, where Frank was first assistant.

In the beginning, as a fairly unskilled person, "you hang around the studio, you clean up, you order coffee — you're a slave. But you're getting an education," she discovered. "You iron clothes, look for props, load film, wash lenses, and answer calls."

"Eventually, you learn how to book models," she continues. "That's an art in itself. If you book them on a 'definite' instead of a 'tentative,' your boss is liable for that fee." She also learned how to "get up on a ladder and put up seamless and set up lights, and how to take Polaroids."

At Brodsky's, Rubin was initially that proverbial extra pair of hands, while Frank was doing the work "on camera." She recalls, "After one shot, the studio would become a mess. There were sync cords, cables, wires, coffee cups around. Just having somebody to clean up was a full-time job."

But it was here, thanks to Frank, that she learned how to print, and many darkroom duties were eventually entrusted to her. She adds, "Joel exposed me to studio life, the operation, the professional side of the photography business. He is a very generous photographer; he would allow me to experiment. He let me borrow equipment; I could use lights and strobes or anything in his studio. He let me drymount before I could afford a dryer. He's been like that with everyone who's worked for him."

Rubin frequently photographs opening night galas. "I don't consider myself paparazzi at all," she insists. "Some of those people (paparazzi) are so hostile it's like the camera is a weapon. They keep flashing and flashing until they blind these poor people. It's as if the photographer is the attacker and the subjects are the prey."

From watching her at work one night outside a benefit at the Metropolitan Museum of Art, or just from seeing the finished pictorial evidence of an evening's work, it is obvious that Rubin has a knack for getting normally recalcitrant subjects to cooperate. "Something about my whole manner and presentation doesn't put them off," she believes. "I'm not resentful of the success of these people. Some photographers are trying to put them down."

In most of these star-studded party situations, patience is a better approach for a photographer than panic. As interesting and newsworthy persons arrive,

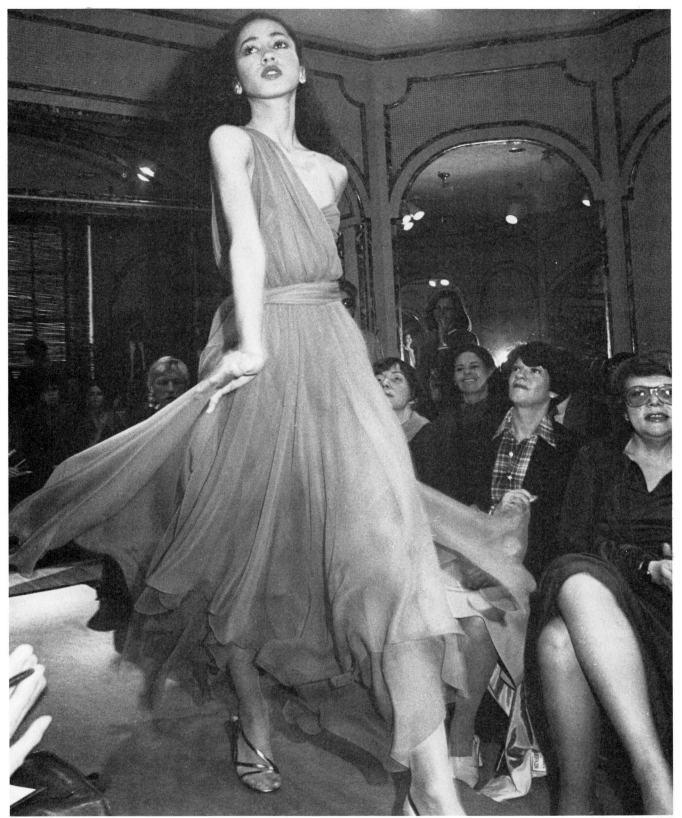

This graceful view of Pat Cleveland gliding down a runway (at a fashion show highlighting Stephen Burrows' collection in 1977) was done by Darleen Rubin "on spec." It ended up in Women's Wear Daily *and began a long and fruitful association between Rubin and WWD's parent company, Fairchild Publications.*

Rubin waits and lets them "interact with each other." And rather than sneak up and catch them off guard, she explains, "I'll ask them an intelligent question because I know their work." As they speak, and are more natural and at ease, "you have to know when to press the shutter and when to listen." The atmosphere can become cordial and even friendly, but Rubin says, "I have to remember I'm doing a job here. They know it, too."

When photographing these fabled personalities, she tries "to get something that is representative of them in very few frames. I'm not flashing away like the paparazzi. They're not even looking in the lens."

"I don't want to get something they are *not*," she says of her subjects. She prefers "to get the essence of someone, the emotion, the very expressive look. The key is to wait, if you can, for someone to reveal himself to you."

In such situations, Rubin always carries a separate strobe. "You've got to be able to guarantee the shot. You can't worry about setting your *f*/stop and your shutter speed," she notes. That would particularly be a problem "if you're working in a varying light situation and someone is turning around." She carries a separate strobe, a Vivitar 285 Zoom Thyristor with rechargeable batteries or a battery pack and can expect "a good, sharp image" up to sixty feet."

HER PREFERRED 35mm camera is a Nikon FM. She uses Ektachrome "because I have such a wonderful color lab and it can be processed in three hours." Her black and white choice is usually ASA 125 Plux-X, "a more contrasty film with a wider range of tones and sharper, finer grain."

A large photo layout of the tenth anniversary party of Poets and Writers Inc. in *WWD* illustrates the fruits of Rubin's patience and good sense. *Sophie's Choice* author William Styron rarely ventures out in celebrity circles and would be noteworthy in any case, but Rubin waited until Lauren Bacall arrived and put her together with Styron — an unexpected, intriguing pictorial juxtaposition. Patience can also yield a new slant on things. Gazing at her full profile shot of John Updike, one realizes that he is never photographed from that angle and that he is barely recognizable as the same person we see on his book jackets.

In trying to capture each outfit being modelled in a runway situation, a photographer has "thirty seconds, if you're lucky," to get the picture, says Rubin. "Thirty seconds doesn't seem like a lot of time, but it should be enough." Still, alertness is of paramount importance. "If you take your eye away from that view screen for more than one second, you're kicking yourself because you've missed what the models have done for you."

There is background music at most such fashion shows, and Rubin suggests that paying attention to it will help tell you when the best photo opportunities will arise. "If the models are good and they're pros, they move to the music," she has found.

Most photographers use motorized 35mm cameras to shoot fashion shows, and Rubin admits that the increased rewind speed with a motor is a great advantage. However, she does not use the motor, electing to "rely on my own sense of timing and rhythm to lock into the right moment, the instant of action that can be special on the runway that's more than just a walking shot." Although some models will stop in front of a photographer they like or admire for a few extra moments, Rubin would prefer that they not do so; such stopping and posing "breaks the flow."

Rubin suggests that 35mm is the only practical camera to use in this kind of situation. It would be conceivable, albeit somewhat limiting, to set up a 2¼ on a tripod at the end of a runway. But your maneuverability is limited, especially when dozens of other photographers may be jockeying for position, and you are confined to twenty-four exposures before reloading. Handholding the bulky 2¼ in this case is out of the question.

In this high-pressure, high-speed setting, "it sure is nice to have someone who's rewinding film and loading cameras," Rubin admits. She will usually have three cameras and will be shooting color and black and white; two of the cameras will have the kind of film her client prefers. An assistant's extra pair of hands are undeniably valuable "when you're in a hurry and you have to get *every* picture." There are plenty of things for a diligent assistant to pay attention to, like making sure the photographer's strobe settings don't change and taking off some of the pressure of loading and reloading. A frenzied photographer or two has been known to open the back of a camera prematurely and expose several frames of film.

"At some of these shows, photographers are four deep elbow-to-elbow, and you have to fight for your space," sighs Rubin. "And sometimes after you pick your spot, they get in front of you. Your territory is usurped by eight people. Both assistant and photographer, in times like this, need coordination and the ability to concentrate," she insists. She might have added the patience of a saint and a high degree of acrobatic skill.

"Fashion for me is an extension of theater," Rubin states. "I think of the runway as a stage." It is important "to have a rapport with the model," she adds. "You have to let them do their thing. If it's a good model, she knows how to display the clothes. It's like an actor understanding a role. It only needs a little

direction. If it's someone like Pat Cleveland or Pat Quinn with a definite personality, you don't have to tell them too much."

Versatility is essential in her case. *Women's Wear Daily* prints mostly black and white, while *W* will usually want color. "When I shoot for *WWD* I use Tri-X," she notes. "That's their standard film. It gives them a lot of latitude."

Rubin mentions covering a recent fashion show that previous week for a client who wanted both color and black and white. She needed to use three cameras, with different lenses on the two containing black and white film. In such a situation, where fumbling and juggling would otherwise be the order of the day, she took along an assistant to "handle lenses, load film, and put in batteries when they ran out."

On location, she also needs someone to hand her the lens she wants immediately for the next shot. "I usually bring somebody with me who understands lighting and who isn't going to compete with me — although I'm open to suggestions." Along with an extra pair of hands, it helps to have an extra pair of eyes "to see threads out of place, to see that the hair is right. An assistant should be an extension of you — synchronized with your thinking."

R UBIN IS A MEMBER of the American Society of Magazine Photographers; she is listed in the Society's directory, and for that reason she gets many calls from would-be assistants. Some assistants actually advertise in the ASMP monthly bulletin, and Rubin might contact one of them if she needs someone on short notice. If no alternative is available, she may even ask a fellow photographer to assist her. "It's a one-shot deal," she observes. "I need someone I can count on. You don't want someone pilfering your filters."

She looks at an assistant's book, and "if they don't have the eye or the talent for it, if you don't have respect for their work," they're not likely to be hired. She wants someone with "an artistic eye, an eye for composition, grace, and form." Personality is important too. An assistant must be "someone who's simpatico, not someone who's fighting you to create a different image."

"If I'm going to have someone assist me now, it's my wishes and desires that come first," Rubin declares. As an assistant, "You have to put your own work aside. Become an extra pair of hands for the photographer. Learn how they think. Anticipate their every move." As far as attributes are concerned, "You have to be mechanically inclined to learn lights. After that it's imagination and suggestion. You watch them (the photographers). I asked a lot of questions."

© Darleen Rubin 1981

Rubin's camera caught Sophia Loren when the Italian beauty had reason to smile; she was receiving three honors at the annual Fragrance Foundation awards. The better female photographers, like Rubin, are getting more opportunities to shoot gorgeous fashion pictures, with results like this image of model Pat Quinn—part of a session Rubin conducted for Quinn's Wilhelmina composite.

As far as Rubin is concerned, it would be intolerable and unforgivable "if an assistant were malfunctioning because he'd been drinking or smoking." She adds, "You have to be straight and level for photography. There are at least 100 technical things to be aware of, and a tiny mistake can be fatal. If you ruin the job, you may lose the client. I make sure I'm rested, I'm not hungry, not wanting for anything. I run my film only when I'm feeling tiptop. You screw up the film either in the shooting or developing and there are no second chances."

Rubin is aware that the physical nature of assisting often works against female applicants. "That's a very valid problem," she acknowledges. "You have to be able to overcome the physical stigma. Women are smaller than men, they haven't got the power. I'm not afraid to get on ladders and set up seamless, but you are inhibited by physical problems."

"Don't interfere with what's happening between the subject and the photographer," is a cardinal rule for assistants, according to Rubin. "An assistant has to be in the background, not be seen and not be heard but be there."

Whatever one knows about photography, and whatever one learns from a teacher or employer, the most important thing, Rubin warns, is to remain flexible. "The object is the picture and how to get it," she affirms. "If there's an easy way to get a shot, I'll opt for the easy way."

THE EQUIPMENT, the time, and the approach will obviously vary with each specific fashion situation. On one end of the scale, in terms of efficiency and simplicity, is a campaign Rubin recently shot for a client who wanted a different ad in a national weekly magazine for each of about twenty-four weeks.

"The ads were to be one column — small, a rectangle (maybe two inches by five), a perfect format for 35mm. If they were to be square I'd use 2¼," she observes. The ads were also black and white, and she would use a slower film, Plus-X ASA 125, for "little grain and a sharp image."

The setups would be fairly basic. "They're not interested in fancy lighting. They want to show the merchandise," Rubin says of her client. With that in mind, she would use essentially the same lighting arrangement for each shot and would use simple seamless paper backgrounds.

Having gone over to the studio she was to use ahead of time and already having chosen what her lighting would be, Rubin would merely have to take Polaroids on the day of the shooting and see if the client okayed the lighting. This would further expedite matters on a day when speed would be of the essence. Shooting a roll or two of each garment, Rubin expected to complete ten or twelve shots in an 8:30 a.m. to 6 p.m. day. Three models would be in the studio on an all-day booking. While one was being photographed, the others would be making up and changing. Half of the entire ad campaign would be accomplished in a single day. The arrangements would be quick and efficient, but would need to go off without a hitch.

For her assistant, Rubin would pick "somebody that's worked for me before, someone who isn't going to be drunk or obnoxious," and he would get $75 to $100 for the full day. It would be his job to "keep the Polaroid loaded, keep the camera loaded (actual two 35mm bodies). "Who knows what kind of emergency will arise?" she wonders. "You may need an accessory or a prop, something may be broken, the client might be missing something, and the assistant may have to run out. He also should be there to check my settings and be ready to hand me another camera."

Hasselblad is so popular and prevalent that the name becomes almost synonymous with 2¼ cameras. But there are other brands, and there are differences. Rubin, for example, owns a Bronica S2A. To her, measuring the relative merits of Hasselblad and Bronica "is like comparing a Cadillac to a Rolls Royce." The Hasselblad lenses, in her opinion, aren't as sharp as Bronica, which uses Nikkor lenses. There are other things to take into consideration, however; Rubin observes that Bronica is the bulkier of the two, and it requires two turns to advance Bronica film as compared with just one for Hasselblad.

"You have to love what you're doing," she concludes. "It shows in your photography. If you don't like women, that's going to be very apparent in your shots. If you don't like fashion, if you think it's all boring and phony and disgusting, you should shoot buildings." No photographer should allow himself or herself to get trapped in a mundane existence, she stresses. "If you aren't enjoying what you're doing, it becomes another disgusting job rather than an exciting creative art."

ARIEL SKELLEY

FASHION PHOTOGRAPHER Ariel Skelley studied her craft at the School of Visual Arts and New York University, but the bulk of her photographic "assistant-ship" was her experience on the other side of the camera as a model for Wilhelmina Models Inc. and its Japanese and European affiliates.

She always believed modeling could be a forerunner to a photography career, and she is by no means the first woman to make such a transition. "It seemed like the best way to get around and see styles and different ways of lighting," she says of her life as a model. And she believes she was "non-threatening enough so that people would be available to me" and divulge valuable information. It is more frequently the case, particularly in New York, she says, that "people keep their technical expertise to themselves."

Ariel Skelley was not shy about asking questions, and many photographers she had befriended were willing to grant her request to "hang out," observe, and learn. Klaus Lucka, Art Kane, and J. Frederick Smith are among the more eminent photographers she credits with providing early guidance.

HER FORMAL assistantship was relatively brief. For four months she was one of seven assistants in the still-life studio of the very successful Michael O'Neill. "It seemed really silly to assist anybody who wasn't great," she declares, and the young studio whiz O'Neill was an ideal mentor.

Ariel learned a bit of styling, some fabric draping, and "a lot about picking up sandbags." She also had to contend with "huge banks of Ascors that scared the hell out of me. (O'Neill) sometimes used twelve Ascor boxes for a single shot." On slower days, she recalls, she might find herself "going for lunch, calling prop shops, or casting models."

She remembers "Michael paid $150 a week, and he paid the best." In the more technical branches of photography, Ariel has learned that "mostly, you have to pay your hard dues for two or three years. I was lucky."

More than anything else, she may owe her initial photographic success to dogged determination and an ingenious sense of self-promotion. Before she had the budget to hire other models, she trained her camera on herself. Her witty self-portraits gained great currency. At the height of the roller disco craze, for example, her pictures of herself on skates earned her a large spread in *Ms*, of all places. Somehow her reputation preceded her on a trip to Australia, where tabloid newspapers put her on the front page and welcomed her as a roller queen-cum-good-will ambassador.

MORE IMPORTANT, however, was Ariel's marvelous series of herself in the mountains, at the shore, on shipboard, in sidewalk cafes, and in any number of exotic locales, all of which included a "Bloomingdale's" sign. It was for the viewer to determine whether this young woman was in fact on a round-about journey to the esteemed New York store or was meant to be an example of the stylishness associated with that retail outlet. Many of the photos included an unusual traveling companion — an oversized bearskin which could be set up to look like the real live intrepid ursine beast.

The shots were not commissioned by Bloomingdale's, never ran anywhere, and never directly earned Ariel any money, but enough acquaintances among New York's photography and fashion circles heard about them and saw them to earn Ariel a word-of-mouth reputation as a witty, skillful cameraperson. The first major client to call for Ariel's inventiveness was Macy's. For a campaign featuring the store's junior department and booked to run in the trendy *SoHo Weekly News*, she created a fun-loving circle of friends led by a woman named J.R. — played, of course, by Ariel herself.

Her own example led Ariel to note that while training and technique are important, "what really tells is the direction a photographer gives to the happening. Everyone has their own style and it makes an imprint on the film. The technical aspect should be second nature. The confidence you have in the technique lets you proceed."

TODAY, in her own work, which includes spreads for several European fashion magazines, Ariel can usually get by with one assistant. If the job is a very big one, she has noticed that the client often provides additional support personnel.

One assistant she employed was the brother of another photographer who lives in her loft building, an eager man wanting to learn more about the trade. He was gracious and hardworking enough for Ariel to consider it worth spending time to teach him the things he needed to learn, such as how to load a 2¼ camera. She is among the photographers who swears that an assistant's personality and attitude are most important. This particular assistant was apparently "a real charmer." After shooting a job for a jeans client, Ariel got a call from someone at the company who felt her assistant was so wonderful that "we simply must send him a pair of jeans."

Ariel Skelley

Ariel Skelley's advertising photographs for Macy's have often featured Ariel herself; here she is seen in triplicate trying to make it to the huge department store one way or another.

JACEK KROPINSKI

JACEK KROPINSKI is already an international phenomenon of sorts. Born in Zambia of Polish parents, he was schooled in Great Britain, majored in English at Flinders University in Adelaide, Australia, came to the United States to assist a New York fashion photographer, and left to take on his own fashion assignments in London and other European fashion capitals.

Kropinski had taken pictures since he was a child but started getting more interested in cameras when he realized he preferred to do his university term papers in photos rather than by written essays. His girl friend in Australia was an actress, and soon he was doing head shots of performers and dress rehearsal pictures for a local theater. "I was amazed someone would pay me," he recalls.

WITH HIS DEGREE in English, Kropinski "had the options of being a teacher or getting some well-paying job." A friend of his was a very prominent fashion photographer in Australia, and Kropinski wanted to assist him, but the friend said it was impossible. Aussie photo assistants are part of a union which mandates very high wages, and, according to Kropinski, many photographers circumvent the demands of the unions by hiring fifteen- or sixteen-year-olds as assistants.

After this rebuff, Kropinski became a buyer for department stores for three years, "I made a lot of money and had a nice apartment," he tells it. "I bought an Alfa Romeo, went out to dinner, and spent money on flirtatious living." The work, however, was only materially rewarding, and he remembered the enjoyment the theater photography had given him.

He sold the car and other earthly goods and came to the United States with $3,000 and a plan to work as an assistant to a fashion photographer, although he had no connections. "I'd analyzed it," explains Kropinski, and had decided that fashion, rather than some other kind of commercial work, would give him the time and money to do his *own* photography, the kind of picture-taking he was personally interested in. He describes that as "a photography of seeing, of capturing instances in the scape of life before us — not to make a statement, to idealize or to scorn, but just to hold up to someone for him or her to see." Still, Kropinski understands, "One has to support oneself. I decided fashion was the way to do that."

"I decided that New York is the center of fashion photography, which I found out it is," he states. "Paris thinks it (the center) is New York, and New York thinks it's Paris." From magazine spreads he'd been studying, Kropinski arrived at a list of six fashion photographers he'd want to assist. On the first time around on the telephone, all six or their proxies said they weren't in need of anyone.

MIKE REINHARDT, whose pictures appear in the American and several European editions of *Vogue*, was on Kropinski's list. Three or four days after the initial rejection, Kropinski called Reinhardt's studio again, and talked to the studio manager (who does not assist but "is more of a producer"). He, as Kropinski puts it, "recognized my English accent and sympathized." As it turned out, Reinhardt and his crew "had hired a second assistant they didn't like and were waiting for an opportunity to unload him." Kropinski, who represented that opportunity, was first taken on for a one-week trial without pay and then put on the "princely" salary of $20 per day when there was work for him. Reinhardt keeps one full-time assistant and a second who works "when he's needed," according to Kropinski, who observes that the need is frequent.

Why was he picked? "I spoke well, I acted suitably, I was well-presented," surmises Kropinski. Technical acuity had "nothing to do with it," he explains. It was the first assistant who interviewed Kropinski and made the decision to hire him, and at Reinhardt's it is the first assistant "who gets yelled at, who gets praised. The second assistant is a trainee to replace him when he goes, hopefully to carry on in the same fashion. It's better that he gets along with people than that he knows the neutral density factor or what the filter factor of an R-2 filter is." Those things, Kropinski notes, "will come in time."

Kropinski came to work for Reinhardt in August 1979 and became first assistant in July 1980. Reinhardt deals very little with the second assistant; that is left up to the first, explains Kropinski. And on many traveling assignments, only the first assistant will accompany the photographer.

Kropinski, who when interviewed at Reinhardt's studio was earning $192.80 a week after taxes, observes that "there are a few things relating to etiquette" that even a second assistant must be aware of. He must, for example, avoid "gawking at the girls when they're changing clothes," although a brief initial spell of such visible interest might be only human nature. The job of fashion assistant "requires a better understanding of the psychology of the people involved," Kropinski stresses. Many of them are "eccentric, romantic, insane people. Either play the game or understand what the game is so you pretend you're playing it," he advises.

An assistant must also realize that a volatile business is going to involve humans of a volatile nature. When

Jacek Kropinski worked with top fashion photographer Michael Reinhardt and even lived in his studio before venturing out on his own. With the fashion flair demonstrated in this picture he found quick success in London.

an assistant is verbally abused by the photographer, Kropinski explains, the assistant must understand the boss is venting frustration and that nothing personal is indicated. "The sun's getting high, it's too hot, the wind's blowing wrong" — any number of problems can exhaust one's patience. "A second assistant takes it as a slight. It's not," Kropinski states. "It's forgotten in thirty seconds." Nevertheless, he observes, certain second assistants have taken outbursts too seriously and have retreated with tail between legs.

Even in the beginning, when his income was meager (and, for a short time, invisible), Kropinski the assistant was living in Manhattan. There was never any doubt in his mind about that. "You have to live in Manhattan because of the long hours and the (need for) availability," he insists. "You can't be taking a train an hour each way to get home." As far as being readily accessible is concerned, Kropinski had no problems. When we spoke to him he was living in Reinhardt's studio, sleeping on the floor and paying no rent. That's one way to reduce travel time to zero.

REINHARDT'S PICTURES, according to Kropinski, are usually taken with 35mm and occasionally 2¼ cameras, but larger cameras are "not necessary" for his boss's style, he claims. In fact, Kropinski is a bit disdainful of some fashion photogs who use 8 × 10, accusing them of posing models in "ungainly" ways. "With 8 × 10 you don't get the rapidity, the fluidity that's so important for the fashion shot," Kropinski believes. And as far as all arguments about the quality of the negatives are concerned, he states "35mm through some Nikon lenses can be pretty damn sharp."

The fact that he lets his assistant *live* in his studio would indicate Reinhardt is no Scrooge when it comes to providing access to essentials, and he was very willing to let Kropinski use his space and contacts for his own photography when the regular working day was done. For wardrobe, Kropinski could "use clothes that are often left hanging here," and getting models to pose for tests is no problem. "The agencies assume you're brilliant if you're working for Reinhardt. They send great girls," says Kropinski, who reveals that models are often willing to test for free.

Schlepping wasn't really such a large part of Kropinski's duties. "We travel heavily," he notes, "well-equipped with petty cash to pay porters." That left the more important things, like "learning the business," and learning to appreciate a studio where "everything is measured to exacting standards." He could watch a boss who is "as exact as a professional must be," and who has a quality crucial for a professional photographer — "the ability to come up with

the goods, and to repeat the things you've shot." Some of the lessons learned can be very specific. "You discover a light [arrangement] that's taken somebody ten years to evolve," marvels Kropinski, who had the opportunity to observe and commit it to memory in a day.

HE HAS ALSO LEARNED that "a good portfolio is not just a random selection of beautiful girls in sharp photos in front of a seamless." Those persons wishing to be assistants would arrive with portfolios in tow, but they are not hired on the basis of the contents; "I see them only to see what my competition is," smirks Kropinski. If the assistant was someone who has previously worked for another photographer, Kropinski would usually observe one of two things. "Either he'll copy his boss almost precisely," Kropinski explains, "or he'll react so much against him in every way. He'll come up with graphically correct photos, but he'll never get jobs."

"I don't think originality is important to the majority of clients," Kropinski has found; they seem more concerned with "professionalism and safety." Upon examining a portfolio, for example, they will not look kindly at "a $3,000 dress surrounded by Glad bags"; they wish to see merchandise depicted in "a way that will help them" sell it.

"I'm hoping to leave for Paris and Milan to get photo work," Kropinski revealed prior to his departure. "Here in New York, if I ran my ass off for six months, I'd scrounge up some jobs." However, he says, "New York also involves expense and responsibility. This is where the big money is but not the freedom. You're not working as closely to layout in Europe, and you're not dealing with the megabucks structure." It is rather simple to rent studio space in several European cites, he believes. "They're used to photographers coming in for six months at a time and then leaving again."

The work can be abundant, he says. "In Milan, there are at least five weekly magazines with four color spreads. That's twenty photographers needed every week." The pay is not as high as New York but it's decent enough, and the stuff on which portfolios and reputations can be built. "You come back to New York," he laughs, "and they think you're a hot shit European photographer."

In the studio, Kropinski's former boss Mike Reinhardt uses strobe, but on location he often uses tungsten light. "Mike has devised a way of using tungsten rather than reflectors; it's very beautiful," Kropinski says. Whether it be studio or location, Reinhardt "wants the camera advanced. One of the worst things you can do is give him the camera not

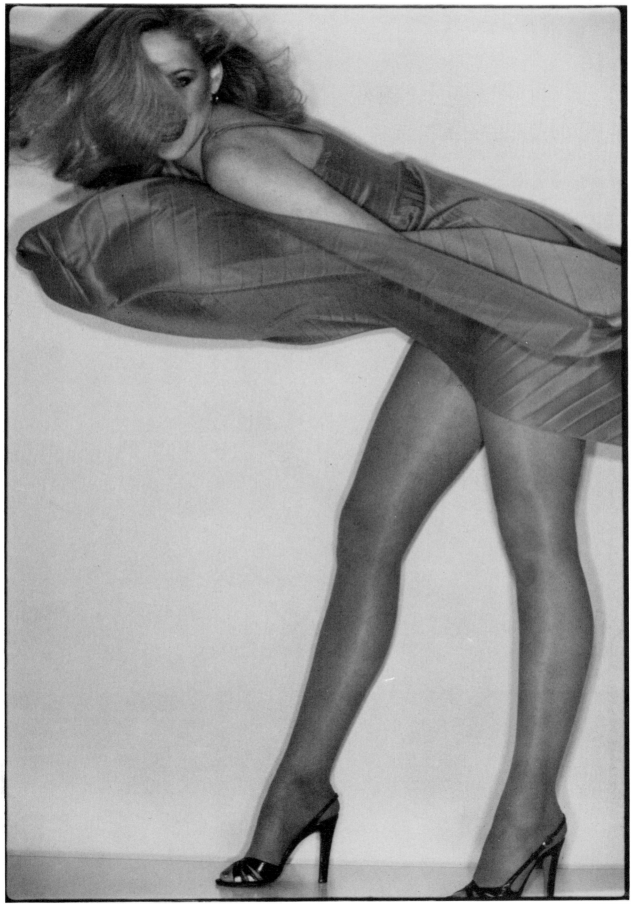

Jacek Kropinski

107

cocked. Speed is the most important thing to Mike. He doesn't want people to dawdle and think. He wants you to think while you're moving." And the preference for second assistants who are "reliable, come on time, and have a good general knowledge" over some university graduate with considerable technical expertise might be because the latter is "not prepared to do things the maestro's way." Kropinski confesses, "We're all selfish egotistical bastards, and we want things done our way. We have to suppress that and do it Mike's way."

THERE ARE FRUSTRATIONS inherent in the assistant's position. It is understandable, although a bit burdensome, that a photographer won't always realize that a task he assigns to an assistant may take ten minutes, and not ten seconds, to complete. It may also be a bit of a tease, Kropinski observes, "to be in beautiful places with beautiful clothes and beautiful girls and not be able to take the picture yourself."

The most frustrating thing, however, was "having to have the ability to read Mike's mind and not having it most of the time." If, for example, he says "Move the light up," does that mean move it on the stand to a higher point, tilt it up, or focus the light beam stronger? Does "Move the wind" mean move it closer, further, to the left, or to the right? "I guess right 51 percent of the time," sighed Kropinski during our interview, "which is why I'm still his first assistant."

"With the combination of what I knew and what I've learned, I'd be ready to handle anything," Kropinski confidently stated. "You can go to FIT (Fashion Institute of Technology) for four or five years and not know a quarter of what I've learned."

"It's more than bracketing and loading cameras," Kropinski says of assisting. "You become a sidekick. You get his bike fixed, water his plants in his apartment when he's away. He's the boss — that's never forgotten. But you're so close, it gets friendly."

DAVID RADIN

FRANCESCO Scavullo is one of the half-dozen or so photographers whose name is most recognized by the general public; to the layman, Scavullo is the fellow who can manage to make *anyone* look glamorous. He photographs for both *Vogue* and *Harper's Bazaar*, but Scavullo's steadiest assignment comes from *Cosmopolitan*. He has shot almost every *Cosmo* cover for more than a decade.

One fellow who served with Scavullo as studio manager and first assistant was David Radin, a Long Island native and School of Visual Arts dropout in his mid-twenties.

Radin had been at the school for about eighteen months when he met a photographer through family connections, a "professional who was cutting it." Soon Radin was working for the man before and after school for no pay but, he adds, "I got free lunches."

Even though his second year of schooling included advanced techniques and studio classes, Radin says, "I realized I was way ahead of it already. It's incredible how much you can learn on the job in a short time." He quit school ("It upset the parents, but I knew I was doing the smart thing") and took over as assistant to still-life photographer Jerry Friedman.

"It was a small still-life studio, but we were cranking out a lot of work," Radin recalls. And it is his belief that an assistant "should start in a still-life studio. That's where you learn about lights, cameras, putting an image on film, getting a perfect exposure, working on a set for two days, and fine tuning."

It is also the place to learn about 8 × 10 cameras, which "pick up every bubble in your glass." The 8 × 10 may be "the toughest, the least yielding" format, as Radin suggests, but he adds, "The detail is unsurpassed. It's so fine, it's incredible." Compared with other cameras, he explains, it requires "more light to produce the same exposure" and "the distance light travels from the lens to the film is longer." Using a view camera allows a photographer to "correct parallels, correct distortions, or *create* them, if he wants," says Radin.

RADIN WAS WITH Friedman for a year and a half, a pivotal period during which he was able to witness the enormous growth of a photography business. "He was exploding as a photographer," Radin says of his former boss. "From June to December there were big accounts every day, and the bucks were rolling in, I couldn't believe it!"

But it was time for Radin to go somewhere else to grow further. In 1977, he became a freelance assistant and arrived at a $35 rate via complex figuring. "At that time $50 was the top and $25 the bottom," he explains. "The $25 guy you wouldn't hire. The $50 guy — I know I didn't know as much as. Forty dollars was more common, but I didn't want to scare people off. I was looking for *work*."

As a freelancer Radin was living with his parents on Long Island — which probably didn't make him as readily available as he should have been. "One week I'd have five days of work, then zip. I was always looking for a full-time job."

One photographer took his resume and immediately gave Radin a job. His forte was catalog fashion, which Radin clearly distinguishes from high fashion. The catalog work, he says, is "the perfect mixture of fashion and still life. You shoot people but you use 8 × 10. I didn't know people but I knew the camera." This kind of photography isn't exactly art, he explains. It involves "a stylist pinning and clipping like crazy to make sure that there are no wrinkles in the garments." Essentially, he notes, catalog photos depict "mannequins with plastic clothes."

After eight months at the catalog studio Radin quit — and was immediately offered a raise to $300 a week, "which you cannot pass up," he observes. "I bought a stereo. I bought a car. I was commuting. I spent it all, I don't know what on. Finally, I got rid of the car — it was stolen, actually. Then I bought a motorcycle. And then I quit." For the second and last time.

In his first round of freelancing, Radin worked for a photographer who constructed enormous sets "like airport furniture" on a floor that was thirty feet wide and twenty feet deep and would be lit with "fifteen quartz lights of 300 watts apiece" — bright stuff indeed. "He'd have them all over the place," notes Radin. "We'd keep them on only as long as we had to. We'd turn them all off while we were making decisions. The electric meter was spinning. You have no idea what wattage that drew from Con Ed." The photographer "shot tungsten by time exposure, counting clicks off his $25 Timex."

ANOTHER PHOTOGRAPHER Radin helped during his freelance days was Paul Christenson; he believes he was in fact the first assistant Christenson ever had. "He had no money to pay me other than the $35 (day rate). That's why he took me," theorizes Radin.

Christenson, who knew Radin from his tenure at his friend Jerry Friedman's studio, is a living example of what a small world commercial photography can be. Paul Christenson, Ross Whittaker, and Ted Wachs were all roommates at Brooks Institute in Santa Barbara. Later, they were all roommates in Manhattan. At

An early test shot by Dave Radin, who was freelancing as a photographer and assistant after leaving Frencesco Scavullo's studio, is shown below, and not with intimations of his mentor's skills

Dave Radin

one time, they were all working together as assistants for Michael O'Neill, and at various times they were all studio managers for O'Neill. All three of them are now New York commercial photographers.

That kind of incestuousness brings Radin to comment, "You could be the best photographer in New York City and live and die without ever being hired unless you know some art director, who knows you through a friend, who'll give you a break. Otherwise you'll never get a job. Suppose you're an art director, and you've got a job to give. Twelve photographers could do it. Who are you going to pick? Someone you've heard of, or someone you know."

It is hoped that an assistant will learn something of value from every boss. "Paul is extremely neat," Radin says of Christenson. "I learned that it's important to be neat and clean. If you have a wire going from here to there, it's got to be taut and straight and not snaked so you can trip over it. Paul's sets are very symmetrical and technically excellent for still life.

Radin also had high praise for Christenson's lighting. "He has Michael O'Neill lighting for still life, and I learned it without working for the guy." Describing that lighting, Radin observes, "The one word is quality." But he also mentions "the contrast and the softness, the ratio of highlights to shadows, the proper exposure, the correct color saturation. The lighting is soft and beautiful."

"Paul would always experiment," continues Radin. "He'd shoot daylight film and strobe. But he'd mix it in with tungsten." In this manner, "A wrinkled brown craft paper could turn a gutsy orange. You couldn't get that color any other way."

FROM HIS FRIENDS along the grapevine, Radin knew there were more glamorous times to be had in commercial photography. "I'd hear 'They flew in this guy from California, he shot it in a half-hour and got

$10,000 and they made a poster.' Or they'd look at a picture by Helmut Newton and say 'Isn't that great. Wouldn't it be terrific to work for him?' "

In any case, Radin knew there were better times to be had somewhere else. He was fortunate to be acquainted with Cameron Stewart, a freelance assistant who "knew everybody who was working anywhere, who needed anything." Stewart knew that Francesco Scavullo was searching for an assistant and called Bill Calderaro, Scavullo's studio manager at the time. Stewart and Calderaro, like so many people who crossed Radin's path, were both Brooks Institute graduates.

"You've got to sweep the floor and make the coffee," Radin was told. "It's a second assistant slot." But the timing was fortuitous; "Bill was phasing out and I was phasing in. I finally took it (the studio managership) over."

Calderaro, when he interviewed Radin, wanted to know if David knew Nikons and Hasselblads. All of Scavullo's color work in the studio is done with Hasselblad, explains Radin, who had some experience with that format from a freelance stint with fashion photographer Maury Hammond.

Loading Hasselblads is "a tricky little thing to do in a short time," notes Radin. Scavullo, he observes, would typically begin a session with seven or eight Hasselblad backs. "You could fall back three and then load one," says Radin, who, as he got "better and quicker," could rely on a cushion of even fewer spare backs. "I got real fast on those backs," he boasts. "I don't know anybody who's faster than I am."

NINETY PERCENT OF Scavullo's work is done in the studio; when he goes outdoors, says Radin, he uses motorized Nikons with Kodachrome 64 and shoots "only in the very early morning light." What travel opportunities there are for Scavullo's assistants are reasonably exotic — to St. Barthelemy, West Indies, to Mexico, and to Paris for the collections.

Inside, where Scavullo's most renowned pictures are taken, the master uses a lighting system that is uncomplicated but precise and perfect, according to his studio manager. The photographer may use independent background lights, but on his subject (almost always a person) he uses a single source light which Radin says seems "as if it was nature" and is "heavily diffused." The results are what count, and the photographer's right-hand man says of his boss, "I've never seen a light more beautiful for people than his." Scavullo's are "the most accurate exposures around," Radin boasts.

As an assistant to someone like Scavullo, every day can be an adventure, notes Radin. "First of all, you don't know what you're shooting until you're actually on the set. You don't know if it's stand up or sit down. You don't know what lens you'll use."

No matter who you're photographing, no moment can be wasted, Radin has discovered. "Each person has an intensity. You have to get whatever you can in X amount of time because they're going to lose that intensity." He has discovered, "If you're half-assed for a long time, you're going to get a boring picture. You have to be intense for a short time. Technically, you can't blow it because you can't get it back again. Nobody reshoots without somebody paying for it."

Radin has been with Scavullo long enough to observe some very major differences between his kind of photography and that of the men he assisted previously. With still life, he notes, "Every set is different. You start from scratch and build. Every lighting arrangement is different." In the realm of fashion, however, "you have *your* light. You plug that model into *your* set." But the importance of timing is not to be understated. "If there's a problem," warns Radin, "solve it in a split second, or you better know how not to have that problem."

Scavullo, according to Radin, approaches each studio session with two motorized Hasselblad bodies and a hand-cranked one, and has two of each lens he'll use.

"We have things very set and technically correct," reiterates Radin. "We clip test every single shot," which means that with each roll he and the second assistant "clip a piece (one or two frames) off, run it, quick dry it, and make a couple of prints. It's usually fine. If it's not, I can correct it." The clip test, which allows for important adjustments on negatives, is a welcome form of quality control. "I'm not sure how many studios do clip tests for every shot," says Scavullo's studio manager, hinting that there may not be any others. Thanks largely to this approach, "we get perfect negatives. It's a pleasure to print them."

Because of the nature of his employer's work, Radin is harvesting valuable hints which will be a boon to him on his own "beauty" assignments. He's seen how a light base makeup can make a face lighter than it actually is, and that adjustments must be made for any extraneous brilliance of reflections. Tanner, moodier makeup can create an altogether different effect — earthier, perhaps even vaguely sinister. In regard to wardrobe itself, he's learned that black clothes will absorb light, while white garments actually add to the existing light. Some of this may seen obvious enough, but Radin has had the chance to see how the knowledge of these facts can contribute to a fine finished photo. The standard trick for flattering an older woman

— raising a light and pointing it down to put shadows on the neck, the telltale aging area — is second nature to him now.

As a boss, Scavullo is "a perfectionist. He's on my back 100 percent of the time. Even when things are perfect, I get criticized," states Radin, who is not lamenting at all. "The learning process is his criticism of my work and my trying to perfect it. He's explaining to me so I can put it in my memory bank and next time do it automatically."

"The photographer is not obligated to teach you," stresses Radin, "but you can pick things up. You're there to work your tail off and do whatever the photographer tells you. What you get out of it all is the knowledge you absorb. Depending on how intelligent you are, it could be a lot of stuff."

During the period he was trying to find time to sit down and be interviewed for this book, Radin seemed to be averaging about ten hours each weekday. Even when he is producing "beautiful editorial work," Scavullo might complete three or four assignments per day, according to Radin — perhaps two before lunch and two after. On other kinds of work, the load may be heavier and the pace quicker. For a Bloomingdale's catalog, for example, Scavullo and his crew completed sixty to seventy shots, taking a couple of rolls of film on each and finishing twelve assignments each day.

In his job with Scavullo, Radin earns $300 a week plus overtime. He also gets to work with the glamorous and the gorgeous folks who come through Scavullo's studio — someone like Princess Caroline of Monaco or Diana Ross. "There's a certain way you have to deal with these people," he observes. "I'm very comfortable with them, and with outrageously beautiful people."

EVEN FOR AN ASSISTANT, the approach to each subject can vary greatly. "A model knows what to expect," observes Radin. "She's there to work and crank it out." Mutual faith between model and photographer is important. "She'll do the changes herself. She'll make the extra weird pose," says Radin. "It's up to you to *stop* her, to stay and shoot that for a few frames. You have to tell her it's what you want, or she'll go right past it." A celebrated person, like Diana Ross, "is used to being photographed. She needs direction, but you sort of let her do what she wants."

There is one more thing to be learned at Scavullo's studio that might not be acquired at most other fashion or beauty studios. For a rather handsome fee, Scavullo does private portraits of just plain folks, some of whom may have never posed for a professional photographer before. An extra set of abilities — patience among

them — is required to work on this kind of session.

A typical "civilian" woman posing in the studio "doesn't know what's going on," notes Radin. "She's never seen a strobe. She's never seen a camera other than an instamatic. Some of them are really waiting for direction. He [Scavullo] moves them around constantly until he sees something he likes. All of a sudden she'll fall into something. After ten rolls, you'll get really nice photos. It's like hockey. In the first eight minutes you feel each other out. Then you get the dynamics going."

It's absolutely essential to know how to behave around people who are posing. "If I'm pushy, then I'm sure he'll say something," Radin says of his boss. "He trusts me, and I know what to do." What is often required is delicate behavior in close quarters. Working with either a professional or amateur model, notes Radin, "I have to put my hand this close [an inch] to her face," because strings are used to gauge exact distances from light to subject. Radin has also learned what kind of people to tiptoe around. "With models, if they're superstars, I back right off," he swears.

RADIN IS PERFECTLY aware of what a rare opportunity his studio managership represents. Francesco Scavullo, the man whose side he toils by, is to his way of thinking "the best in the world for beauty, beauty, beauty. I look through every magazine every month to see what people are up to. I think we're the best." Scavullo's major distinction, to Radin, is that "he is the one who developed his light, and no one can take that away from him. That's all that counts."

A studio manager like himself has to be "a personable person, a nice guy," Radin suggests. "I can read people right away. You pick up vibes. You get a feeling for someone." And he can state confidently of his relationship with Scavullo, "I'm sort of his first mate now, rather than swabbing the decks. I can sort of reason with him."

In his position of studio manager, it is Dave Radin's responsibility to find a good second assistant, and he declares he is "looking for a Labrador retriever. A guy with his tongue out, waiting to fetch." Such a person should "be so eager" and "ready to do anything"; he must possess "an incredible amount of energy" and be in "constant motion." Radin emphasizes, "If they're going to be slow, I don't want them. I could do it faster."

He notes, "You can't hire someone who doesn't know anything, because anything he learns, you taught him." Having all knowledge originate from a single source unnerves Radin. On the other hand, a second

assistant must not be "too proficient. He'll try to blow you out of your job, or he'll get bored. You have to go for the middle ground. It's the attitude that counts the most, the guy who says 'I'll die to work here.' "

"There's a reward in finding a capable backup."And, Radin adds with a smirk, "The fun part of being studio manager is getting things done your way through other people."

Any reputable studio manager can supply a long list of what an assistant should and should not do, but Radin once witnessed a second assistant commit one of the most severe transgressions imaginable.

Scavullo and his team were on location at the photographer's home in Southhampton on Long Island to shoot a *Vogue* spread on resort wear. It was a cloudy day, however, and there would be no photography. Instead, there were people drinking wine by poolside.

Among them were one of the models and a young man, who was working as second assistant for a short spell and waiting to be taken on as a full-time staffer. It was an informal afternoon, of course, and a bit of clowning around ensued. But one always must know where to draw the line, even in these cases. The young assistant did not. As Radin recalls, "He pushed a model into the pool when she was clothed, and she did not like it. Francesco came out ten minutes later, and the guy got fired on the spot. He went back to New York on the train. After a few frantic calls, we got another one out the next day."

"He got too buddy-buddy and he was totally out of line," Radin says matter-of-factly about the dismissed assistant. "He didn't even know the model. That was a bad decision — and you can't keep someone around who could make that bad a decision."

FROM HIS OWN experiences, Radin would tell an aspiring camera operator, "If you have an opportunity to work in a photography studio, do it. If you want to go to school, be my guest." His opinion is that "it's better to get paid in a photo studio to learn a ton than to pay somebody to learn nothing." In his first year at the School of Visual Arts, Radin learned how to develop film and how to print, but he insists "I had to teach myself. The teachers were just there."

At the outset, he notes that "unfortunately, you're going to have to work for someone for $5 a day. They're cheap. I've never known a photographer who isn't cost conscious."

The massive responsibilities of his position have limited Radin's chances of participating in some of the most common preparations for launching his own photographic career. His testing, for instance, has been minimal. "I've shot three pictures in the last three years," he says, but adds quickly, "I got exactly what I went for."

He's not terribly concerned that his expertise is chiefly theoretical and has not yet been applied practically. "I know what to see and I know how to get it," he feels. "I see what's in front of me and I know what it looks like in the camera. I have all this information waiting to be used." Those last words are the comment of a photographer waiting to be unleashed on the world.

As far as his own photography is concerned, Dave Radin explains, "I want to stay with people. But I also like still life." Handling both is difficult, he realizes. "You need two sets of equipment and space for two sets. You don't want to rob from one set to go to the other." Unlike some people, Radin doesn't believe that an 8 × 10, the practical format for still life, is feasible for human subjects. A single shot can take thirty minutes, he says, and he knows one top model who fell asleep while posing for a 8 × 10 camera.

He isn't sure if his dual photographic passions can be satisfied. "It's tough to get jobs both ways. You can't be biphotographic. You have to be a heterophotographer."

Note: Radin has since left Scavullo's studio to become a freelance photographer and assistant.

MUSIC
AND
THEATER

WITH THE POSSIBLE exception of local newspapers, the photographic opportunity attracting the largest number of young people with cameras is surely the rock music concert. The classified pages of magazines like Rolling Stone are filled with offers for live-action shots of Springsteen, Bowie, Seger, and other rock idols, many of them taken by inexperienced amateurs trying to make their first dollars in photography.

Indeed, concert photography can be a good place for a serious cameraperson to start his or her contemplated career. A decent 35mm camera with some kind of flash is all that's needed at the outset. And rock concerts are dramatic, vivid, colorful subjects for shooting. In the course of an evening, you'll have a chance to capture fast action along with slower contemplative moments, and you'll be shooting under a wide range of lighting arrangements. The concert is good photographic practice.

The field of rock photography is now a competitive one, and veterans in the field complain that managers of top musicians are now putting greater restrictions on their movements and their access to the stars. Still, anyone who captures a rare and golden musical moment on film may have at least slightly opened the door to a photographic career. The markets for good concert shots are considerable, and a young person with a long lens in the audience has a good chance of getting a saleable shot. It can get more sophisticated as one progresses, but at the beginning, at least, concert photography requires less equipment and less capital than other types of photography. For that reason, it may be a good place for a complete outsider to start.

The four persons profiled in this section — Richard Aaron, Peter Cunningham, Waring Abbott, and Ebet Roberts — are now among the most successful concert and performance photographers in America. Some of them are now working in the fields of theater, dance, and classical music as well, and they are all established enough to have exclusive access to studio sessions with rock music's biggest names. All four of these photographers started as fans in the audience, however, and all of them either use assistants or were assistants themselves. A true beginner — without experience, photographic education, or thousands of dollars of equipment — can learn from their examples that good pictures and a good level of economic success can be obtained by anyone who's nimble, watchful, and enterprising.

RICHARD E. AARON

RICHARD E. AARON studied at the Brooks Institute of Photography in Santa Barbara and received a B.F.A. from the school of Visual Arts in New York before commencing his brief period of assistantship. One photographer for whom he loaded film magazines of twelve exposures of 2¼ film treated him "like a peon." Another was more reasonable and civil. "He wanted feedback," Aaron recalls. "He wanted to extend his *own* knowledge." Aaron suggests, "In order to get the most out of someone, you have to treat him well."

He notes, however, that even the healthiest relationship between photographer and assistant has its restrictions. "You have to limit yourself on what you tell an assistant in terms of client information and 'in' secrets," he has found. "You have to keep him away from a lot of stuff or he'll wipe you out."

Aaron is now an eminent rock music photographer, having recently moved his operations to Los Angeles after many years in New York. His star has been on the rise ever since he shot the cover of "Frampton Comes Alive," the 1975 release which ranks behind only "Saturday Night Fever" as the highest-selling double album of all-time. Today, Aaron certainly ranks among the half-dozen biggest names in his field.

"MY NEXT ASSISTANT would be someone fresh out of photography school, someone who will work the years to learn," asserts Aaron, who greatly emphasizes the importance of formal training. An assistant must also possess "a willingness to learn under all situations and to do jobs under all circumstances," he stresses.

When he is considering potential assistants, Aaron believes "talking to them is most important. Anyone can have a portfolio." What counts more is "their reputation, their appearance, their presence."

Aaron's is a people-oriented profession, where it is important for an assistant to get along famously not only with his boss but with the occasional recalcitrant client. It may be necessary to cater to the whims of a difficult subject; Aaron may leave it to his assistant to retrieve coffee or satisfy another request from the subject "so I don't have to worry." He expects an assistant to know how to set up seamless paper for backdrops and to load whatever cameras will be used. "An assistant alleviates all worries and lets you concentrate on the shooting," Aaron declares. "He should also be outgoing," which is to say he should show initiative. "If he doesn't know something, an established assistant won't ask; it's his job to find out."

There is a certain standard body of information Aaron expects a fledgling assistant to possess. A man or woman stands a chance of being hired "as long as he knows what a synch cord is, how to put in a quartz light (don't put fingers on it; even slight skin oils will change the color of the lamp), what 1,000 or 650 (watts) means, what lenses are what, and doesn't give me a blank stare when I ask him for the green seamless." An assistant need not come equipped with a long list of contacts at prop shops and other outlets, as far as Aaron is concerned. "Your pre-shooting planning for a studio session is three days," he states. "You give an assistant a couple of names, and the Yellow Pages."

Aaron warns that many young assistants find this contact with the music business "glamorous at the beginning, but it's all work. The glamour is 1 percent." He revises that a bit. "Especially in music, it can be 90 percent garbage and 10 percent work."

Aaron is one photographer who offers an assistant a legitimate growth opportunity. "If he or she works out well, I may give them a partnership," he says. He had one assistant who was originally hired to help in the darkroom but eventually had the chance to shoot jobs and grow with Thunder Thumbs.

That assistant eventually went out on his own. When that happened, Aaron realized just how much of the photographic load he had been surrendering. "With an assistant like that, you start getting lazy as a photographer," he admits. "When he left, I got back into it. It was a shot of adrenalin."

Aaron now recommends that a photographer draw up a contract with his assistant. A decent arrangement, he says, is a base salary for the assistant and 50 percent of the take on any jobs he shoots. When the sum from shootings reaches a certain level, the salary is then nullified. Even with an arrangement like this, Aaron has learned, the assistant may have a complaint or two. "They want the big jobs. The record companies want *me*. They don't understand that." It is a given that must be made clear at the outset.

FOR MOST OF HIS performance photography, which included an exclusive arrangement on the 1980 Billy Joel tour, Aaron will forego the use of an assistant. "With five cameras and fifteen lenses on the road, I can't have somebody standing behind me," he explains. "I can't see taking four assistants with me."

Photographing a frantically paced concert might appear to be a task fraught with anxious moments, but to hear Richard Aaron tell it there is absolutely no need to panic. "Lie back and relax," he suggests. "You'll get your shots." The "photo opportunities" in ninety minutes or two hours of musical performance are plentiful, he seems to feel.

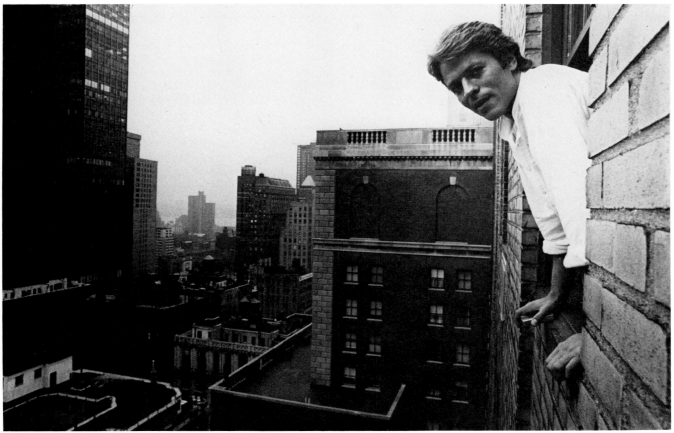

© Richard Aaron

Aaron never uses a flash or strobe in the concert situation. "I'm there to capture and document, not to interrupt," he states. "I'm shooting with the performer's lights. A strobe overrules his lights. Five songs out of twenty will have highlights. You have plenty of chances."

He is also unperturbed by the specter of a mass of camera-toting people huddled at the foot of a stage. It's all the same to him if he is one of twenty-five or one of one. "I approach everything as if I'm the only photographer there," says Aaron.

"I know where to be concertwise," he adds. He discounts the importance of any "tricks" in getting great concert pictures. The key factor is "premonition," he believes. You're ahead of the game if you "know the song, know the beat. The light *is* the beat. If you know a performer's music, you know that at the end of a song he might do something special, or he might jump in a certain area at a certain time."

Aaron had shot a couple of Peter Frampton shows, befriended the artist, and got the image which became the cover of "Frampton Comes Alive" in a concert at Madison Square Garden in 1975. "It was a needle-sharp

photo; it was crisp," Aaron remembers. "They wanted a hypnotic effect, so they put a diffusion filter on for the printing. I hit the ceiling."

An album cover should be shot in the most straightforward manner, Aaron contends. "You have to shoot without tricks for the addition of tricks. Once you add the tricks, you can't take them away."

One of the less publicized benefits of formal education, Aaron suggests, lies more in the area of temperament than technique. A complete photographic education, he says "teaches not only the tricks, but how to be a person, how to deal with people." Aaron took three years of psychology, and perhaps one of the things which most clearly separates him from the pack of lesser lights is his understanding of the personality of a typical rock star.

"Everybody is an individual, everybody has his own hangups, and everybody hates photographers," Aaron says. "You get to know them and you deal with them as person to person, not as photographer to subject. After that, you can introduce your role as photographer into it. If you treat them as people, they'll treat you as a person."

RICHARD E. AARON

THE RELATIONSHIP of intimates rather than adversaries is essential for Aaron to get the effect he always wants. "I want to get people as they look good — with virgin, relaxed baby expressions, not ugly or bad. I let them be what they are."

Aaron's best photography indicates a knowledge of his subject's personal nature, and an appreciation for the context of the event on such occasions as an outdoor appearance by James Brown in Harlem. He didn't just shoot Brown onstage; there are hundreds of thousands of those unpublished pictures resting on the bottom of files in 50 states. The situation called for a "very wide angle" 24mm lens. Using Tri-X (ASA 400), Aaron was able to show a beaming Godfather of Soul in the foreground and get enough depth of field to pinpoint adulatory fans in a daytime crowd that stretched to the horizon. The composition also included several towering apartment houses in Harlem's skyline. "This gives you who, what, where, and when," notes Aaron. "Every pictures tells a story." Every *successful* one, like this one, that is.

Remembering a key comment made by your subject, or a minor trait he may have betrayed at one time, can also give a photo an element to put it a cut above the norm. British singer Robert Palmer had said somewhere in print or over the airways how much he liked to come into New York and look at the skyscrapers. With that in mind, Aaron opted for something other than a normal studio session with Palmer. Again he used a 24mm lens on a Nikon and Tri-X and recalls, "I stuck my head out one window, he put his out the other, and I just shot." The resultant image of Palmer positioned against the Manhattan vista he admires was used by *Rolling Stone*.

Dealing with a large group in a studio setting can be a little taxing on the photographer. If he's trying to assemble five or more people, at least one of them is guaranteed to be surly, out of sorts, or plainly not interested in having his picture taken. Aaron encountered such a situation in a session with the eight-member band The Crown Heights Affair. "I stood in front of the camera, screamed at the top of my lungs, and jumped up and down until I got their attention," sighs Aaron, who got his picture of the six- or seven-eighths amused Crown Heights Affair group by using a Hasselblad with 120 Ektachrome ASA 64 film ("to get fine grain") abetted by two Ascor 1,200-watt units with four lighting heads and diffusion umbrellas.

In more spontaneous situations where he must shoot with available light and does not wish to use a flash, Aaron will use Tri-X pushed to ASA 800 "for a great depth of field. Everything is in focus from the foreground to the backdrop."

Aaron has also learned that if he can't pose the precise picture he wants, he can make certain adjustments afterward. The superflamboyant group Kiss was backstage in their dressing room and so was Aaron, who was using a Nikon and available light. The photographer got the four band members in the position he wanted, although the cluttered and uninspired backstage trappings were not the environment he desired. He snapped the picture anyway. Later, using potassium ferrocyanide, water, and a Q-tip, he bleached out the areas of the print he didn't want. In this case, what he didn't want was the entire background, which after bleaching became pure white. The Kiss quartet appears to be walking on air, or floating on a cloud.

PETER CUNNINGHAM

PETER Cunningham, an accomplished photographer of musical and theatrical subjects, had just one experience as an assistant and it was an opportunity few in the field of photography, be they high and mighty or low and woebegone, would ever have passed up. Cunningham was the right-hand man to Henri Cartier-Bresson for two weeks as the French master traveled around New Jersey as part of Public Broadcasting's "Assignment America" series.

CARTIER-BRESSON had selected New Jersey as a "microcosm" of the United States, and would capture its contrasts, from its wealthy corporate presidents to its ghettoes. Cunningham learned that his temporary boss "works very, very hard at what he does. He shoots every day, and he has a talent, and he takes himself very, very seriously."

Cunningham would pick the Frenchman up at his hotel every morning and drive to his chosen New Jersey destinations. For much of their venture, Cunningham walked directly alongside his master. "He didn't want to have to talk to people while he shot," Cunningham states. "I had to explain to people after we did the shots what we were doing." There was no time to brief these people beforehand because the venerated photographer "shoots very quickly."

From a technical point of view, little was required of Cunningham. Cartier-Bresson took no light readings, but "his exposures were right on." The photographer carried two Leicas; his assistant wouldn't even touch them. The two men were traveling light, Cartier-Bresson apparently prefers to "slip in and slip out."

There were a few tasks for Cunningham to attend to. He took care of the labeling of film and the relations with the processing lab. He also scouted locations, but Cartier-Bresson wasn't particularly concerned with examining those beforehand. "Just take me there," he would say.

Cunningham's most important function may have been to part the waters in Cartier-Bresson's path. "My job with him was to make it possible for him to move freely," the American remembers. "He didn't have to deal with the principal in the high school about getting access. I did all the negotiating, so he could move about."

One of the happier lessons Cunningham learned was that his mentor is a true egalitarian. "The attitude he had was that we traveled as equals," Peter recalls. "One night at a motel we had just one room, and just a cot and a bed. I started to take the cot, but he said we'd flip a coin. We did, and he lost. I got the bed."

ANYONE WHO has admired the photos of fabled musicians hanging at The Bottom Line, New York's venerable rock music showcase, is familiar with Peter Cunningham's own work. Everyone of those performance pictures is his, and many of them are the definitive images of the stars depicted.

Cunningham, who never served an assistantship (other than the brief two-week period with Cartier-Bresson), admits, "I miss that experience. You get things assisting you can't get elsewhere — little state-of-the-art tricks. And you get a vocabulary of how to do different things." Now, he says, "I'm learning from my assistants. I've just started working with them. One great thing is that it spreads the responsibility around. Someone else is involved in addition to yourself. When you're working, there are too many things to worry about, too many things that can go wrong."

Although he may still be best-known for his rock music photography, Cunningham's pictures are getting to be plentiful on the marquees of Broadway's legitimate theaters. He is getting more and more work shooting dress rehearsals and commercial stills which are used for all sorts of publicity purposes. Some of his stills end up in television spots ("Eubie") while others become posters, like the montage of three images of Sandy Duncan as Peter Pan.

IN HIS THEATER work, Cunningham always uses at least one assistant. "You get a very short photo call," he notes. "You need someone to load a camera because you can't miss anything." In this situation, an assistant also has an excellent chance to double as photographer. "I can't be everywhere," Cunningham acknowledges. In a typical situation, he may have one assistant shooting a whole show from the balcony and a second one photographing it with a long lens on a tripod in the center aisle while he remains free to move about, taking pictures from out front and even onstage.

For the best concert photos, Cunningham advises, "What helps is to have seen the performer once," and lays down a few cardinal rules. "A microphone in the face kills the picture. And no toplight is bad. If there's only front light and you're shooting from the front, it's boring. Move to the side and shoot *across* the front light."

The lighting situation is constantly in flux at most concerts, but Cunningham suggests, "Only consider the exposure on the performer's face. Let the lights go where they will." He adds, "A little diffusion is always

PETER CUNNINHAM

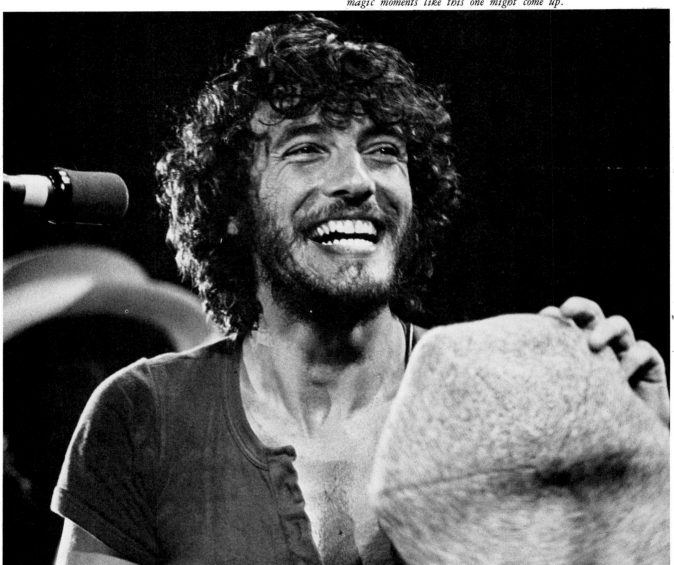

© 1976 Peter Cunningham

nice. It creates a field of color around the picture."

Cunningham is among the photographers who resist using flash or strobe in concert. "Never! It's rude to the performer and rude to the audience. I hate when people do it."

Intrusion is to be avoided; it would not reap the desired results anyway, believes Cunningham. His famed 1975 shot of an ebullient Bruce Springsteen at The Bottom Line is a case in point; Springsteen has no awareness of the photographer, but is rather exulting in the joy of music. "That's him," Cunningham wagers. "That's his personality. That's what you try to capture."

The best pose "often happens in a break in the music, when people are clapping," the photographer states. "Their faces aren't expressive if they're at the mike."

Cunningham knows his art and his equipment well, and he can rattle off statistics with the best of them. But some of the most essential "tricks" are rather elementary. What, for example, does he do if he wants a bit of diffusion? "I blow on the lens," he confesses. "It usually doesn't work. But if it does, you get an interesting shot."

WARING ABBOTT

ONE OF THE BUSIEST and best-paid photographers on the contemporary music scene is a classically trained trombonist who didn't even buy his first camera until he was twenty-five. Waring Abbott lived in Venezuela until he was thirteen, and his earliest music memory is of a radio blaring out "Volare." At fourteen he came to New York for a summer to study music, living at the now defunct Hotel Nevada, one of those "single rooms only" establishments. He remembers how the older tenants "would buy a loaf of bread and live off it for a week," while he himself "learned the trick of going into a restaurant and just ordering coffee and pouring the entire sugar bowl into it. That would keep me going."

Abbott in time earned a music degree from the University of Florida, worked as a performer in New York for a spell, and then became an advertising copywriter for three or four years. He soon switched his profession to art direction: "It looked like art directing was easier. A friend showed me all the tricks, which weren't very many." He caught on well enough to create his own agency, but was eventually tempted to sign on with a bigger organization.

AT THIS POINT Abbott "saw an opportunity to acquire vast quantities of camera equipment" at the agency's expense. To learn how to use the contraption, Abbott got himself subscriptions to *Popular Photography* and *Camera 35* and acquired the *LIFE Library of Photography*, which he still insists is of infinite value.

Somewhat self-effacingly, Abbott insists he acquired the camera "because I was the world's worst art director. I was the main reason the agency went bankrupt." He in fact bought the camera "with the intent of becoming a better designer," and tried shooting some campaigns himself until time, funds, or luck ran out and the agency went under.

In the tradition of the great self-starters, Abbott began shooting the summer rock concerts in Central Park, photographing groups who were obscure at the time but whose pictures would later command top dollar for several years. He didn't position himself in the pit at the foot of the stage with the high and mighty camera operators; instead, he sat in the tenth row, "which is the best place to be in that situation."

Pure gumption was perhaps Abbott's greatest asset in getting his photography career off the ground. He did not shy away from contacting the major publications, or from showing up in offices where he was not exactly expected. "You're very aggressive at the beginning," he asserts. "You're determined and even obnoxious." His rock photography was soon appearing in most periodi-

cals covering the subject in this country. "Then I found out about Japanese and German magazines," he notes, "and I forgot about American ones." That's not precisely true, but Abbott now estimates that 50 percent of his income is from West Germany and 25 percent from Japan. Many foreign publications have offices in New York; in the case of Japan, Abbott is represented by an agency called Imperial Press. He has recently augmented his markets by adding classical music to his photographic repertoire. He's done album covers for the Philips and Deutsche Grammaphon labels and has focused his camera on "serious" music stars like James Levine, Claudio Arrau, and Sherril Milnes.

BECAUSE OF his late start in the business, Abbott never served a photographic assistantship. Although he admits "I'd probably be a lot further along with commercial photography if I'd done that," he's not so sure that a good rock music photographer needs to have served at the side of a master.

Nevertheless, Abbott treasures the presence of an assistant on his own assignments. Unlike some of his contemporaries, he even likes having one along for concert shooting if conditions make it feasible.

Part of the reason an assistant comes in handy for Abbott is that he carts along a great deal more equipment than other concert photogs customarily do. For a live performance, he arrives with three cameras, two Nikons with motordrive and one without. His array of lenses is larger and more versatile than the norm. He'll bring a 70-210 Macro Zoom Vivitar, a 24/f 2.8, a 28/f 2.8, a 35/f 1.4, a 50/f 1.4, an 85/f 1.8, and a bulky 135/f 2.8 "if I have the strength." He will also have a couple of Sunpak 411 strobes in his equipment bag. The strobe, which some concert photographers do not use, is essential to Abbott, who suggests, "There may be something in the audience, like a fight, that I might want to see. For that you have to have it. There isn't any light at all." Abbott's assistant, then, is present to reload camera and change lenses but also because "she may see something on stage or a development in the crowd I don't see."

EVERY LENS Abbott uses has a specific purpose; "it all comes in handy." He remembers one instance in which a 24mm lens saved the day. Graham Parker ventured out into the audience to shake hands, and was only a few feet away from the photographer. Only a wide-angle lens would have permitted Abbott to prop-

erly capture Parker so much in the foreground, with an adulatory audience very much in focus to the rear and the sides.

"The wide-angle lens gives you a better chance of doing multiple exposures," instructs Abbott, who has successfully produced more than a dozen images of the same performer on one frame of film. A good example of Abbott's multiple exposures can be seen on the inside of the album "Here At Last . . . Bee Gees . . . Live."

The effect is not so impossible to achieve, Abbott asserts. "You read the manual that comes with the camera. People think it's some mystical secret. They think you have to go to college." To keep shooting on the same frame, he says, you can keep the film release button on the bottom of the camera pressed down, hold down the rewind crank, and cock the shutter.

A multiple exposure can feature separate images of a performer in an even row from left to right, in a descending line from top left to bottom right, or even stacked from the top to the bottom of the print. It is entirely up to the way a photographer positions his camera. As Abbott explains, "I move. He (the performer) doesn't." To get six Elvis Costellos in a row, for example, you'd first sight Elvis in the left side of the lens and shoot and then move slightly to the right on each of the next four shots. The multiple exposure is only effective, by the way, if there is total blackness to the left and right of your subject.

WARING ABBOTT adheres to the belief that at a concert "nobody is there to interrupt. The way to bring an abrupt end to your career is to give that illusion." He adds, "My respect is more for the audience. The show is for them, not for me."

You don't have to be a privileged or credentialed character to get terrific concert pictures, Abbott insists. "So many kids think they have to have a backstage pass. Some of my very best jobs are from out front." He observes, for example, that the only way to get a decent shot of a singer with a guitar is from out front and off to the right. He won't turn left into the microphone because the neck of his guitar would then knock the mike over. He *has* to turn to you. Obviously, this whole situation works in reverse for a left-hander like Paul McCartney. In that case, you'd line up to his left.

In the huge loft he uses for studio sessions, Abbott prefers to "keep the number of people down to a minimum." Frequently he can get by with just the help of a woman named Liz, who is his only full-time employee. She is an art major who took a few pictures in college, and she happened to be living in Abbott's building when he developed a critical need for dark-room relief. He had been doing all of his own printing. "It was severely limiting my income," he remembers.

Abbott taught Liz how to print, and she now does all of his printing. She also "filters out the people I might not want to do business with" and "has the power to decide if someone is reliable enough to lend transparencies to, or whether someone should have a print for $150."

There are times when Abbott prefers to have a second or even a third assistant to back him up. It might be an occasion "when there is a more tense situation or a more important group" is in for a studio session. Or it may be when he elects to have "the security of dividing up the job more, of giving everybody maybe a third of each job. It's like backup systems for space shots. If one goes out, you have the other two."

ABBOTT'S HIRING practices might surprise more orthodox professionals in the field. "Somebody who has been to a photo school is immediately ineligible," he states. "I think it (the photo school) destroys them. They have no understanding of the real world. They have no knowledge of what it takes to make a picture. Psychology is the most important element of photography, and they don't know how to deal with people. I'd rather have somebody who's just intelligent and can talk to people than someone who knows about *f*-stops."

"A lot of kissing and handholding" is involved in private photography sessions with popular musicians, Abbott observes. Having the dependable Liz present allows him to pay attention to the client while she's handling technical matters, "or allows her to (pay attention) when I don't want to." Liz also helps pose the members of a band when the photographer doesn't want to "walk those fifteen feet out from behind the camera to push people together." And when Waring is talking to their manager, Liz can talk to the musicians.

Studio work is pretty painless when the rock groups have a professional demeanor and comportment. Kiss, for example, arrived at Abbott's loft with one person who *carried* their makeup, another person who *applied* the makeup, and a woman who not only made them tea but brought her own teapot. "The problem you have," says Abbott, "is with new groups that don't know what's expected of them."

Those are the times when he may hunt for freelance backup. He has tried a few of the assistants who post notices on the bulletin board at the photo lab he frequently uses. "Some didn't have answering services, which was amazing," he states. And he encountered a distressing paucity of people who were available on short notice.

Abbott is among those photographers who feel the temperament of an assistant is of extreme importance. "I can't afford attitudes, the 'I won't do it, it's beneath me' thing. There's no room for politics or emotional hangups."

When considering taking on another assistant, Abbott wants "to make sure they're for real, not just some kid who borrowed their father's camera. If they were to load wrong, how is it if I go to the client and tell him I have to do it again?"

Abbott looks for "someone who's grown-up, mature, and not consuming an enormous amount of drugs, someone who's lucid. Counterculture people aren't needed anymore. This is a 9-to-5 job. I'd rather have someone conservative than a flake."

To see what an applicant is made of, he will "ask them circuitous things, to see if they'll let something slip that shows they don't know how to use a Mamiya RB67 or how to take a strobe reading."

Will he look at portfolios? "What for? I don't want them to take any pictures. I don't have two weeks to shoot Helen Reddy; I have twenty minutes. A portfolio doesn't tell me about the conditions someone worked under. If an amateur has all the time in the world to get good results, it's almost meaningless to me."

The Mamiya RB67 is Waring Abbott's favored studio camera. It produces superlative 2¼ by 2⅜ negatives. What may be more significant is that it can produce Polaroids which "show exactly what you'll get" when you take the finished photo.

His main light in a typical situation would deliver 1,600 watt-seconds, with an umbrella set up over his camera to "send the light straight toward the subject and nowhere else at all." He also likes to light on the sides, with strobe heads of 200 watt-seconds to the right and left aimed at his background. He can achieve more intense, more completely fill-in color if, for example, he uses red gels over the side strobes while using red seamless paper. He will usually add a small hair light hanging down from a boom.

All of this is variable if the situation mandates it, and other lights may be added. In a recent session with Paul Stanley and Gene Simmons of Kiss, he hooked up a pink light emanating translucently behind the white paper background "because I thought it was subtle." And he is open to suggestion. "If Liz comes up with a better idea than mine," he says, "we'll do it."

With the Mamiya, Abbott uses Ektachrome 64 or 400, noting "it's such a large format it doesn't matter how fast the film is." He may lean toward the 400 because it "gives more depth of field." And he will be using Kodachrome 64 with a backup camera (probably a Nikon) anyway. "You'd have to be a moron to do a job with only one camera," says a man who takes precautions. "Any professional who tells you he doesn't mix his pictures is kidding you.

EBET ROBERTS

EBET ROBERTS' metamorphosis from a Memphis figurative painter to a New York rock music photographer was a gradual but logical one. In her canvases, she began adapting such techniques as photo collage, lithographs, and painting on photographs until the camera and not the paint-brush became her primary creative tool. The seed of her new career sprouted when a boyfriend asked her to "please take pictures" of the band he was managing. Once in New York, Roberts made her entry into photography as a profession when a music executive called and asked if he could buy a shot she'd taken of romantic Willy DeVille.

ROBERTS IS NOW one of New York's busiest visual documentarians of the music scene; she pines for a week when she would only have to work six days. With a crowded schedule of studio, location, and performance shooting, her most crucial staff need is for an assistant who can dependably and skillfully handle a large volume of darkroom work. More than in almost any other category of picture-taking, the music photographer has to service a huge number of markets in only a modicum of time. A capable darkroom assistant is an extremely prized commodity.

Roberts found such a person when she was contacted for this book. A friend of hers called to tell of a high school girl who "was really into photography and music" and so was so anxious to work for Roberts that she was offering her services for free. At the time, Roberts didn't need anyone.

Twelve months later, the girl had spent her senior year working for school credit at The Light Gallery, a photography showcase on Fifth Avenue. At seventeen, "She is better in the darkroom than twenty people I tried out," Roberts claims. The difference, she believes, may have been the stint at the gallery, "seeing fine print quality and learning what to look for."

When Roberts searched for assistants in the past, she usually decided against advertising in the newspapers because she "couldn't deal with the response." She's made calls to the International Center of Photography or to the photo departments of Columbia University and the New School for Social Research. Nevertheless, it is hard to escape an onslaught of applicants who are unqualified to assist any photographer. "I got a lot of calls like 'I used to work in a Xerox place once,'" Roberts remembers.

She will look at an applicant's portfolio, not so much for artistic merit but with an eye to print quality. "People will say 'Don't look at that one, the negative was dusty' or 'I should have burned that in more.' You shouldn't *show* those pictures. You won't get work on that basis."

Sadly, Roberts reports that chauvinism is rampant again in aspiring assistants. "It seems like everybody I interviewed who was male was saying 'I hate printing and I want to shoot and I can probably teach you a lot.'" She was not looking for aggravation; she wanted a cooperative soul who would print for a floating weekly schedule of about 35 hours.

A darkroom worker is the only full-time assistant Roberts requires. For certain studio or location jobs, she can call upon a photographer and writer named Ron who lives in her apartment building and has studio space and his own lights. Ron accompanied her on a backstage assignment to shoot The Kinks in Philadelphia, bringing a Dynalite 800 with two heads. "It shoots fast," observes Roberts. "I can shoot 64 film at 16 easy."

Ron can expect $50 for a day's labor or perhaps $20 if his services are only required for an hour. The proper skills are of course a necessity, but like many a good assistant, Ron's strong suit is attitude and preparedness. "He seems to be totally on top of it," explains Roberts. "He keeps everything well-organized. With everyone else I have to say 'Do that, set this up.' But he tells me what film I've got, what the light is. That anticipation — that's the whole key to everything."

EBET ROBERTS keeps her camera kit lightweight and uncomplicated. She will use 2¼ film if the session is for an album cover, because 35mm would "lose detail" if it were enlarged that much. Generally, however, she prefers 35. "I can shoot more comfortably and faster. What's important for me," she reveals "is the moment, capturing the second. The 2¼ is slower."

In studio works, she tries to get by without a tripod, preferring to move around and shoot at different angles. Although Roberts rarely uses motordrive, she admits, "It's good for those times when you missed the shot and now it's one second later."

For concerts, Roberts arrives with two cameras, not alternating back and forth but "shooting with one and having the other just in case I need it." She will usually begin by shooting two rolls of black and white (Plus-X gives the look she prefers) and then switches over to color.

Although Ektachrome 200 allows her to shoot with stage lights only, she says that many magazines will no longer use it. "You blow it up and it's mush," she laments. "The grain is too big and nothing looks sharp." Roberts' alternative is Kodachrome 64. If she's using that, her camera will be equipped with a built-in strobe which recycles over three or four seconds, or longer in pitch darkness. Her lenses are 35mm, 50mm, and 135mm. The latter is especially important "to get

Late '70s rock music wasn't all sweetness and light. As Roberts' photo so ably attests, Stiv Bators oozes malevolence on stage, and it's not surprising to learn he was leading a group called The Dead Boys.

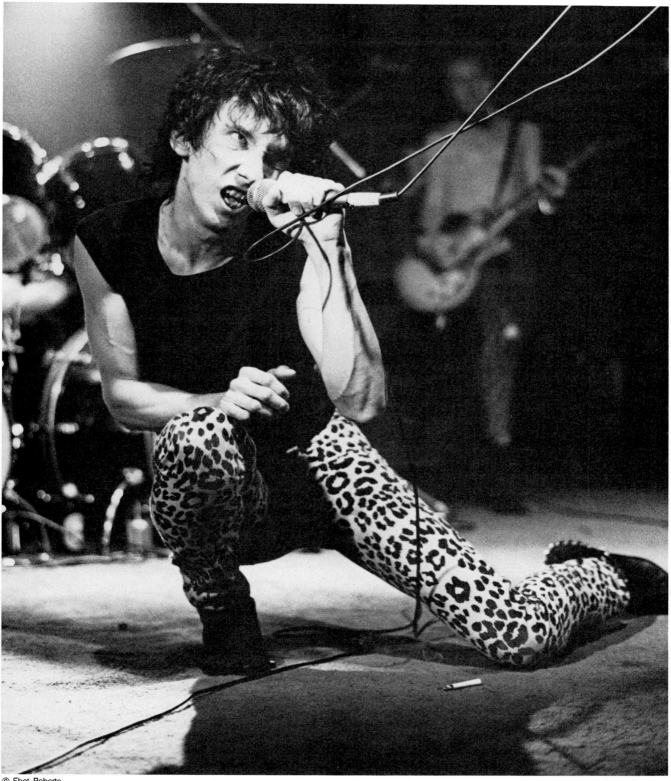

© Ebet Roberts

in closer, especially in case I'm two miles away."

There may be times when a concert attracts a slew of credentialed picture takers, all seeking to operate within a much too confined space. "When I see photographers I know," says Roberts, "they mostly have respect for the fact that you have to get pictures, too. That's the way I am; I'm not going to get in front of them." There are surly and unwelcome exceptions, however. "There are some who are beyond belief," she gasps. "They push, and they stand right in front of you when they see you're shooting. When it gets like that, I don't want to fight. I want to go home."

Lust never sleeps, as is proven in this shot of The Cars shortly after their 1978 debut album made them the most acclaimed new band of that year. This is a prime example of fortuitous, perfectly timed shutter clicking.

INDEX

Aaron, Richard E., 116-118
Abbott, Waring, 121-123
American Society of Magazine
 Photographers (ASMP), 31, 101
Annual report photography, 18, 21
Art Center College of Design, Los
 Angeles, 24
Art photography, 72
Assistants
 ambitions of, 36, 43, 53, 65, 92
 without aspiration, 39, 53, 82
 attributes of, 13-14, 26-27, 37, 42-43,
 45, 52, 56, 62, 65, 69, 82, 89,
 91, 101, 116, 123
 in decision-making, 9, 34-35
 duties of, 12, 27, 29, 50, 65, 67, 72,
 74, 93, 98, 100, 101, 106, 116
 education of, 12, 15, 24, 28, 31, 33,
 42, 48, 50, 68, 94-95, 113, 117,
 122
 fashion, 105-106, 108
 female. See Women assistants
 hiring process for, 9, 14, 31-32, 37,
 72, 74, 83, 86, 89, 93, 101, 111,
 122, 124
 jumpers, 60
 payment of, 28-29, 38-39, 45, 50,
 60, 93, 116
 programs for, 31
 setting up in business, 9-10, 12-13,
 32, 36, 44
 See also Freelance assistants
Aubrey, Joy, 74-75
Avedon, Richard, 24-26, 27, 37

Beauty assignments, 111-112
Benson, Gigi, 83
Benson, Harry, 82-83, 98
Blumenthal, Irwin, 92
Booth, Greg, 91
Brodsky, Joel, 98
Bronica camera, 102
Brooks Institute, Santa Barbara, 28, 109,
 111
Burtner, Melissa, 48-49

Calderaro, Bill, 111
Campbell, Barbara, 30
Cartier-Bresson, Henri, 119
Catalog photography, 109
Christenson, Paul, 109-110
Corlette, Paul, 37-39
Cunningham, Peter, 119-120

Day rate, 33-34, 35
Duke, Dana, 91
Dunning, Robert, 74

8 × 10 camera, 27, 52, 56, 106, 109,
 113
Fairchild Publications, 98, 99
Fashion Institute of Technology, 48
Fashion photography, 16, 24-25, 27, 29,
 34-35, 88, 97, 99, 100-101, 105,
 111-112, 113
Folmer and Schwing view camera, 86, 87
Food and beverage photography, 41, 44,
 45-49, 51, 52-53, 57
4 × 5 camera, 60-61, 73, 91, 93

Freelance assistants, 8, 29-30, 43-44
 career launching by, 36
 payment of, 30, 33-34, 35, 65, 82,
 93, 109
Friedman, Jerry, 109

Gold, Charles, 45-49
Grainger, Peggyann, 33-36
Greenfield-Sanders, Timothy, 86-88

Hasselblad camera, 44, 102, 111
Hausner, George, 48
Heisler, Gregory, 13, 14, 15-21, 91
Hiro, 24, 26, 37-38, 55

Interns, 42, 91
Iooss, Walter, 78-81

Jones, Carolyn, 38
Jumpers, 60

Karsh, Malak, 60
Kolleogy, Frank, 98
Krementz, Jill, 30
Krongard, Steve, 8-11
Kropinski, Jacek, 105-108

Lambray, Maureen, 30
Leo, Donato, 50-51
Lewin, Gideon, 24-27
Life magazine, 21, 82, 91
Lighting
 arena, 81
 bounced, 92
 edge, 50
 for Forties look, 30
 for rock concerts, 119-120
 of women, 111-112
Location scouting, 31, 38
Loengard, John, 21
Lucka, Klaus, 60-63

Meola, Eric
 and Heisler, 13, 14, 18
 and Turner, 12
Models
 photographic career for, 103
 working with, 112
Moscati, Frank, 48

Nakano, George, 28-29
Nesti, 36
Newman, Arnold, 15-16, 89-92
Newspapers, career launching from, 21,
 68
Nichols, Bruce, 42

Ohringer, Frederic, 93-95
Olson, John, 18, 21
O'Neill, Michael, 55-57, 103, 110
One Mind's Eye (Newman), 92
Opening nights, photography of, 98, 100
Paparazzi, 98, 100
Pell, Betty, 52, 53, 54
Pell, Bill, 52-54
Penn, Irving, 42, 44
People magazine, 82
Photographers
 as teachers, 42, 44, 60, 91
 See also Specific names
Photographic assistants. See Assistants

Photography schools, 15, 26, 28, 31, 33,
 45, 48, 50, 68, 94-95, 113, 117, 122
Photo illustration, 59
Photojournalism, 77
Pippin, Wilbur, 36
Playboy, 15
Portfolio, 8-9, 27, 31-32, 45, 62, 72,
 82, 91, 106, 123, 124
Portrait of the Theater, A (Ohringer), 93,
 95
Portraiture, 56, 85, 86
 of Newman, 90, 91-92
 wide angle lens in, 16
Posar, Pompeo, 15

Radin, David, 109-113
Reinhardt, Michael, 28, 29, 105, 106,
 108
Resume, 32, 62-63
Roberts, Ebet, 124-127
Rochester Institute of Technology (RIT),
 15, 33, 48, 50, 62
Rock photography, 115, 116-118, 119-120,
 121-122, 125, 126
Rubin, Darleen, 98-102

St. John, Lynn, 42-44
Salzano, Jim, 64-67
Satterwhite, Al, 68-73
Scavullo, Francesco, 109, 111-112
Skelley, Ariel, 103-104
Skzrebinski, Victor, 15, 16
Slavin, Neal, 38
Sports Illustrated, 78-81
Sports photography, 78-81
Still-life photography, 29, 41, 42-43
 trick effects in, 50-51, 57
 See also Food and beverage photography
Stuart, John, 14
Studio manager, 8, 37-38, 74, 112-113

Theater photography, 119
35mm camera, 9, 38, 48, 50, 72-73,
 92, 100, 106
Toto, Joe, 64
Turner, Pete
 and Krongard, 9-10
 and Meola, 12
 staff of, 7, 8, 9

Uher, John, 48
University of Missouri, 68

Van Schakwyk, John, 8

Wachs, Ted, 109-110
Weckler, Chad, 28-32
Weckler, Chuck, 28
Whittaker, Ross, 109-110
Wier, Tom, 36
Women assistants, 38, 45, 49, 56, 62,
 74-75
 physical problems with, 102
 prejudice against, 35-36, 83
 travel restrictions with, 64-65